FROM INDIAN EARTH

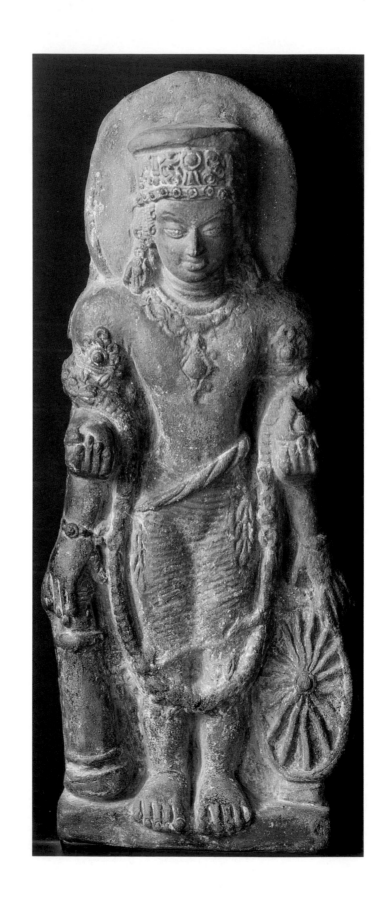

FROM INDIAN EARTH
4,000 Years of Terracotta Art

Amy G. Poster

THE BROOKLYN MUSEUM

Published for the exhibition
From Indian Earth:
4,000 Years of Terracotta Art

The Brooklyn Museum
New York
January 17–April 14, 1986

The festival logo

FESTIVAL

OF INDIA
1985·1986

From Indian Earth: 4,000 Years of Terracotta Art is part of the eighteen-month-long *Festival of India* in the United States, 1985–86, which is being organized by institutions in over ninety cities across the country. This exhibition was made possible, in part, through the support of The Indian Advisory Committee for The Festival of India, the Department of Culture and the Government of India, the National Endowment for the Humanities, The Morgan Guaranty Trust Company of New York Charitable Trust, the Indo-U.S. Subcommission for Education and Culture, and various private sponsors.

Cover:
Rama and Lakshmana (detail)
Uttar Pradesh
Gupta period, 5th century A.D.
Red terracotta relief tile,
 41.9 x 42.6 x 11.4 cm.
The Asia Society, New York;
 Mr. and Mrs. John D. Rockefeller
 3rd Collection
Cat. no. 94

Frontispiece:
Standing Vishnu
Uttar Pradesh
Gupta period, 5th century A.D.
Red molded terracotta plaque,
 25.8 cm.
Collection of Samuel Eilenberg
Cat. no. 90

Library of Congress Cataloging-in-Publication Data

Poster, Amy G., 1946–
 From Indian earth.

 Exhibition held at the Brooklyn Museum, Jan. 17–April 14, 1986.
 Bibliography: p.
 Includes index.
 1. Terra-cotta sculpture, Indic—Exhibitions.
I. Brooklyn Museum. II. Title.
NB1265.P6 1986 732'.44'074014723 85-30964
ISBN 0-87273-103-0

Photo Credits:
Vidya Dehejia: figs. 9, 10
John C. Huntington: plate 2; fig. 3; cat. nos. 74, 75
Stephen P. Huyler: figs. 15, 16, 17, 18, 19
Scott Hyde: frontispiece; plates 1, 3, 4, 5; cat. nos. 27, 34
Otto E. Nelson: cover; cat. nos. 94, 104
Ellen Page Wilson: cat. no. 96

Contents

Foreword

The Brooklyn Museum's exhibition *From Indian Earth: 4,000 Years of Terracotta Art* places this little known art form in its proper perspective. Terracotta sculpture is one of the most ancient and diverse forms of creative expression, and in India potters have been not only the creators of the sacred forms of the great mother but also the guardians and priests at her shrines. Drawing their material from the earth, using fire as energy to transform and strengthen the body of the clay, they have modeled icons of the mother-goddess in forms that express the passions, the fears, and the devotions of India. Theirs is an art of the people, of village and tribe.

Modeled by hand, their features pinched into shape, terracotta *matalas,* or great village mother-goddesses with primordial faces and schematized bodies, have been made for five thousand years or more. These icons epitomize fertility and life and are integral to rites of agriculture and the sowing of seed. They are also used in funerary rituals, installed in shrines, worshipped under trees or in caves, abandoned outside village boundaries, or consigned to rivers. No clay icon of the mother-goddess could be kept under the roof of a householder.

In the cities of the ancient Indus Valley Civilization, mother-goddess figures wore elaborate ritual headdresses. They took serpentine forms and had shamanistic faces with brooding eyes. As the timeless nude earth woman, mother-goddesses at Chalcolithic sites on the Deccan plateau appeared headless with outstretched arms. Free of all inessential detail, their forms were abstracted to a sacred austerity.

Matalas have been created at times with bird, animal, or human faces, with clay pellets applied for the eyes, mouth, and breasts, with a hole for the genitals. In the second century, the mother-goddess was represented with prominent breasts and massive thighs, holding a baby in one hand while the other held a cup of blood with which she fecundated the earth. The conception was monumental.

The tradition of molding clay images of the mother-goddess survives to this day. Indian potters still make such images for worship, as offerings to trees, as wish-fulfillment figurines, and as ritual objects for black magic and sorcery. As *From Indian Earth* makes clear, it is a practice that is likely to continue for a long time to come.

Mrs. Pupul Jayakar
Chairman
Festival of India

Preface

The Brooklyn Museum has a long and, in the New York area, pace-setting history of interest in Indian art. The pioneering ethnologist Stewart Culin made collecting tours of India for the Museum in 1904 and 1913, and during the 1930s Ananda K. Coomaraswamy, the early twentieth century's most influenctial scholar of Indian art, acted as a Museum consultant. Under his guidance, the Museum acquired sixty-nine objects from an important excavation conducted between 1935 and 1937 by the University of Pennsylvania and the Museum of Fine Arts, Boston, at Chanhu-Daro, an Indus Valley site from about the third millennium B.C. With the addition of the Bertram Schaffner collection in 1969 and further contributions in the early 1970s, the Museum's collection of Indian terracottas has grown to include 205 pieces.

In keeping with this tradition, we are pleased to present *From Indian Earth: 4,000 Years of Terracotta Art,* an exhibition which examines a medium that may have more to tell us about Indian life than we can learn from any other single art form. Juxtaposing rare terracottas from antiquity with more modern examples, the exhibition provides a complete picture of terracotta art throughout India's history, inviting historical comparisons and demonstrating the diversity of the many regional traditions to be found in India today.

From Indian Earth is part of the *Festival of India,* a celebration of Indian culture that is being held throughout the United States in 1985 and 1986. The exhibition would not have been possible without the generous support of the National Endowment for the Humanities, the Indo–U.S. Subcommission on Education and Culture, and the Morgan Guaranty Trust Company of New York Charitable Trust. Further support has come from several private sources.

Robert T. Buck
Director
The Brooklyn Museum

Acknowledgments

Amuseum exhibition is always a cooperative endeavor, particularly so when nations separated by great geographical distance and considerable cultural distance join forces. We are pleased to have been able to contribute to this year's celebration of Indian culture and would like to express our appreciation to all of the people, both here and abroad, who gave their time and effort to make this possible.

Amy Poster, Associate Curator of Oriental Art at The Brooklyn Museum, was the chief organizer of the exhibition and principal author of the catalogue. She has long been a student of Indian terracotta art, having pursued research in this area since the initial exhibition of the Museum's own collection of terracottas, which she organized in 1973. She has subsequently visited and studied many important sites in India as well as collections there and in America and Europe.

In India, Dr. Kapila Vatsyayan, former Additional Secretary of the Ministry of Education and Culture, assembled a committee of eminent Indian scholars, archaeologists, and curators to help with the selection of loans and to write some of the essays and entries for the catalogue, including Dr. Devangana Desai, distinguished author; Dr. M.K. Dhavalikar, Joint Director of the Graduate Research Center, Deccan College, Pune, and distinguished author; Mr. M.C. Joshi, head of the Antiquities Section of the Archaeological Survey of India; and S.C. Kala, former Director of the Allahabad Museum, Allahabad. Our thanks are also due to Dr. L.P. Sihare, Director of the National Museum, New Delhi, who coordinated the collection and shipping of all loans from India. Since the inception of this project several years ago, these scholars have been consulted on a regular basis regarding the selection of the material and the conceptual foundation of the exhibition. In fact, their generosity and cooperation have made it possible for The Brooklyn Museum to borrow sixty terracottas from three private collections, eight museums, and the Archaeological Survey of India.

This committee has been complemented on the American side by Dr. Barbara Stoler Miller, Professor and Chairman of Oriental Studies, Barnard College, who acted as consultant on the project, and three scholars who contributed essays to the catalogue: Dr. Vidya Dehejia, Adjunct Professor of Art History and Mellon Research Fellow, Columbia University; Mr. Stephen P. Huyler, author and specialist in the field; and Dr. Lambertus van Zelst, Director, Conservation Analytical Laboratory, Smithsonian Institution.

We are most indebted to the Indo–U.S. Subcommission on Education and Culture and Ted M.G. Tanen, Executive Director, American Secretariat, for recognizing the importance of this project and supporting its development into a major exhibition over the past four years; and for sponsoring the trips from India to the United States of Dr. B.B. Lal and Dr. Dhavalikar and from the United States to India of Dr. Miller, Mrs. Poster, Mr. Huyler, Dr. Dehejia, and John C. Huntington in connection with this project. And our utmost thanks to the governments of India and the United States for their joint sponsorship of this exhibition through the Indo–U.S. Subcommission.

Many other individuals and institutions have been helpful in the research and preparation of the exhibition and this volume, and to all of them we extend our deep gratitude.

Robert T. Buck
Director
The Brooklyn Museum

8

There are many people I would like to thank for their advice and support: first, of course, The Festival of India Advisory Committee and Mrs. Pupul Jayakar, its chairman, to whom the credit belongs for a Festival that has achieved its purpose of enhancing awareness and understanding in America of the richness and cultural variety of India; S.K. Misra, Director-General of the Festival of India; Niranjan Desai of the Embassy of India in Washington; Ted M.G. Tanen and the Indo-U.S. Subcommission on Education and Culture; the U.S. Information Service in New Delhi, especially Michael Pistor, formerly Counselor for Public Affairs; and the members of the Terracotta Advisory Committee set up in India to review our requests for loans, who enthusiastically endorsed the loans of these wonderful but often fragile objects.

I would also like to express my gratitude to:

In India, Dr. L.P. Sihare, Director, National Museum, New Delhi, and N. Nath, I.D. Mathur, C. Bhattacharya, S.P. Gupta, and many other cooperative members of the museum staff; Dr. M.S. Nagaraja Rao, Director-General, and members of the Archaeological Survey of India, J.P. Joshi, M.C. Joshi, and B.B. Lal, who introduced me to terracotta sites and museum collections throughout India on many visits, and Dr. S. Ray, Director, the Indian Museum, Calcutta; Dr. N. Goswami of the Asutosh Museum of Indian Art, Calcutta University; Mr. O.P. Tandon, Director, Bharat Kala Bhavan, Varanasi; Dr. A.K. Srivastava, Director of the Government Museum, Mathura; Dr. H.K. Prasad, Director, Patna Museum; Dr. S. Mukherjee of the State Archaeological Museum, West Bengal; Dr. M.K. Dhavalikar, Deccan College, Pune; Dr. S.C. Kala and Dr. Tripathy, Director, Allahabad Museum; Dr. G.C. Pander, Allahabad University, Chairman, Department of Ancient History, Culture, and Archaeology; Dr. R.C. Sharma, Director, the State Museum, Lucknow; lenders Mrs. Pupul Jayakar, G.K. and Vinod Kanoria, and S. Neotia; scholars S.C. Kala and S.S. Biswas for their generous advice; Dr. Devangana Desai for her catalogue essay on the social background of early terracottas; M.K. Dhavalikar, who assisted in catalogue entries 8–10 and 46–49; and Karl K. Khandalavala, L.A. Narain, B.P. Sinha, and K.V. Raman.

Air India for arranging transportation for the loans from India and the Smithsonian Institution for travel grants for personnel connected with this exhibition.

Columbia University for the symposium held jointly by The Brooklyn Museum and its Southern Asian Institute in April 1984, which enabled many of us to explore the preliminary selection of objects for this exhibition, compare Indian terracottas with similar figures from other sites in the ancient world, and investigate the ways in which technical and laboratory analysis could be brought to bear on this subject; The Museum of Fine Arts, Boston, Technical Laboratories, and Dr. Lambertus van Zelst, formerly its director and now Director, Conservation Analytical Laboratory, Smithsonian Institution.

Among European museums and collectors, Robert Skelton of the Victoria and Albert Museum; Dr. James Harle of The Ashmolean Museum; Robert Knox of The British Museum; Dr. Herbert Härtel of the Museum für Indische Kunst, Berlin; Anthony Gardner; and David Salmon.

In the United States, Professors Stella Kramrisch, Carol Bolon, Pramod Chandra, Jack Hawley, Gregory Possehl, and Walter Spink; museum colleagues Milo C. Beach, Stanislaw Czuma, Vishakha Desai, Martin Lerner, Robert Mowry, Pratapaditya Pal, and Emily Sano; also Mr. and Mrs. James Alsdorf, Dr. and Mrs. Wayne Begley, Mrs. Robert M.

Benjamin, Michael deHavenon, Jay Dehejia, Sammy Eilenberg, Robert H. Ellsworth, John and Berthe Ford, Harry Holtzman, Debra Nagao, Cynthia Hazen Polsky, Tom and Margo Pritzker, Paul F. Walter, Doris Wiener, and William H. Wolff; and Patrice Fusillo, Sheila Crespi, and other staff of the United States secretariat of the Indo–U.S. Subcommission on Education and Culture, to whom I owe a special debt of gratitude. The curators and directors of all the lending institutions have been helpful in a way which we have perhaps come to take for granted in the American museum world but which should indeed be considered a remarkable phenomenon.

Scott Hyde and Otto E. Nelson for photographs taken in the United States and John C. Huntington, Professor of Art History at Ohio State University, for photographs of many of the objects taken in India, often under less than ideal conditions.

For their perseverance and wisdom, special thanks are due to Barbara Stoler Miller, with whom I consulted throughout this work and whose unwavering support is deeply appreciated; Dr. Vidya Dehejia, for her essay on brick temple architecture; George Michell; and Stephen Huyler, for his essay on terracottas of modern India, his help in preparing catalogue entries 46, 47, 48, 49, 127, 128, and 129, and his assistance in the preparation of the public programs brochure, didactics, and photographs for this exhibition.

I would also like to thank the following members of the Museum staff who contributed to this catalogue and exhibition:

Ken Moser, Ellen Pearlstein, and Jane Carpenter, Conservation Department; Richard Waller, Michael Batista, and J.R. Sanders, Department of Design Services; Arthur Lindo and Susan Rapalee, Department of Public Affairs; Registrars Barbara La Salle and Liz Reynolds, who coordinated all loans and shipping; the staff of the Education Department, particularly Deborah Schwartz and special intern Barbara Larson; the staff of the Financial Office; Rena Zurofsky, Department of Marketing Services; William Lyall, Glenda Galt, and Howard Ferrara, Photography Department; the staffs of the Development Office and the Membership Office; the art handlers, carpenters, electricians, and paint shop; and especially Robert Moes, Sheila Canby, Anthony Trapp, and the interns of the Department of Oriental Art. Dr. Robert S. Bianchi, Associate Curator, Department of Egyptian, Classical, and Ancient Middle Eastern Art, offered considerable advice in connection with the ancient world.

Linda Ferber, Chief Curator, and Roy Eddey, Deputy Director, for their guidance and Robert T. Buck, Director, for his advice and encouragement in supervising and coordinating the negotiations for loans from India and especially for demonstrating that the success of this exhibition was a real priority of the Museum.

In closing, my thanks to:

Lillian and Elliott Eisman, whose annual contributions to the Oriental Department at the Museum have helped make this project possible, particularly at its early stages; The National Endowment for the Humanities and Morgan Guaranty Trust Company of New York Charitable Trust for major grants acknowledged elsewhere in this catalogue; Ann Thompson for typing the manuscript innumerable times; and Sheila Schwartz for her skillful and careful editing.

Dr. Bertram Schaffner, whose donations of terracottas first aroused my interest in the subject and to whom I have dedicated this volume.

And my husband, for his patience and understanding.

Amy G. Poster
Associate Curator of Oriental Art
The Brooklyn Museum

Color Plates

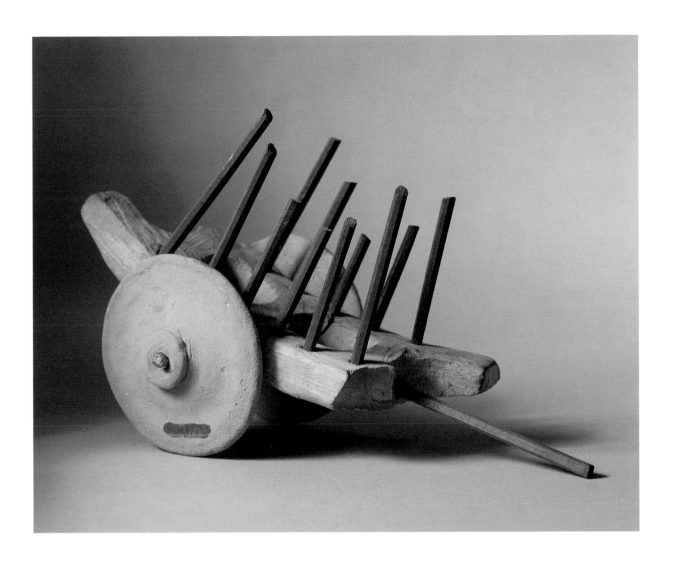

Plate 1 **Toy Cart with Two Wheels**
Pakistan, Chanhu-Daro
Indus Valley Civilization, ca. 2500 B.C.
Red hand-modeled terracotta, 4.5 x 19.0 x 7.5 cm.
Collection: The Brooklyn Museum 37.103-105; A.A. Healy Fund Cat. no. 7

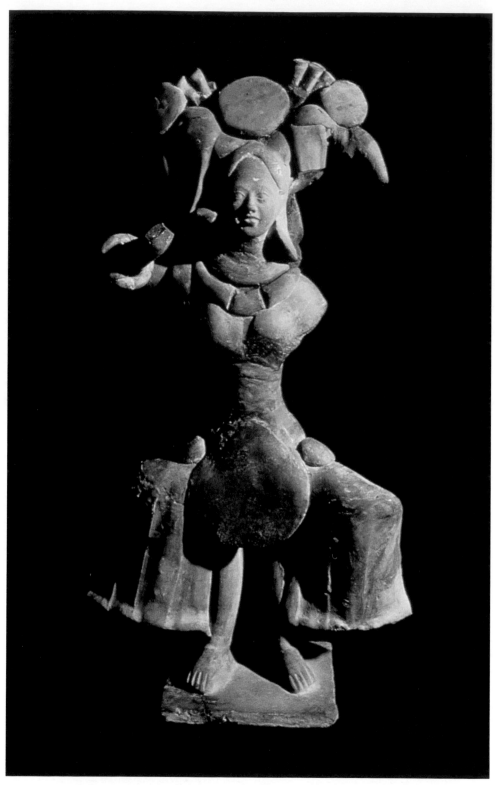

Plate 2 **Dancing Female**
Bulandibagh (Bihar)
Maurya period, ca. 320–200 B.C.
Red hand-modeled terracotta with molded face and applied ornaments, 25.7 cm.
Collection: Patna Museum, Patna Cat. no. 13

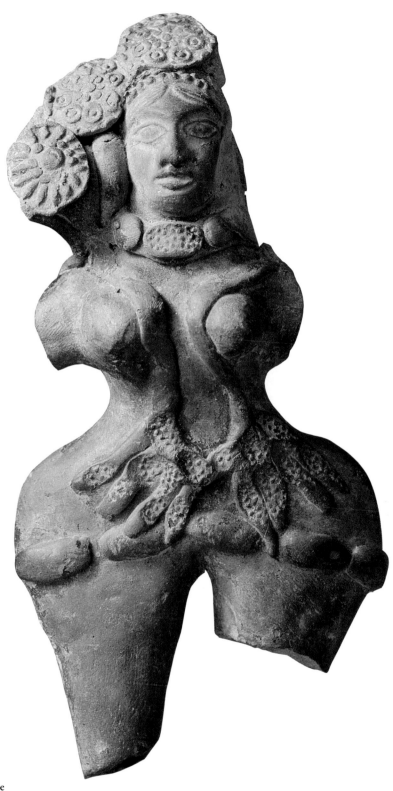

Plate 3 **Female Figure**
Mathura region (Uttar Pradesh)
Maurya period, ca. 320–200 B.C.
Gray hand-modeled terracotta with molded face and stamped and applied ornaments, 17.8 x 8.8 cm.
Collection of Dr. Bertram Schaffner; on loan to The Brooklyn Museum Cat. no. 18

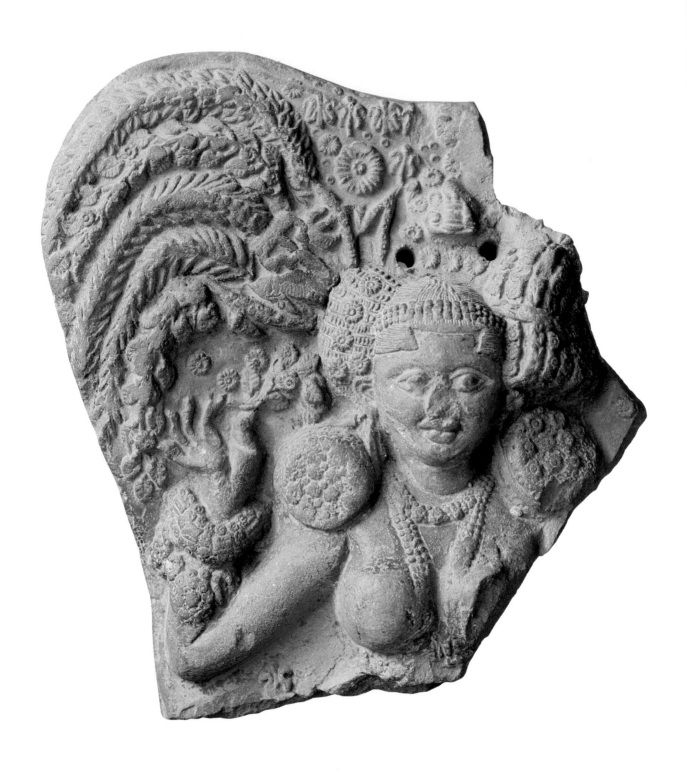

Plate 4 **Yakshi**
North or eastern India
Late Shunga period, 1st century B.C.
Red molded terracotta plaque, 12.0 cm.
Private Collection Cat. no. 34

14

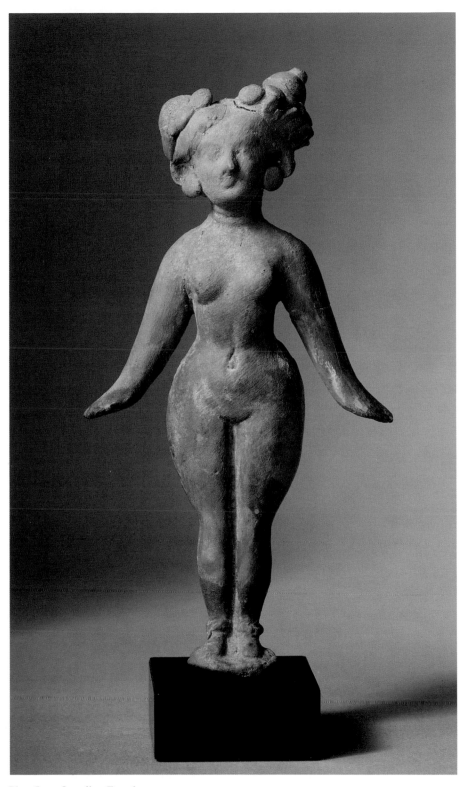

Plate 5 **Standing Female**
Sirkap or Charsadda, Pakistan
Kushan period, 1st century A.D.
Red molded terracotta, 17.5 cm.
Private Collection; on loan to The Brooklyn Museum Cat. no. 51

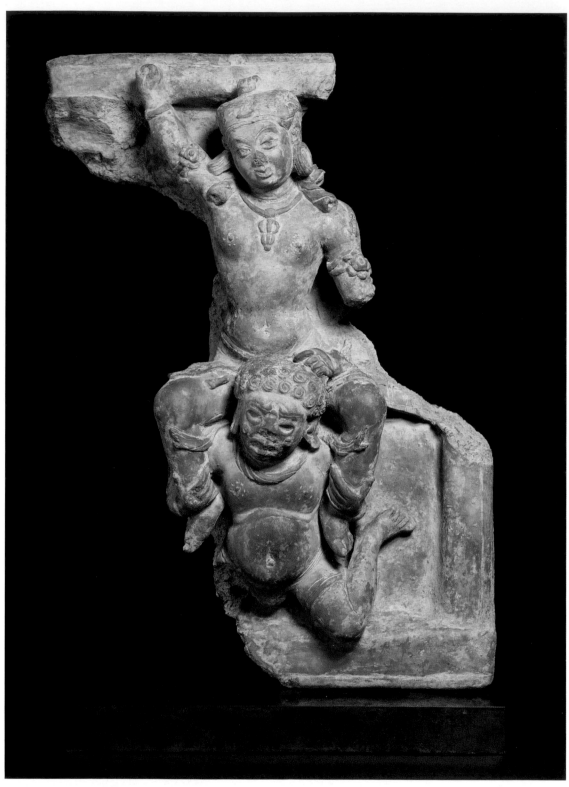

Plate 6 **Balarama Abducted by Pralamba**
Uttar Pradesh
Gupta period, 5th century A.D.
Red terracotta relief tile, 55.8 x 38.0 cm.
Private Collection Cat. no. 100

16

Indian Terracotta Art: An Overview

Amy G. Poster

Indian artisans have been fashioning objects from terracotta since at least the third millennium B.C., producing all manner of works from votive offerings and icons to ornaments and toys. Their art has ranged from the ephemeral—made for seasonal observances or use in everyday life—to the permanent—meant to endure as long as the monumental architecture it adorns. Because clay is abundant, inexpensive, and easily shaped, artisans working in terracotta have enjoyed greater liberty to improvise and experiment than sculptors in stone or bronze and hence have employed so many techniques and styles continuously through time that, as Stella Kramrisch first pointed out in 1939, it is not always possible to tell one era's art from another's.[1]

This long, complex history makes the study of Indian terracottas an art historical challenge. Although the material for such a study is plentiful, it is geographically scattered and there is often little or no literary evidence to guide the interpreter. However, through analysis of styles, materials, techniques, uses, and iconography, one can begin to understand the development of India's terracotta traditions and to appreciate their continued vitality and creativity.

Scholarship and Archaeology

The study of terracotta art has received less attention than its importance and pervasiveness in Indian society would warrant. While the subject has been treated in articles, books, and exhibitions since the 1920s, scholarship has tended to focus on

17

the dating and stylistic classification of specific groups of works rather than attempt a broad historical survey.

Exceptional in this regard are A.K. Coomaraswamy's initial works on Indian terracottas (1927, 1928) and Stella Kramrisch's description of "timed and timeless terracottas" (1939). While Coomaraswamy developed a typological chronology for the comparison of terracotta artifacts with contemporaneous stone sculpture, Kramrisch established a dichotomy between terracottas whose qualities are influenced by historical factors and works whose forms and styles remain unchanged. Kramrisch's pioneering attempt to categorize terracotta figures in terms of temporal distributions, forms, techniques, and themes continues to enhance our understanding of the production, function, and history of Indian terracotta art.

Subsequent stratigraphic studies, meanwhile, have revised Coomaraswamy's chronology.[2] One of the earliest site reports of stratigraphically excavated terracottas was V.S. Agrawala's survey of Ahichchattra (1947–48). Although the accuracy of Agrawala's chronology has been questioned, his study is important for its systematic typological investigation and terminology. Similarly, C.C. Dasgupta's comprehensive study of 1961 remains a valuable reference even though it was published before the excavation of certain significant finds.

Although the terracotta figurine stands out in the history of Indian art as the only type of object with a continuous archaeological record from the sixth century B.C. to the present, the use of the term archaeology in speaking of terracottas can be misleading. Most terracotta scholarship is based on surface finds that lack a secure provenance. Even where sites have been carefully excavated, stratigraphic information for particular objects is often missing. Fortunately, recent excavations—for example, at Sonkh (Härtel 1977) and other sites in Mathura (Joshi/Margabandu 1976–77)—have been better at providing us with scientifically excavated material from which we may derive invaluable information about the date and appearance of terracottas, the archaeological contexts in which they are found, and often clues as to their function. We can compare this evidence with the vast store of unexcavated and unprovenanced material to obtain more accurate identification, dating, and characterization.

Stylistic Analysis

Indian terracotta objects can be stylistically grouped according to iconographic and regional distinctions, with objects from stratified excavations serving as fixed points of reference. For example, three terracottas in the present exhibition (see cat. nos. 18–20) can be dated to the Maurya period and ascribed to Mathura on the basis of a stylistic comparison with a Maurya-period mother-goddess discovered at Mathura (see fig. 1). Although no two examples are identical, the Maurya-period Mathura group is technically and stylistically consistent. The female figures are hand-modeled as relatively flat shapes with narrow waists and broad hips and are usually fired gray with a burnished surface. They are embellished with a multitude of applied floriate and decorative ornament, primarily on the front, and their faces, for the most part molded, have similar features.

Such stylistic analysis can be difficult, however, and the potential for misidentification is great. Kushan- and Gupta-period productions, for instance, are often

mistaken for one another, because artists of both periods had the technical ability to fashion large hollow figures and modeled bas-reliefs. Only after careful and repeated examination of the figures depicted on terracotta panels of the Kushan and Gupta periods do subtle differences of physical form, facial features, spatial treatment, and iconography begin to emerge.

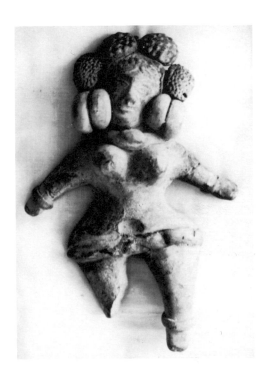

Figure 1
Mother-Goddess
Excavated at Mathura (Uttar Pradesh)
Maurya period, ca. 320–200 B.C.
Molded terracotta
Collection: Archaeological Survey of India, New Delhi

Materials and Techniques

Although technically terracotta refers only to baked clay objects, Indian artists through the ages have also fashioned unfired clay images that dissolve when immersed in water and are meant to be discarded after they have been used. These images, though related to terracotta, are generally excluded from the present study, which is largely confined to clay objects that were fired.

The clay used for terracottas is the same as that used for common pottery. Ideally it comes from riverbeds or alluvial plains, but alternative sources are sometimes selected for other, perhaps ritualistic, reasons. After the clay is cleaned of pebbles and other impurities, it is mixed with a tempering material (such as rice husk, ash, sand, cattle dung, or a combination of these), which reduces the shrinkage, warping, and splitting that may occur in firing. Varieties of clay can be mixed in different proportions to achieve different results, depending on the purpose for

19

which the terracotta is intended. Local traditions for the selection of the clay mixtures vary.[3]

Regional differences in Indian terracottas stem not only from differing fashions but also from the availability and quality of the clay. On the Deccan Plateau and in the south, for example, the local clay is usually too poor for the modeling or molding of fine figurines. As a result, certain artists there developed an especially refined clay substance for figures.[4]

Terracotta objects may be pressed into shape, molded, coil-built, wheel-thrown, or formed by a combination of these techniques. The various tools used in the process include wooden beaters, fabrics for wiping or smoothing the clay surface, sharp implements or blades for carving decoration, and a variety of wood and clay stamps for impressing surface decoration. The potter's wheel may be used in shaping bodies and limbs, which are then joined together to form a whole figure. Single or double molds made of unbaked clay, terracotta, or other materials have been used since the Maurya period. Objects may be either completely molded or formed by using the mold for one section and modeling the rest by hand (as in cat. no. 19).

The use of the mold reached a peak of refinement during the Shunga and Gupta periods, but was less popular in later centuries. Certain sites, such as Mathura and Kaushambi in the upper Gangetic plain, and Tamluk in eastern India, even developed distinctive styles of molded figures. Although craftsmen at these sites used similar molding techniques, the Tamluk artists styled their figurines with a systematic profusion of surface decoration, while the Kaushambi and Mathura artists, without sacrificing ornamentation, emphasized physical form.

When the clay of a terracotta object is in the leather-hard stage of drying before firing, the surface is ready for shaving or smoothing, stamping or impressing with decoration, applying a slip made of finely grained clay mixed with water (as in cat. nos. 19 and 23), or burnishing after the application of slip to heighten the luster (as in cat. no 21). Mica powder is also sometimes sprinkled on the surface at this stage.

The basic methods of firing include using an open pit, an oven, or a kiln. Again, there are many local variations. The colors of fired specimens range from red to biscuit to black, depending on the firing conditions. If the kiln is sealed, the result is gray or black; if the object is exposed to air, the result is red, usually with a gray core. Oxidation occurs at a temperature of about 600° F., and the colors become darker as the iron in the clay oxidizes. After firing, most large terracottas are painted. The paint often consists of mineral or organic pigment mixed with water or a water-gum solution (see cat. no. 22). Although glazed terracottas dating to the Maurya period have been found, glazing was extremely rare in India prior to the Muslim invasions.

Indian terracottas have traditionally been made by potters, but other specialized craftsmen, such as the brick makers of eastern India, have produced terracottas as well. If one compares Indian terracottas with pottery (where the variety of surface decoration is limited to simple geometric, floral, and sometimes figural patterns), the versatility of these craftsmen becomes evident. In general, men have shaped the objects while women have painted the surfaces.

The names of specific artists are usually not recorded, for the only known signed terracottas are from recent times. Though several undeciphered inscriptions of the Gupta period may contain the names of artists, it is impossible to be certain

without other documentation. Most of the inscriptions that can be read either identify the subject (see cat. no. 98) or indicate the placement of the piece in its architectural setting (see cat. nos. 63–65).

Functions, Forms, and Symbols

The precise function of many Indian terracotta objects is still a matter of speculation and dispute. A single terracotta may be interpreted variously as a votive offering or a devotional object, a magical image or a portrait, a souvenir for pilgrims or a toy. The distinction between sacred images, in which efficacy is based on fixed rules governing iconography and ritual, and votive objects, which often have the same imagery but are not consecrated, is especially problematic, for when votive offerings are offered for ritual purposes—i.e., connected with worship—they become sacred.

The following episode from the *Mahabharata* shows how clay images were sometimes used in ancient times:

> So, great king, a certain Ekalavya came, son of Hiranyadhanus, the chief of the Nishadas. But Drona, who knew the Law, declined to accept him for archery, out of consideration for the others, reflecting that he was a son of a Nishada. Ekalavya, enemy-burner, touched Drona's feet with his head and went into the forest. There he fashioned a likeness of Drona out of clay. The image he treated religiously as his teacher, while he spent all his efforts on archery, observing the proper disciplines. And so great was his faith, and so sublime his discipline, that he acquired a superb deftness at fixing arrow to bowstring, aiming it, and releasing it.[5]

Whatever their function, most Indian terracottas are endowed with meanings that reflect the rich tradition of Indian symbolism also found in literature, theology, painting, and ritual. Auspicious symbols denoting fertility, protection, and nurturing abound, and even the simplest handful of clay, when placed on an altar in worship, can assume profound significance.

The earliest terracottas are representations of the female form symbolic of fertility. They conform to a basic conventional type in which the nudity of the figure is well emphasized. This terracotta fertility figure, usually identified as the mother-goddess,[6] evolved in later periods into several goddesses with individual symbolic motifs and characteristics (see cat. nos. 24, 29, 31, and 32). Related auspicious figures include *yakshis* (nature goddesses), *shalabhanjikas* (tree goddesses), Hariti (the Buddhist patroness of children), and Lakshmi (the goddess of fortune, fertility, and prosperity).

A mother holding a child (see cat. no. 54) usually represents nurturing, while male figures such as nature spirits *(yakshas)* or the Tamil god Ayyanar and his attendants suggest a protective function (for instance, as guardians of a village). Animals traditionally associated with protection and fertility—humped bulls, elephants, rams, and horses—appear in terracottas from earliest times as the vehicles of divine spirits, and floral and vegetal motifs are used on the ornamental plaques of temples to express notions of universal fecundity.

The iconographic components of a figural composition are sometimes

layered in a multiplicity of details in order to achieve a more powerful aesthetic statement. Two terracotta plaques of females in this exhibition, for example (see cat. nos. 33 and 34), depict a profusion of jewelry signifying prosperity and repeat a variety of flowers used as hair ornaments or space fillers. Together with an exaggerated female physique, these elements make for a dazzling unified expression of auspicious power.

Development of Terracotta Styles

Indus Valley Civilization (Northern India), circa 2500–1800 B.C.

As in other parts of the world, in India the earliest terracottas have been found at sites dating to the Neolithic era. These specimens have come primarily from the valley of the Indus River in present-day Pakistan, where several excavated sites such as Mohenjo-Daro (see cat. nos. 1 and 4), Harappa (cat. nos. 2 and 3), and Chanhu-Daro (cat. nos. 6 and 7) provide important early evidence of urbanization. Mostly simple hand-modeled figures of females and animals, particularly bulls (see cat. no. 5), they occur in large numbers and are often considered to reflect the sophistication of culture in this early period. They have been found as far east as Rajasthan, as far south as sites in Gujarat, and as far west as Balakot, a Harappan site on the Makran coast of the Arabian Sea where recently discovered pottery kilns still contained bull figures.

Post-Harappan Transition Period
(Central and Eastern India and the Deccan), 2nd–1st Millennium B.C.

There is little evidence of terracotta production in the subcontinent in the period between the decline of the Indus Valley Civilization and the beginning of recorded history (i.e., the time of the birth of Buddha, circa sixth century B.C.)—an unsurprising fact since this is a period about which much remains to be discovered in Indian archaeology. Although this was the time when ironworking was introduced to India, it has generally been considered a period in which artistic standards degenerated. Excavated sites such as Inamgaon and Nevasa (Maharashtra) have yielded crude figures associated with fertility (see cat. nos. 8–10), and figures found in the northwest (see cat. no. 12) continue the tradition of the hand-formed female type of the Indus Valley Civilization. A recently excavated torso of a male figure from West Bengal (cat. no. 11) documents the survival of the early terracotta tradition in eastern India.

Maurya Period (Central and Eastern India), circa 320–200 B.C.

The rule of the Mauryas, who extended their supremacy over most of the subcontinent by the early third century B.C., engendered a period of increased trade and prosperity. The Maurya capital, situated at Pataliputra (present-day Patna in Bihar), has yielded some of this period's finest terracottas, objects that represent significant technical and stylistic changes in an increased number of types.

22

A standard terracotta type found throughout eastern India at this time is represented by the celebrated female dancing figures of Bulandibagh (see cat. no. 13). Unlike the well-known polished sandstone sculptures of human figures from the same region ascribed to this period, these figures are modeled in lively and naturalistic poses, reflecting a Western Asiatic influence that is probably a result of contacts with the Greek world. Knobbed or plaque earrings, heavy bangles, thick necklaces, and elaborate coiffures with circular medallions enhance their graceful character; thin ankle-length garments, usually shown sashed about a disproportionately narrow waist, emphasize their physical form. Their typically youthful facial features, which come in a variety of repeated types, are generally molded. In addition to Bulandibagh, such figures have been found in fragmented form at Chandraketugarh, Tamluk, and Patna.

These sensuous females contrast with another type of Maurya-period terracotta figure from other sites in the Ganges Valley, particularly Mathura. Mathura-type female figures represent the auspicious female by means of an awesome static presence, ranging from simple flat standing figurines (see cat. nos. 18–20) to elaborate figures in seated postures. Their black glossy surfaces can be associated with the Northern Black Polished Ware discovered in the same context. The figures' faces with high cheekbones, small mouths, and elongated almond-shaped eyes are molded; their fiddle-shaped bodies and prominent breasts are hand-formed; their elaborate hair and dress ornaments are applied.

Shunga Period (North-Central and Eastern India), circa 200–50 B.C.

The Shunga rulers were able neither to impose their domination as completely on the regions nominally under their control nor to expand their empire over as wide an area as their Maurya predecessors. In keeping with the diffuse nature of their political influence, the terracotta art of the Shunga period saw a proliferation of regional styles and techniques.

The emphasis on nudity and surface detail continued, while the use of the mold became more popular, with complete figures and often narrative subjects appearing in molded plaques. Recent excavations at such sites as Tamluk, Kaushambi (cat. no. 23), Mathura (cat. nos. 25 and 26), and Chandraketugarh (cat. nos. 30, 35, and 39) have revealed an ever-increasing variety of types and decorative motifs.

The faces of Shunga-period female figures found in eastern India are well defined, with smooth rounded cheeks that contrast dramatically with the beading found on the figures' ornamental elements. Perhaps the finest terracotta female figure ever made is a well-known Shunga-period plaque from Tamluk now in the Ashmolean Museum, Oxford (see fig. 2). Although its lacelike fretwork scheme of surface embellishment is one of the primary characteristics of molded terracottas from the eastern region of the Ganges Valley, the richness of the jeweled decoration on this piece is unmatched by any other example. The figure's bicornate headdress wrapped with pearled fabric is set with five emblematic hairpins that take the form of weapons. Identified by Stella Kramrisch as the *panchachuda,* these pins symbolize the five elements (see cat. nos. 25, 26, 31, 32, and 35).[7] Beyond that, the specific significance of the headdress is not known. Although Shunga-period terracottas are sometimes regarded as the stylistic precursors for stone sculpture,[8] a comparison of

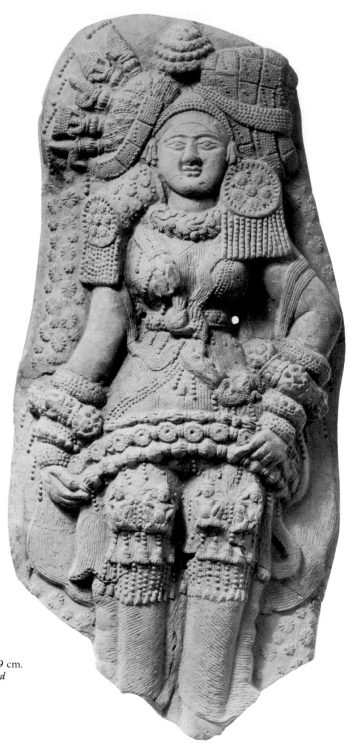

Figure 2
Female Figure
Tamluk (West Bengal)
Shunga period, ca. 100 B.C.
Molded terracotta plaque, 21.0 x 9.9 cm.
Collection: Ashmolean Museum, Oxford

this and other eastern Indian Shunga-period terracottas with contemporaneous sculpture in stone or bronze reveals that the impact of the terracottas comes from intricate surface play, while in stone and bronze images of the same subjects the emphasis is on voluptuous form and contour.

24

Satavahana Period (Central India, the Deccan, and the South), 200 B.C.–225 A.D.

Though the four-hundred-year reign of the Satavahana rulers centered on Andhra Pradesh, the style of Indian terracottas named for them is found not only there but also in Maharashtra and farther south (see cat. nos. 46 and 49). These terracottas, which consist largely of figures and animals molded in hollow two-sided images, are less obviously religious than earlier ones. Their clay is often a refined white "kaolin" or reddish terracotta.

Of the large number of terracotta animals discovered at Satavahana-period sites—including elephants, bulls, and rams—horses are the most common. They are often richly caparisoned with bridles, reins, saddles, and ornaments, suggesting a possible reference to rites of the royal horse sacrifice *(ashvamedha)*.

The end of the Satavahana dynasty saw the parceling of the empire into many smaller kingdoms and the disruption of artistic traditions. By the fourth century, those terracottas still being made in the Deccan were crude and molded of inferior clay. Never again has the sculpting of small terracottas been as refined in central or south India as it was during the reign of the Satavahanas.

Kushan Period (North India), circa 50–300 A.D.

By about 50 A.D., northern India was under the control of the Kushans, a nomadic people of Central Asian origin. Under Kanishka (late first century A.D.), expansion of the Kushan realm reached its apogee and contact with the Mediterranean world led to the development of a classically influenced Buddhist art. The consequent style is usually named after the Gandhara region, which comprises areas of what is now Pakistan as well as adjacent Afghanistan and Kashmir, but the Mathura region was an equally important center for Kushan art. Both regions produced terracottas that represent a synthesis of indigenous traditions and Greek, Roman, Scythian, Iranian, and Central Asian prototypes.

The mold was not as widely used during the Kushan period, and hand-modeled figures were more in evidence. As in stone sculpture of the time, the number of subjects increased and the iconography grew more complex, resulting in more definitive regional styles. Narrative reliefs were less common in terracotta than in stone, and emblematic and decorative approaches prevailed. Judging by dress and ornament, some images seem to have been secular.

Although terracotta figures of the Kushan period are sometimes characterized as coarse or crude, they are in fact quite inventive. The numerous terracotta heads found throughout Uttar Pradesh and the Gandhara region show a variety of freely delineated ethnic features and individual expressions, indicating both an increased mastery of technical skills and a concern for portraiture.

Despite this trend toward portrait figures, the fashioning of *yakshis* or mother-goddess figurines persisted, particularly at Taxila and Sirkap, where *yakshis* dating to the first century A.D. have been found (see cat. no. 51). These northwest Indian *yakshis* are often hollow double-molded figures that have shed their characteristic Indian voluptuousness for a narrow-waisted, flat-chested form similar to Greek and Iranian prototypes.

25

It is from the late Kushan era that we find the first evidence of monumental hollow figures in terracotta. Three life-size figures (Shri Lakshmi, Hariti, and a head of Kubera) found in a monastery at Kaushambi are the primary examples of this development (see cat. nos. 57 and 58). Their provenance suggests they were intended for devotion.

Gupta Period (North and Central India), circa 300–550 A.D.

A proliferation of terracotta work marks the Gupta period, an era of political stability that saw a flowering of cultural and artistic production. From these years date many monumental brick temples decorated with large terracotta relief panels and free-standing figures representing deities. The figures in particular demonstrate a new aesthetic in their reduction of surface detail and their emphasis on simplified decoration. They are often dramatic compositions with a remarkable sense of vitality. The mood is distinctly theatrical and narrative rather than descriptive, reflecting the dramatic literature of the period.

The best known Gupta terracottas are perhaps the late fifth-century examples from Ahichchattra, many of which are now considered masterpieces (see cat. nos. 74 and 75). One of the largest extant terracottas, a monumental relief depicting the river goddess Ganga, was originally placed at the entrance to a Shiva temple at the site (see fig. 3). Although the goddess is shown in a traditional pose, standing on her animal vehicle, the *makara,* she has a relaxed naturalistic posture and a voluptuousness seldom evident in more formal stone sculptures of the subject.

Buddhist and Hindu deities are often depicted in Gupta terracottas in narratives taken from epic themes of Sanskrit literature (some still unidentified). The usual depiction of the Hindu deity Vishnu on his eagle mount Garuda, for example, is made more literary by showing Vishnu with an archer's bow (see cat. no. 92)—a reference to the epic *Ramayana,* probably the episode in which Vishnu dispels the demon *rakshashas.*

The precise identification of regional styles in Gupta relief panels from temple architecture is often difficult, since the exact provenance of most extant pieces is unknown. It is evident, however, that the two principal Gupta-period artistic schools in central India provided inspiration for terracotta artists: the style of Mathura-school stone sculpture found its way into terracottas in Uttar Pradesh and north-central India, and the style of the Sarnath school spread to sites in eastern India. The remains of the Buddhist monasteries at Mirpur Khas (Sind, Pakistan) and Devnimori (northern Gujarat) and the Hindu terracottas of Rangmahal in Rajasthan speak for the widespread nature of terracotta art in this period.

Pala Period (Eastern India), 6th–12th century A.D.

After the Gupta period and especially during the period of the Pala rulers of eastern India (765-1175 A.D.), terracottas continued to be produced for a great many purposes, especially brick architecture. At a number of sites in eastern India dating to the eighth and early ninth centuries, including Antichak in Bihar (see cat. nos. 116 and 117) and Paharpur and Mainamati in Bangladesh (see cat. nos. 114 and 115),

Figure 3
Ganga
Ahichchattra (Uttar Pradesh)
Gupta period, 5th century A.D.
Terracotta plaque, 175.2 cm.
Collection: National Museum, New Delhi

monumental monasteries of brick were extensively decorated with terracotta reliefs. The stylistic innovations of these friezes include a new figural treatment, more rigid compositions, and larger constructions. Small Buddhist votive plaques (see cat. nos. 118–121) were also produced in great numbers. These are often associated with eastern Indian Buddhist art such as stone and bronze images from Nalanda.

Period Following the Muslim Invasions (North and Eastern India), 13th–15th Century A.D.

The Muslim conquests in the north almost completely brought to an end the classical Hindu-Buddhist artistic traditions there. Terracottas were rarely used in Muslim art, except in eastern India, where geometric and foliate patterns were incorporated into

27

the design of brick mosques and tombs. In eastern India, too, the practice of covering Hindu temples with molded bricks and carved terracotta tiles continued. These decorative terracottas, which often incorporate epic and narrative themes (see cat. no. 123),[9] were made well into the nineteenth century, after which they were replaced by cheaper stucco work.

Continuity and Modern Traditions

Although the tradition of decorating temples with sculpted bricks has waned, terracotta continues as a typical folk art throughout India. Among the types of objects produced, toys and votive figures are the most prevalent. Simple hand-modeled mother-goddess and animal figurines of the archaic types found in archaeological contexts are still fashioned all over India today. In Tamil Nadu, potter-priests make monumental horses and equestrian figures as offerings to the local hunter deity Ayyanar (see cat. no. 129), and in West Bengal the artisans who fashion Bankura horses preserve a centuries-old village art. Often, as with the molded plaques of a horse and rider and the goddess Hariti included in this exhibition (see cat. nos. 126 and 127), the only way to identify Indian terracotta images as modern is by their costume and ornament.

In addition to reflecting the continuity of a four-thousand-year tradition, contemporary Indian terracottas are often expressive of the tremendous changes taking place in the Indian subcontinent. In Gorakhpur, Uttar Pradesh, hand-modeled terracotta figures that were once made for local rituals are now being mass-produced as house decorations and exported throughout the country. Shops in Tamil Nadu and West Bengal sell thousands of double-molded clay images of gods and goddesses whose features resemble those of Indian movie stars. And in Gujarat, people place terracotta figures in front of irrigation pumps in order to facilitate the running of the pump. Because terracotta objects are so integral to Indian society, one may expect that they will continue to change with that society in the years to come.

Notes:

1. Dr. Kramrisch has returned to this topic in a recent article entitled "Siva Bholanatha" (Kramrisch 1984).
2. See Joshi/Margabandhu 1976-77, p. 18, and Sankalia/Dhavalikar 1969, p. 39, for examples of Maurya-period artifacts that have been reanalyzed.
3. This section is based largely upon Saraswati 1978, part 1, chap. 1.
4. This refined white clay substance is often mistakenly identified as kaolin, a material free of mineral impurities. It is composed of alumina, silica, and water and remains white in firing. The importation of Roman kaolin objects into the Deccan in the first century A.D. seems to have spurred the production of double-molded figurines in this high-grade, opaque, chalky clay. See cat. nos. 46 and 47.
5. *Mahabharata (The Book of the Beginning)*, section 123, trans. van Buitenen 1973, I, pp. 270-271.
6. No evidence, as yet, exists for any cult of the mother-goddess in the Indus Valley Civilization. The American archaeologist George Dales (1979, p. 141) sums up the sentiment of his fellow scholars in encouraging even further restraint in denoting clay figurines (especially the typical nude corpulent male and female figures) as significant of any religious practice until more is known about the Harappan civilization. Yet is is difficult to avoid seeing these objects as fertility figures, particularly in view of terracotta figurines from the ancient Near East and the classical world.
7. Kramrisch 1939, ed. 1983, pp. 75-76, identifies the weapons as the *ankusha* or elephant goad, the *trishula* or trident, the arrowhead, a variation of the *trishula* with a caplike device, and a bladelike device.
8. Huntington 1985, p. 89.
9. See McCutchion 1984.

The Social Milieu of Ancient Indian Terracottas 600 B.C.–600 A.D.

Dr. Devangana Desai

Although terracottas, or baked clay figurines, often appear to be the spontaneous handiwork of simple folk, they can be produced on a large scale only when certain complex social conditions are fulfilled. The making of terracottas in large numbers involves technical equipment at an artisan level that goes beyond the independent domestic pattern of production and is therefore possible only in a society that is well settled and differentiated into specialized professions. Such production is undertaken when there is a demand arising either from institutionalized religious cults that require the use of clay figurines as votive offerings, magical charms, or household deities or from a public who would buy secular figurines for the decoration of homes, for children's toys, or for varied other purposes. This demand is best fulfilled in urban societies, whose well organized markets are a stimulus to the expansion of industries in general.[1]

It is hardly surprising, then, that the history of terracottas in India is associated with the rise and flourishing of urban cultures. The early settled pre-Harappan Zhob and Kulli cultures began to produce terracottas in their later stages when they were evolving from village to town level, and large-scale production of terracottas occurred in the urban culture that flourished in the Indus Valley—with Harappa and Mohenjo-Daro as its twin capitals—between about 2300 and 1700 B.C. Comparatively few terracottas have been found from the village settlements of the post-Harappan Chalcolithic cultures, although these were river valley sites with easy access to clay, but terracottas appeared again in large numbers with the second urbanization of northern India from about 600 B.C.

Beginning around this date, there was a ferment in the social climate of northern India that was a part of the upheaval of the Iron Age in the civilized world

from the Mediterranean to the Jaxartes River in Central Asia. Iron technology ushered in a process of gradual urbanization in the Ganges-Yamuna Valley that reached its peak in the period after 200 B.C. The use of iron implements in agriculture and in the clearance of dense forests made agricultural production on a large scale possible to a degree unknown in earlier periods, and extensive agricultural cultivation created a surplus large enough to sustain non-agricultural groups. Specialization in industry and crafts increased, spurring trade. Between 500 and 200 B.C. coins began to appear for the first time. Even small artisans and workers could now save for future use and amusements, and the manufacture of cheap goods for popular consumption became profitable.

The production of pottery was recognized in ancient India as one of eighteen principal industries. Potters *(kumbhakaras)* were organized in guilds *(shrenis)* and settled in suburbs or market townships *(nigamas)* outside the gates of towns. Their thriving business is suggested by textual references to their apprentices or hirelings, their shops with five rooms, and their trading on highways.[2] An early Jain text, the *Uvasagadasao,* speaks of a potter named Saddalaputta who owned five hundred workshops and had a large number of potters working under him.

These ancient Indian potters faced a big demand for terracottas. Tribal and peasant cults and seasonal festivals in which terracotta figurines were used continued to survive in Indian towns. Although the folk practice of making figurines of unbaked clay and flour persisted among some sections of townspeople even as it does today in Bombay,[3] there also developed in towns a regular industry to supply ready-made figurines of snake goddesses, *yakshas,* and so on. In addition to ritual figurines, the potter craftsmen made decorative figurines for the cultured *nagaraka* class, an urban leisured class who consciously cultivated arts and crafts.[4]

We shall study here in broad outline the social history of Indian terracottas from 600 B.C. to 600 A.D., examining terracotta making as a social process in the context of the art-loving public and potter-artists of the time. The period is divided into five sub-periods on the basis of socioeconomic and political changes: (I) circa 600–320 B.C., (II) circa 320–200 B.C., (III) circa 200 B.C.–50 A.D., (IV) circa 50–300 A.D., and (V) circa 300–600 A.D.

I. Circa 600–320 B.C.

The controversy among art historians about the existence of terracottas in India in the pre-Maurya period has been settled by the unearthing of some specimens belonging to the period before the consciously organized movement in art began under the Mauryas. These have been found from Buxar, Pataliputra (Patna), Sonpur, Chirand, Vaishali, and Champa in Bihar and from Kaushambi, Atranjikhera, and Mathura in Uttar Pradesh. The sites had still not attained urban conditions. Terracottas were found from their pre-coin levels and also from levels dating to before the deluxe pottery known as the Northern Black Polished Ware began to be manufactured there.[5]

The themes of these terracottas consisted of *nagini* (serpent goddesses), birds, animals, and human female figures. The latter are distinct as to type and differ from the female figurines of an earlier period found at Chirand (Neolithic), Oriup (Chalcolithic), and Mahisdal,[6] while the *nagini,* animals, and bird figurines have

their prototypes in earlier Chalcolithic cultures.

The *nagini* figurines of this period are stylized and show an iconographic form consisting of the hood of a snake and the body of a human. There are punched circlets for the breasts and navel and incised lines to mark parts of the body. These figurines may have been used as votive offerings or as images in the *naga* cult, which was so powerful in the middle Ganges Valley that it survived for more than seven hundred years. Terracottas of the same form and style were produced up until the Kushan period.

The mother-goddess cult, on the other hand, had yet to develop to its full-fledged form, and not many female figurines have been found from this period. Still, those that have been discovered can be divided into three distinct types. The first is represented by a wide-eyed female with a round face, punched earlobes, prominent breasts, and perforations over the head for decoration (fig. 4). This type is seen at Buxar, Pataliputra, and Kaushambi.[7] The second type is represented by animal-faced handmade figurines from Pataliputra,[8] and the third is a thick-necked figurine looking upward found at Vaishali, Kaushambi, and Mathura. The first and third types continued to flourish in the Maurya period, gradually acquiring embellishment.

All the terracotta figurines of this period were handmade and not molded. They were neither decorative nor artistic in intent and were not produced on a large scale. The society had not yet reached the stage of commodity production. The process of urbanization had just begun and had not yet had much of an impact on the cultural life of the people.

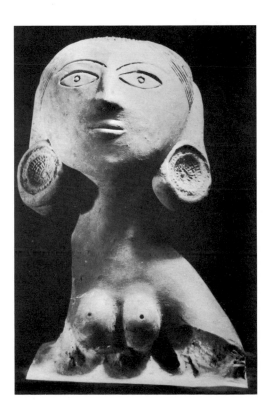

Figure 4
Wide-eyed Female with a Round Face
Buxar (Uttar Pradesh)
Pre-Maurya period
Hand-modeled terracotta
Collection: Patna Museum, Patna

II. Circa 320–200 B.C.

During the Maurya period terracottas were treated for the first time in India as objects of art. This development was mainly confined, however, to the kingdom of Magadha (south Bihar), which became the most important economic and political center of India under the Mauryan empire.

Just as the official stone art commissioned by the Mauryan king Ashoka bears Achemenian and Hellenistic artistic elements,[9] so Mauryan terracotta art reveals foreign influence. This was perhaps the result of the influx of foreigners into the Magadhan capital of Pataliputra, which was so great, the Greek historian Megasthenes noted, that the municipal board had to set up a special committee to look after them.

Hellenistic influence in particular is reflected in a number of beautiful "dancing girl" terracottas of Pataliputra and Sonpur (see fig. 5). In their facial features, drapery, and scarflike headdresses, these figurines are reminiscent of the Greek terracottas of Tanagra of the third century B.C.[10] They are modeled in the round and are freestanding on thin platforms.

That only about a dozen such dancing girls have been found and that they are large and fragile suggest that they were meant not for the common man's dwellings but for decorating the large palaces of royal and aristocratic families. They were most probably modeled by the skilled potters *(raja-kumbhakaras)* mentioned by the Sanskrit grammarian Panini and in the *jatakas,* the stories of Buddha's past lives.[11] Instead of producing for the market, these potters worked for the individual needs of the royal and *shresthin* (merchant) families. According to the *Kusha Jataka,* their patrons paid them handsomely.

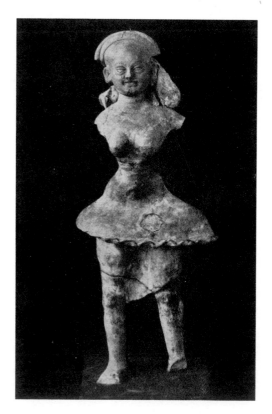

Figure 5
Dancing Girl
Pataliputra (Bihar)
Maurya period, ca. 320–200 B.C.
Hand-modeled terracotta
Collection: Patna Museum, Patna

Figure 6
Head of a Female
Buxar (Uttar Pradesh)
Maurya period, ca. 320–200 B.C.
Molded terracotta fragment with applied and incised ornament
Collection: Patna Museum, Patna

Sophistication in its highest form is seen in contemporaneous terracottas of Buxar that represent fashionable ladies with elongated foreign facial features and elaborate hairstyles (fig. 6). The foliage and floral designs in their ornaments and headdresses suggest they could be associated with vegetation rites such as the *shalabhanjika,* or tree goddess, festival, which, according to Panini, was peculiar to the eastern people. From Buddhist literature it is known that the people plucked *shala* flowers to celebrate this festival. Similarly, in the vegetation festival of *ashokabhanjika,* the girl who performed the rite of rejuvenating the tree wore *ashoka* leaves in her ears. The Buxar figurines seem to be a sophisticated version of such fertility maidens.

Along with these urbanized figurines, there was a continuation during this period of archaic forms like the *naga* figurines, which retained the linear abstraction and stylized form of the earlier period. That the cult of the mother-goddess was widely prevalent in the Maurya period is evidenced not only by such figurines but also by numerous stone disks representing the goddess, sometimes with her partner.[12]

The largest number of mother-goddess figurines has been found in Uttar Pradesh at Mathura, which in the Maurya period became an important terracotta making center outside Magadha. The archaic and vital form of these figurines is altogether different in idiom from Magadhan figurines. The inspiration is clearly religious, and there is no emphasis on drapery as in Pataliputra terracottas. The Mathura figurines represent a fat, steatopygous female with prominent breasts, an appliqué collar or necklace, an appliqué girdle often punch-marked or incised, and a well marked navel. Earlier examples have animal or birdlike faces, while later ones have faces that are molded and oval. Rosettes and large round earrings are peculiar decorations of this type of goddess, which has also been found at several other sites in Uttar Pradesh, including Ahichchattra, Hastinapur, Saraimohana, and Kaushambi.[13]

Another popular theme of the Maurya period is animals: elephants, horses, rams, bulls, dogs, and so on. Animal figurines of Pataliputra, Buxar, Vaishali, Mathura, Hastinapur, and Atranjikhera are meticulously decorated as if they were meant to represent ceremonial animals, with the decoration consisting of appliqué and of punch-marked and incised circlets. The animal figurines of Mathura have rosette motifs similar to those seen on the mother-goddess terracottas, while elephants from Hastinapur and rams from Vaishali are decorated with vegetation motifs similar to those found on the female figurines from Buxar. It is possible that animal terracottas were connected with mother-goddess worship, for the contemporaneous stone disks show such animals as lions, elephants, horses, rams, and deer surrounding the goddess. But animal figurines may have been also used as toys, such as the toy horses, bulls, and elephants referred to in the *Vessantara Jataka*.

The monopoly of Magadha in the economic and political life of the Mauryan empire is reflected in terracottas of the period. While the royal society and upper classes of Magadha commissioned special potters to produce artistic terracottas resembling Hellenistic figurines, the country outside Magadha was producing crude terracottas for cults and rituals. Magadhan terracottas have been found at Kaushambi, Bhita, and Rajghat, but the reverse is not the case.[14] This indicates that Magadhan terracottas were popular in other regions and also possibly that they were traded. Chandraketugarh and Tamluk in Bengal have yielded some native specimens of this period but they also show the influence of the Magadhan style.

III. *Circa 200 B.C.–50 A.D.*

From about 200 B.C. to 50 A.D. there was a spectacular and unprecedented growth in the production of terracottas in India as a consequence of the rapid progress of urbanization. The rule of the Shungas following the imperial Mauryas lasted only a short time, and after Pusyamitra Shunga's death in the middle of the second century B.C. there arose many small kingdoms—including Kaushambi, Koshala, Mathura, and Panchala—each with its own coinage system. Numerous urban centers between Bengal and the Punjab came into prominence. The political and economic dominance of the Magadhan state broke down, and the surplus was widely distributed among other regions. Even private individuals amassed considerable wealth. People other than royalty and the aristocracy—traders, merchants, artisans, craftsmen, and so on—now had money to spend on the decoration of religious monuments and the purchase of art objects.

Potters met the mass demand for terracottas that resulted by adopting the mold technique. This gave such a boost to production that terracotta making rose to the level of an industry. Terracottas became commodities for the market, and an impersonal relationship developed between the potter and his clientele.

The adoption of molds also affected the art of the terracotta. The round figures of the earlier period gave place to compositions in flat reliefs consisting of several figures. Exhaustive details of dress, ornament, coiffure, and so forth were minutely worked out in terracotta plaques as they were in the carving of ivory and stone. Indeed, the gap between stone and terracotta art almost disappeared. One can see much similarity, for instance, between the stone reliefs of Bharhut and the clay art

of Balirajgarh even though there is a difference in the thematic content of these arts due to their different functions.[15]

The use of molds made it easier to depict the narrative themes in which the public was interested, and some *jataka* tales and popular stories were depicted in miniature terracotta plaques. A plaque depicting the *Chaddanta Jataka* (cat. no. 40) has been found at Tamluk, for instance; others showing Asvamukhi Yakshi and her partner in the *Padakusalamanava Jataka* have been discovered at Chandraketugarh and Mathura, and plaques relating the *Vasavadatta-Udayana* story have been found at Kaushambi and Tamluk.

Although religious themes were often depicted in terracotta plaques of this period, their treatment was influenced by urban sophistication. Almost all the excavated sites have yielded female figurines associated with the mother-goddess and vegetation cults, but the goddesses are decorative female figurines in urbanized garb. Instead of the primitive archaic goddesses of the Maurya period, these are beautifully bedecked and richly bejeweled female figures with elaborate hairstyles. Nudity is often shown through their transparent apparel. Such fine textiles and large variety of rich ornaments, made possible by the growth of industries of luxury, are rarely represented in art of other periods.

Shri Lakshmi, the goddess of prosperity, wealth, and beauty, became a popular goddess with the rise of commercial and mercantile communities, and her representations are seen in numerous terracottas of Tamluk, Chandraketugarh, Bangarh, Harinarayanpur, Lauriya Nandangarh, Kaushambi, Mathura, and Awra. Another auspicious goddess, Vasudhara, was popular in Rajasthan, Uttar Pradesh, and Bengal, and the cult of the goddess of the five *ayudhas* (weapons in the form of hairpins) in her headdress, who may be called Panchachuda for convenience, was widely prevalent from Bengal to the Punjab (see cat. nos. 25, 26, 31, 32, 34, and 35). The representation of Panchachuda's partner in plaques from Ahichchattra—he holds a musical instrument symbolizing the role of music in fertility rites—suggests that she was a fertility goddess whose ceremonial or symbolic marriage was celebrated for the general welfare of the community and for agricultural and vegetation fertility as in West Asiatic cultures (see cat. no. 29). Symbols of fertility and auspiciousness are shown in association with many goddesses of this period. They touch their *mekhala* (girdle) or gold earrings, hold flowers or two fish, and wear symbolic ornaments.

Several male deities also make their appearance on terracottas of this period, not only as consorts of goddesses but also as independent figures. There are plaques representing Surya, the Sun God, from Chirand, squatting *yaksha* figures probably representing Kubera from Chandraketugarh (see cat. nos. 38 and 39), and winged deities from Vaishali, Kaushambi, Balirajgarh, Chandraketugarh, and Tamluk. In addition, male figures standing on wheeled rams, elephants, and horses have been found.

The cults of these gods and goddesses were associated with festive gatherings (*samajas*) in city gardens (*nagaropavana*). In an urban atmosphere, these fertility festivals tended to get secularized and sensualized and were treated as *kridas,* or sports, to use a word from the *Kama Sutra.* Accordingly, garden party scenes depicted in a terracotta from Mathura have a secular air, and a plaque from Kaushambi showing a richly dressed couple sitting on a chair manifests urban taste and vision (see fig. 7). The latter terracotta, however, retains its ritual significance by

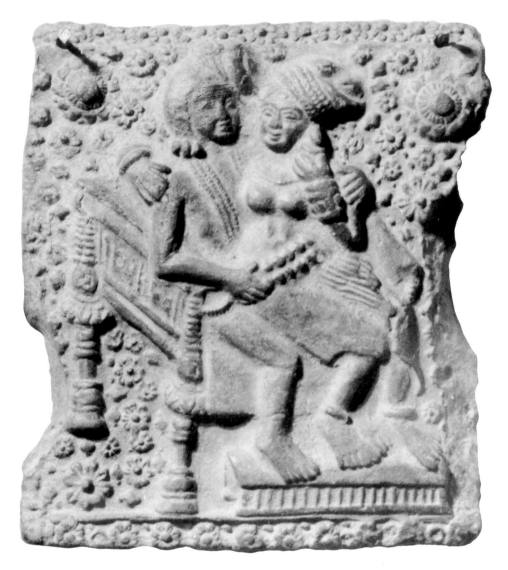

Figure 7
Couple Seated in a Chair
Kaushambi (Uttar Pradesh)
Shunga period, 2nd century B.C.
Molded terracotta plaque
Collection: National Museum, New Delhi

depicting the woman touching her earring in a symbolic gesture associated with fertility goddesses such as Shri.

The taste of the leisured *nagaraka* class is further reflected in plaques showing—among other things—*gosthi* (social gatherings), wrestling, animal fights, palace scenes, ladies decorating themselves, a well dressed *nagaraka* with an elephant, a child writing the alphabet, couples making love, and other erotic scenes (see cat. no. 36). The vast array of themes is astounding. In terracottas, the potter-artists of the period succeeded in communicating the dynamic quality of their popular culture.

36

IV. Circa 50–300 A.D.

Active trade with Rome and consequent commercial prosperity created a favorable situation for the manufacture of terracottas in the southern regions of India during the early centuries of the Christian era. Terracottas made from a rich white clay called kaolin were produced in a number of southern Indian towns, including Kondapur, Yelleshwaram, Nagarjunakonda, and Chebrolu in Andhra Pradesh, Sannatti in Mysore, and Ter, Paithan, Kolhapur, and Nevasa in Maharashtra.

From the first-century navigator's manual *The Periplus of the Erythraen Sea,* we get detailed information about the maritime trade between India and the Roman Empire and about the number of ports and inland market towns that grew up as a result. The discovery in southern India of Roman coins of the first century A.D. and the well-known reference of the Roman scholar Pliny to the drainage of Roman gold to India indicate the extent of this trade.

It is from this period of urbanization in the south that we get one of the earliest inscriptions referring to a guild of potters. This inscription from a cave at Nasik records that money was deposited with a potters' guild for the benefit of a Buddhist monastery.

Besides fine pottery with a red lustrous polish, potters of the period also made beautiful bangles, amulets, and beads, a large number of which have been found at sites associated with the southern dynasty of Satavahana. Kondapur and Maski in particular were known for terracotta beads.

In making terracotta figurines, Satavahana potters catered to the tastes and interests of the wealthy mercantile community. This is especially evident in the thematic content of the terracottas, most of which are secular. Among the themes most popular were joyous aristocratic men and women wearing rich ornaments and neatly arranged coiffures (see cat. nos. 48 and 49). One such terracotta representing a couple riding a horse (see fig. 8) is reminiscent of a similar motif on the capitals of the

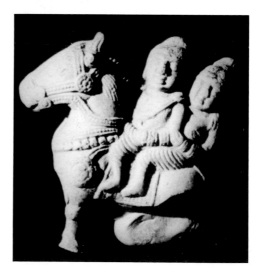

Figure 8
Royal Couple on Horseback
Ter (Maharashtra)
Satavahana period, ca. 1st century A.D.
Double-molded terracotta
Collection: Archaeological Survey of Maharashtra

37

contemporaneous caves of Karle and Kanheri, although there are stylistic differences. Other Satavahana figurines depict children, *ganas* (dwarf attendants of Shiva), and animals such as horses, rams, lions, and buffaloes. Too delicate to have been used as toys, these dainty figurines seem to have been intended as decorative pieces.

Satavahana terracottas have a totally different idiom than northern Indian terracottas. This difference has little to do with the widespread adoption of the double-mold technique in the south, because the double mold, which gives roundness and depth to a figure, was also used at many places in the north, including Mathura, Ahichchattra, and Purana Qila. Rather, it is the dainty forms and delicate workmanship of Satavahana figurines and the representation of a distinct type of ethnic features and physiognomy that distinguish them from those of northern India.

Some of the most interesting Satavahana terracottas are cultic figurines showing a nude goddess sitting with her legs apart. Roman-Egyptian in inspiration, these figurines have been found at Ter, Nevasa, Yelleshwaram, and Nagarjunakonda. That the goddess's cult was widespread among the aristocracy is suggested by an inscription at Nagarjunakonda that mentions a queen who apparently made an offering of such a figurine for the fulfillment of certain desires.

Under the Kushanas, northern India during this period was also materially prosperous, having its own trade links with Rome and the Hellenistic West. A century before and after the beginning of the Christian era, there were several invasions in the north by nomadic tribes—including, in addition to the Kushanas, the Shakas and the Parthians—as a result of events in Central Asia. The period witnessed an acculturation process whereby foreign religious cults, motifs, and forms were gradually assimilated into the cultural pattern of northern India. Terracottas vividly document the interesting results of this process.

Two distinct trends are noticeable in Kushan terracottas. One is the continuation of the old tradition of molded plaques seen in the Shunga or post-Maurya period. The other is the emergence of new forms and techniques due to the cultural changes brought about by the influx of new races.

The older tradition of terracotta reliefs is widely seen in plaques from Chandraketugarh, Tamluk, Rajghat, Kaushambi, Shringaverapur, Bhita, and Mathura. Though traditional, these plaques show improvement in formal quality, with the flattened reliefs of the earlier period giving way to reliefs in depth. The themes reflect the tastes of an affluent *nagaraka* class. Among the plaques that have been found are a well dressed *nagaraka* in a dancing pose from Chandraketugarh, erotic plaques from Chandraketugarh and Bhita, an example from Kaushambi showing a woman with a parrot on her right hand, a specimen from Mathura depicting a woman holding flowers, scenes from Kaushambi and Rajghat of a *shalabhanijika* under a tree, and a depiction from Ahichchattra of a drunken woman helped by her paramour or husband. Some of the same subjects are also seen in Mathura stone art.

The other, newer trend in Kushan terracottas is represented by mainly two types of figurines, one produced by double molds and the other modeled completely by hand. Seated *ganas* and *yakshas,* grotesque figures, musicians, and riders on horseback were produced by the double-mold technique. More crudely produced than the Satavahana double-mold figurines of about the same period, they are reminiscent of terracottas from the West Asian city of Seleucia dating to the period when Seleucia was ruled by the Parthians.[16]

The completely hand-modeled figures were more prevalent and were made to

satisfy both the religious and the secular demands of the public. The Kushan rulers supported the newly rising Brahmanical cults of Shaivism, Vaishnavism, and Shaktism, as well as Buddhism, and religion was humanized and emotionalized in the name of *bhakti* (devotion). Consequently, there was a demand for images of gods and goddesses for household worship. Several Hindu gods and goddesses received their shape and form during this period. *Ekamukhalingams* (shaftlike Shiva symbols) have been found in large numbers at such sites as Mathura, Rajghat, Kaushambi, and Bhita (see cat. no. 77). The deities Balarama, Vishnu, Karttikeya, Gajalakshmi, Sapta Matrikas, and Devi Mahishasuramardini were made in both terracotta and stone (see cat. no. 61). Among Buddhists, Buddha and *bodhisattva* images appeared for the first time. Mathura and Hastinapur in particular have yielded notable terracotta *bodhisattvas.*

Among the foreign cults assimilated into Kushan religious practice were sects of Parthian and Roman-Egyptian derivation. Parthian influence is seen in terracotta votive tanks. These tanks, which enshrine a mother-goddess surrounded by birds and musicians, have been found at Ahichchattra, Sonkh, Kaushambi, Hastinapur, and Taxila (Sirkap).[17] A Roman-Egyptian cult of a lotus-headed nude goddess is evidenced by clay plaques of Bhita, Kaushambi, and Jhusi (see cat. no. 55).

The Kushan public was also interested in portraiture. The dramatist Bhasa, who flourished in this period, tells of *rajakula* (royal chapels) that housed statues of ancestors, and Kushan royal portraits in stone are well known. In terracotta there are a number of heads of both men and women with expressive facial features. Because the center of economic and political activity had shifted to the north, sites in Uttar Pradesh have yielded higher quality terracotta heads than sites in Bihar. Heads from Mathura, Kaushambi (cat. nos. 58 and 62), Bhita, Masaon, Atranjikhera, and Ahichchattra—some of which represent distinctly foreign ethnic features—reveal great artistic talent. But there are also a number of crudely made heads from these sites having heavy and harsh facial features. One wonders whether they were meant to be portraits.

The appearance of a large number of crude and coarse terracottas during the Kushan period poses a problem to the social historian of art, as this was a period of great prosperity. The Kushan rulers issued numerous gold and copper coins, and even the indigenous dynasties used copper coins. As Professor R.S. Sharma has written, "This would suggest that perhaps in no other period had money economy penetrated so deeply into the life of the common people. . . ." Urbanization was at its peak during this period, and most of the excavated Kushan sites have revealed large brick structures with baked-tile roofs and floors.[18]

Perhaps Kushan potters were sometimes preoccupied with the baking of bricks, tiles, and pots at the expense of terracottas. The experimentation required in the creation of the new images emerging in this period could also account for some of the more crudely made forms, and when potters had to meet the large demand for terracottas they may have paid more attention to quantity than to quality.

Of course, Kushan potters could afford to pay special attention to images for which they were paid more. Accordingly, some of the best executed Kushan portrait figures are heads from Kaushambi (see cat. no. 62), Bhita, Ahichchattra, and Mathura representing noblemen and aristocrats. It is the massive, sturdy forms and expressive facial features seen in these heads that distinguish the best Kushan terracottas from those of other periods.

V. Circa 300–600 A.D.

The fourth to the seventh century A.D. in India was a period of transition marked on the one hand by tremendous prosperity and on the other by signs of decline leading toward feudal conditions. Toward the end of the period a new class of landed aristocrats arose as a result of numerous land grants by the Gupta rulers and their feudatories. These grants surrendered police and administrative functions to the aristocracy, weakened the position of the state, and paved the way for partial feudalization.[19]

Yet the accumulation of wealth by the upper classes—both the old commercial class and the newly emerging landlords—also resulted in an overall development in the arts of this period, both visual and literary. Terracotta art in particular reached the highest technical perfection and refinement. A study of Gupta terracottas has shown that they have a superfine texture unspoiled by an admixture of rice husk and that there is an absence of air holes and grit in their clay.[20] Large-size terrcottas such as the Ganga and Yamuna of Ahichchattra were baked in cylindrical pits 10 to 12 feet deep.[21]

Two distinct types of terracottas are seen from the Gupta period. The first consists of molded miniature figurines and small plaques used by individuals for household decoration or religious purposes. The second includes large-size figures and plaques used for the decoration of temples and monasteries.

The first group seems to have catered to the tastes of the urban class, the *nagarakas*. Barring a few religious images, such as Naigamesha and Hara-Gauri, most of the themes are secular. Beautiful, neatly produced heads of aristocratic men and women with a variety of fashions and coiffures—perhaps associated with the *nagarakas* of Vatsyayana who flourished in this period—have been found at Vaishali, Rajghat, Bhitari, Bhita, Kaushambi, Jhusi, Shravasti, Ahichchattra, Shringaverpur, and Mathura. At Bhita, marks of terracotta paint are still visible on these heads, suggesting they may often have been painted. Small reliefs include *mithunas* (couples) found at Shravasti, Bhita, Rajghat, and Mathura; *kinnara-mithunas* from Ahichchattra; erotic scenes discovered at Chandraketugarh; depictions from Pataliputra-Kumrahar and Masaon of a lady with a pitcher; scenes from Vaisali, Bhita, and Ahichchattra of a mother and child; and *shalabhanjikas* from Pataliputra-Kumrahar. *Ganas* and horse riders have been found at numerous sites.

The large-size figures and plaques associated with the Brahamanical temples patronized by the newly emerging feudal class reflect the Smarta-Puranic ideology and outlook. Themes of epics that had been known at least a thousand years now received sudden prominence in the visual arts. *Krishna* themes seen in stone art during the Kushan period, for instance, were more widely depicted in terracotta during the Gupta period (see cat. nos. 100 and 101), especially in terracottas of Rangmahal. *Ramayana* scenes have been found in terracottas from Shravasti, Chausa, Apsadh, and Barehat (see cat. nos. 94 and 95), while *Mahabharata* themes and Shaivite mythology are illustrated in terracottas of Ahichchattra (see cat. nos. 74 and 75). Along with religious subjects, secular scenes were also depicted on large-sized plaques. A large palace scene of Mathura (cat. no 105), for example, shows a woman in the company of a *vidushaka,* or court jester.

Compared to the sophisticated terracottas of the first group, temple terracottas tend to be more homely in character, more intimately connected with the daily life

of the people, and more playful in attitude. This is evident from a depiction of Shiva and Parvati in a family scene and from terracottas of the Bhitargaon temple that show Vishnu Seshayi or portray Ganesha running away with the *laddus* (sweetmeats) while his brother gives chase. On the other hand, a spiritual quality is captured in the Buddhas of Mirpur Khas in Sind and Devnimori in Gujarat. Some of the large heads of Panna and Ahichchattra also reflect equipoise and self-composed disposition.

Unlike the making of terracotta figurines, which were produced seasonally for festive occasions, decorating a monument with large figures and plaques involved continuous work. This work was done by specialized craftsmen called *pustakarakas* (modelers in clay and plastic material). Such craftsmen, who are mentioned separately from *kumbhakaras*, or potters, in the *Mahavatsu* of the third-fourth century A.D.,[22] worked according to the architectural scheme of a monument. They were under the supervision of architects and overseers who are mentioned in inscriptions and texts.[23] The decorated *stupa* at Devnimori, for instance, has an inscription of the fourth century A.D. that mentions the names of two monks who were in charge of construction.[24] Thus, clay modelers had a relationship with their patrons quite different from that of the makers of miniature terracottas who produced independently for the market.

In the period after 600 A.D., the large-scale output of miniature terracottas for the urban market dwindled with the decline of several towns. From the study of archaeological material of a number of sites in northern India, it has been shown that Pataliputra, Vaishali, Chirand, Kaushambi, Shravasti, Hastinapur, Mathura, Koh, Bairat, and several towns in Hariyana and Punjab that thrived in the Kushan age showed signs of decline from the Gupta period onward.[25] Towns that had been centers of crafts and commerce decayed with the dislocation of trade. The urban market economy suffered a setback.

However, some of the old centers such as Varanasi, Ahichchattra, Atran-jikhera, and Kanauj survived, while some new centers emerged. The production of terracotta figurines continued, albeit on a smaller scale. What is noteworthy is that these early medieval terracottas were bereft of urban sophistication and generally represented either wrestlers or *sati-sata* (memorial) themes. The urban ethos and *nagaraka* cultural life had faded, giving way to *samanta,* or feudal, values in art and literature. Though the market for miniature figurines had declined, the art of architectural terracottas used in the decoration of Hindu temples and Buddhist monuments flourished under the patronage of kings and the newly rising aristocracy. According to the seventh-century court poet Bana, terracottas were also occasionally employed in the decoration of royal palaces for such auspicious occasions as weddings. Gradually, the making of terracottas acquired the character of an elite art and was preserved in feudal headquarters and religious centers such as Paharpur (see cat. no. 114), Mainamati (cat. no. 115), Antichak (cat. nos. 116 and 117), Akhnur (cat. nos. 70–72), and Ushkar.

Notes:

1. This essay is revised from Desai 1978. On urban aspects of ancient Indian terracottas see also S.P. Gupta 1980, pp. 173 ff.
2. *Digha-Nikaya,* II, p. 88; *Majjima-Nikaya,* II, p. 228; *Nisitha-Churni,* 15, p. 1059; Jain 1947, p. 101. See also Desai 1983.
3. *Apastamba-Grihya Sutra,* IV, pp. 15 and 19. *Manu-Smriti* refers to *Pista-pasu,* V, p. 37. On the day of the *Naga-Panchami* festival in the rainy season, when the snake god is to be worshiped, some sections of the people in the city of Bombay make *naga* figurines of clay or cereal, whereas some others use terracotta snake figurines readily available in the market for this occasion.
4. The *Kama Sutra,* III, pp. iii, 6, 14, and 16, mentions clay figurines presented or shown by the *nagaraka* to his beloved. Desai 1985, p. 17.
5. *Indian Archaeology: A Review,* 1954–55, 1960-61, 1963–64, 1964–65, 1965–66, 1970–71; G.R. Sharma 1960; Sinha/Narain 1970; Sinha/Roy 1969; Joshi/Margabandhu 1976–77. See also Desai, "Pre-Maurya Terracottas of the Ganga Valley, circa 600–320 B.C." in the forthcoming O.C. Gangoli memorial volume of the *Journal of the Indian Society of Oriental Art.*
6. *Indian Archaeology: A Review,* 1971–72, pl. XIV-A; Sinha 1969, pl. 1.
7. *Indian Archaeology: A Review,* 1963–64, p. 8, pl. V-A.
8. Sinha/Narain 1970, pp. 10, 41, pl. XVI. The excavators identify the figurines as males, but the punch marks for the breasts and navel suggest they are females.
9. Ray 1945.
10. Webster 1966, pls. 13 and 18.
11. *Chullakasethi Jataka, Kusha Jataka,* and a gloss on Panini. Patanjali (*Bhashya,* II, 1.1) clearly states that a carpenter engaged to work for the king did not entertain private work. See also R.S. Sharma 1958, p. 89.
12. P. Chandra 1971. See also Desai 1983.
13. *Ancient India,* no. 4, 1947–48, pl. XXXI-A, pp. 106–107; *Ancient India,* nos. 10–11, 1954–55, pl. XXXVI-4; *Indian Archaeology: A Review,* 1967–68, pl. XXIII; *Indian Archaeology: A Review,* 1964–65, pl. XXXVI-1815, pp. 42–43; Sharma 1969, pl. 44-3.
14. Kala 1950, p. 13.
15. *Indian Archaeology: A Review,* 1962–63, pl. XI.
16. Ingen 1939, p. 27.
17. Agrawala 1947–48, pp. 125 ff., pls. XXXVIII, XXXIX.
18. R.S. Sharma 1972, p. 93.
19. R.S. Sharma 1965.
20. S.K. Srivastava 1971.
21. Ray 1954, p. 556.
22. Jones 1956, III, pp. 112, 443; *Mahavastu-Avadana,* ed. Basak 1963–68, I, p. xxxix.
23. Mishra 1975, pp. 17–19.
24. Mehta/Chowdhary 1966, pp. 121, 179.
25. R.S. Sharma 1972.

Brick Temples: Origins and Development

Vidya Dehejia

A lofty and peerless temple of the bright-rayed [Sun] was caused to be made by the weavers of silk-cloth formed into a guild, with stores of wealth acquired through [their] craft; [The temple,] which has broad and lofty spires, which [thus] resembles a mountain, is pale-red like the mass of the rays of the moon just risen, and being charming to the eye, shines like the tucked-in lovely crest-jewel of the western ward [of the town];

When considerable time had passed away and one part of this [temple] was shattered; hence now, for the augmentation of their own fame was again renovated most munificently by the magnanimous guild, this whole edifice of the Sun.
Which is very lofty, burnished, as it were touching the sky with [its] attractive spires, [and] has become the receptacle of spotless rays of the moon and the sun at [their] rise.

Mandasor inscription of 473 A.D.[1]

The development of the sacred architecture of India, its temples and *stupas,* has been evaluated primarily in terms of its many stone monuments. One is aware, of course, that this is not the complete picture—that shrines in early times were constructed of wood, thatch, and bamboo, and that brick was often used in combination with wood to produce these structures. But it is only

in recent years that attention has started to focus on the many brick monuments of India, thus widening the perspective within which the development of Indian architecture is viewed. It has generally been assumed, for instance, that the now non-existent sun temple of the Mandasor inscription was built of stone.[2] But since this temple, completed in 436 A.D., called for repairs as early as 473, is it not more likely that it was built of the relatively more fragile brick and thus appeared "pale-red like the mass of the rays of the moon just risen"?[3] Admittedly the inscription is on a stone slab, but we find a similar dedicatory inscription on a stone slab in the case of the Sirpur brick temple.[4]

The easy distinction between architecture and sculpture that may be made in many cultures does not exist in India because no Indian monument was ever intended to present to the viewer a plain and unembellished exterior. Every temple architect, whether working in stone or brick, experimented with the decorative treatment of wall surfaces until he achieved what he found satisfying and fulfilling. With great love for the purely decorative, Indian architects covered the exterior walls of their temples with gods and goddesses, maidens and couples, birds and animals, bands of intertwined foliage, and a variety of other ornamental motifs. The important panels depicting the divine beings were generally carved from separate slabs of stone or molded as individual terracotta plaques and inserted into niches prepared for them. Lesser sculptural details were carved directly into the stones or bricks of which the temples were constructed. Decorative bricks and terracotta plaques are thus an integral part of the architectural scheme of Indian brick temples.

It is intriguing to consider the change in the status of the brick in India over the centuries. From a position of great prestige in Vedic times, brick began to lose its status, first reaching parity with stone around 500 A.D., before assuming an inferior position by 1000 A.D. Various *Shilpa* texts give detailed instructions for the preparation of bricks. The *Mayamata,* although a late compilation of post-twelfth-century date, must reflect earlier practices since it refers frequently to "the words of the sages of yore." It specifies that the earth selected for bricks should be of uniform color and soft texture, free from extraneous items like sand, pebbles, roots, and bones. It should be mixed with water and vigorously kneaded with one's feet. To this mixture should be added the milky juice from the bark of the fig, mango, and neem trees, as well as the juice of three medicinal fruits. After a month of kneading, the bricks can be prepared, dried, and evenly fired.

The knowledgeable *shilpi* will allow these bricks to cool off and settle for two, three or four months; he will then take them and gently lower them into water; when he has removed them from the water, he will allow them to dry out thoroughly; after this he may make use of them for building purposes.[5]

The size of bricks may be used as a rough gauge to approximate the date of a temple. Bricks of the Kushan period generally measure about 20 inches in length, while early Gupta bricks are 16 or 17 inches long; bricks continued to diminish gradually in size until by the fifteenth century the 9-inch brick was much like the modern one.

The evidence of surviving shrines indicates that brick temples were regularly covered with a layer of plaster which was then painted over with suitable colors, probably in bright hues. When carved bricks and terracotta plaques with figure sculpture were introduced to enliven the character of brick walls, these too were apparently plastered over and painted. This practice was followed on stone temples

also. Much as our modern taste may prefer the look of plain terracotta plaques or uncolored stone surfaces, it seems that in India, as in much of the ancient world, monuments and sculptures were painted over.

Early Beginnings

In the Vedic period, when worship centered around the sacrificial altar of fire,[6] brick was a prime construction material. Because brick was thought to partake of the nature of earth, laying the first brick of the altar was considered the equivalent of instilling the altar with the firmness and steadiness of the earth. Not only was Mother Earth believed to reside mysteriously in each brick, but, as Stella Kramrisch has pointed out, the brick itself was considered a goddess.[7] The very term for brick, *ishtaka*—from *ishta,* or sacrificial offering—emphasizes the importance of the medium; like Mother Earth, the word *ishtaka* is feminine. It was believed that through baking each brick underwent a process of transubstantiation, and by its symbolic significance, brick, in the first millennium B.C. took precedence over other building materials.

The first temples were built of a combination of brick, wood, thatch, and bamboo. A temple of this type, dedicated to Vasudeva-Vishnu, appears to have existed in the second century B.C. at the site of Besnagar.[8] Recent excavations there have revealed the brick foundation of an elliptical shrine that seems to have had a wooden superstructure. A similar elliptical shrine of brick and wood apparently existed contemporaneously at the site of Nagari.[9]

It appears that not long after this shrines began to be built entirely of brick. Since earth along riverbeds provides the best material for manufacturing bricks, ancient brick shrines will probably continue to be discovered along riverbanks. One such shrine uncovered in recent years—with bricks measuring just under 20 x 13 x 3 inches—is an apsidal *naga* temple of Kushan date at Sonkh along the Jumna River near Mathura.[10] A major concentration of brick temples exists along the Ganges and Jumna Rivers, and there are numerous brick shrines, both Buddhist and Hindu, along the Krishna River. Along the foothills of the Himalayas, brick temples have been excavated in the town of Chamba on the Ravi River and outside the town of Kangra in the Sutlej Valley.[11]

The cluster of Hindu temples and the numerous *stupas* and monasteries built in the third century A.D. at Nagarjunakonda on the Krishna River not only testify to the widespread use of brick but also speak tellingly of the continuity of the brick tradition during the period often referred to in the north as the Kushan-Gupta transition. The temples represent a regional style influenced by the marked Buddhist character of the region. They had single or double shrines (as did the Buddhist monasteries at the site), and the shrines varied in shape, being apsidal, oblong, or square. All were built of brick, but stone was frequently used for the pillars of the *mandapas,* while in one instance at least the image of the god was carved from wood. We may only conjecture regarding the superstructure of these temples. Possibly the oblong and square shrines had flat roofs, while the apsidal shrines, like Buddhist *chaityas* (chapels), may have had vaulted roofs.

Some thirty Hindu brick temples generally dedicated to Shiva were constructed at Nagarjunakonda during the reign of the Ikshvaku monarch Ehuvala

Chamtamula in the last quarter of the third century, either by the ruler himself, by members of his family, or by his courtiers. The Ashta-bhuja-svamin (Eight-armed-lord) temple dedicated to Vishnu had two brick shrines, one oblong and one apsidal, each fronted by a hall with stone pillars. We learn from an inscription in this temple that in 278 A.D. a wooden eight-armed image of Vishnu on a stone pedestal was installed.[12] An oblong temple to Shiva's son Karttikeya was also erected, and beside a stepped, masonry tank stood the many-storied palatial Sarvadeva temple, described in its inscription as "the abode of all the gods."

Gupta Shrines

Between 300 and 600 A.D. brick temples were built all over India. Those in the northern belt of Gupta influence, whether Hindu or Buddhist, were elaborately adorned with carved bricks and terracotta plaques, while in eastern India they were frequently decorated with stucco, an unbaked and fragile substance. In other parts of the country brick shrines were relatively plain and undecorated.

Smaller bricks gave Gupta-period builders more flexibility in construction. At the same time, however, the small size of the brick created problems in bridging spaces. Wooden beams were frequently introduced over doors and windows, and in other crucial portions of construction, such as for spanning the roof. A dilapidated brick temple at Ter that uses carved wooden beams and sculptured wood door frames testifies to such usage.[13] The size of this shrine's bricks—16 x 9 x 2½ inches—indicates its Gupta date.

Of slightly earlier date are two small apsidal shrines at Ter and Chezarla, both presumably Buddhist, although in view of the many apsidal Hindu shrines uncovered at Nagarjunakonda, doubt may be raised regarding their religious affiliation. Both have a barrel-vaulted roof and a horseshoe-arched entrance reminiscent of Buddhist *chaityas,* and both are built of bricks measuring 17 x 9 x 3. The roofing at Ter is exposed, revealing a vault built by corbeling out each level of brickwork; with a few notable exceptions, corbeled architecture was the norm in India, whether building in brick or stone.

Devnimori

Among the earliest sites to have yielded hand-modeled terracotta figures, as well as carved and molded bricks, is the great *stupa* of Devnimori along the Keshvo River in Gujarat, dated to 375 A.D. on the basis of inscriptions and coins. A series of finely modeled seated images of the Buddha, some displaying the influence of the Gandhara style, were placed along the lower edge of the *stupa*. Twenty-six of these were recovered, along with a large quantity of terracotta architectural units including *chaitya* arches, pilasters, capitals, and brackets. In addition, decorated bricks measuring 17 x 11 x 3 inches and carved in varieties of foliate scrolls, lionlike heads, and decorative bands formed part of the structure. The quality of the workmanship, especially of the Buddha figures, was extraordinarily high. Intriguing calculations made by the excavation team suggest that with a sufficiently large task force the half-million bricks of the *stupa* could have been prepared, fired, and raised into place

in five years.[14] This would appear to be a considerably shorter time than would have been required for a comparable monument of stone.

Bhitargaon

Bhitargaon is the lone and spectacular survivor of a series of brick temples that once existed in the Ganges Valley (see fig. 9). In it, the practice of decorating shrines with terracotta plaques, introduced in the Gupta period, reached an early climax.

Terracotta plaques and carved bricks have been unearthed at a host of other Gupta sites, including Shravasti, Rangmahal, Pawaya, Mathura, Nagari, Kasia, and Ahichchattra. Like the plaques in the exhibition, they give us a glimpse of the astonishing virtuosity of the terracotta modeler, who, working in clay, enjoyed greater freedom and expressiveness than a sculptor of stone. Such modelers are referred to in an early Buddhist text not later than the third century A.D. as *pustakarakas* (modelers in clay),[15] as distinct from potters *(kumbhakara)* or brick masons *(ishtaka vardhakin)*.

Terracotta, it must be emphasized, is not necessarily a poor man's art. It is generally assumed that Indian monarchs, whether Mauryan, Shunga, Satavahana, Ikshvaku, or Gupta, built their palaces of brick, decorating them with wall paintings and with sculptures of clay and wood. Indeed, royalty continued to favor brick over stone for the construction of palaces, fortifications, and civic buildings right up until the coming of the Muslims.

Figure 9
The Bhitargaon brick temple, constructed circa fifth century A.D.

Figure 10
Detail of the facade of the Bhitargaon temple

47

The theory that brick was used for construction in areas where stone was scarce is also faulty. We know, for instance, that limestone was readily available along the Krishna River; yet it appears that brick was chosen for the construction of temples there.

The measurements of the Bhitargaon temple are impressive. A square with sides 36 feet long, it has a superstructure of receding levels reaching up to 50 feet. The walls are of considerable thickness, resulting in an interior shrine that measures 15 feet square. An arched roof covers this shrine, while a passageway and the small porch beyond, now fallen away, had semicircular arched ceilings. These arches are not of the usual corbeled variety found in early Indian constructions. Rather, we find that the builders of the Bhitargaon temple, laying their bricks in mud mortar, knew a version of the true arch. The bricks measure 17½ x 10 x 3 inches, an indication of the early Gupta date of the structure.

Bhitargaon is a *tri-ratha* temple, or one in which the walls consist of three vertical segments, with a wide central projection and two narrower recessed segments. Each such projection has three rectangular terracotta panels of equal size (30 x 24 inches), thus reflecting a phase prior to the standardization of temple decoration, which required one large panel to adorn each face. Here, the three panels, which contain relief images of deities, alternate with ornamental pilasters, each carved in a slightly different pattern. Above the pilasters is a double cornice of carved bricks, and between the two cornices is a frieze of smaller rectangular panels (16 x 9 inches), generally containing elaborate floral scrolls, with an occasional panel depicting a bird or other figure (see fig. 10). Each molded cornice is decorated with a row of dentils, a band of lotus petals, or a twisted-rope motif, and with a row of simple, stepped merlons. Above this rise the receding levels of the spire, which consist of tiers of arches of varying size. Instead of progressively diminishing in size, these arches alternate in levels of larger, smaller, and medium size. The small arches are decorated with finely modeled heads that survey the scene below, while the medium-size and larger arches contain figure sculpture.

Although some of the plaques, particularly the smaller ones, are initially the result of working with molds, the finishing seems to be the result of free modeling. Both carved and molded bricks were used in the decoration of the temple. Simple patterns, geometric or floral, were carved into the clay before firing; molded bricks had clay pellets added to the front surface and then built up, for instance, into a head. Knowing that pure clay has a tendency to crack, the Bhitargaon brick makers tempered it with fine-grained material to create pores for the escape of heat during firing.

The Bhitargaon terracottas have a fine glossy surface produced by applying a thin slip of clay, one-sixth of an inch thick, prior to firing. The archaeologist A. Cunningham tells us, however, that the clay within is coarse, black, and imperfectly burnt.[16] As we know, when air has free access to the objects within a kiln, the result is a brick red color; when air is insufficient, a blackish patina results.

Platform Shrines at Shravasti, Nagari, and Pawaya

Ample excavated evidence exists of sacred structures that were apparently larger and possibly more impressive than Bhitargaon. At Shravasti, Nagari, and Pawaya, for

48

example, there were great brick platforms, over 100 feet square, upon which were built brick shrines.

The Shravasti brick platform, 105 x 72 feet, stands 14 feet in height. The wall of this platform was decorated with plain brick pilasters alternating with niches containing terracotta plaques, of which over 350 were found lying along all four sides. An entire series of panels measuring 15 x 12 inches depicts scenes from the *Ramayana,* with figures shown in animated action. Another series seems to depict scenes from the life of Krishna. An interesting feature of the Shravasti panels is that most of them have numerals incised along the lower border. Clearly these numbers were intended to indicate the exact position of each plaque, so as to form a connected narrative. A brick stairway, 14 feet wide, led to the top of the platform, upon which there presumbly stood a brick temple dedicated to Vishnu. Both the platform and the stairway are covered with a layer of ancient plaster just under half an inch thick.[17] Several Shravasti terracottas can vie with those from Bhitargaon in their plastic quality; however, the work at the site is not of the consistently high standard seen at Bhitargaon.

The Nagari platform, with projections on three sides, stood 8 feet in height and was decorated with carved and molded bricks. An entire series of bricks (13 x 9 x 2½ inches) was molded to represent birds, sometimes the pigeon, but more often the *hamsa,* or wild goose (see cat. no. 109). A second type of brick was molded to depict a human head within a half arch (see fig. 11). These bricks were planned in pairs, one male and the other female, and when placed together appeared as conversing heads within a complete arched window. Set along the upper levels of the platform, they looked downwards toward the viewer. Yet other bricks were carved in floral designs. On top of the platform was a brick structure about 45 feet square; only its lowermost

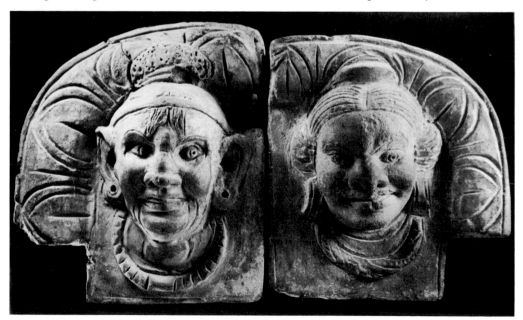

Figure 11
Pair of Molded Bricks
Nagari (Rajasthan)
Gupta period, 5th century A.D.
Molded terracotta
Collection: Deccan College, Pune

49

molding, 2 feet high, survives. The precise nature of this structure remains uncertain; it may have been a Hindu temple, but since its excavator seems convinced it was solid, it may also have been a Buddhist *stupa*.[18]

The Pawaya platform, 140 feet a side and decorated with plain brick pilasters, stands some 40 miles from Gwalior at the confluence of the Sindh and Parvati Rivers. The brick shrine, 56 feet square, that stood upon it was decorated with pilasters and with bricks molded into human heads. Both the platform and the shrine were made of bricks measuring 18 x 9 x 3 inches. The small number of terracotta plaques recovered at the site, most of which depict animals and birds, perhaps decorated some subsidiary structure. Although the excavator suspects that the shrine may have been solid and hence a Buddhist *stupa*, all associated remains at the site, including the famous Pawaya stone *torana* (gateway), are sculpted with scenes from Hindu mythology.[19]

Temples of Ahichchattra

The site of Ahichchattra has yielded some of the largest, best known, and most spectacular terracottas, including life-size images of the river goddesses Ganga (see fig. 3) and Yamuna, exquisitely modeled heads of Shiva (see cat. no. 74) and Parvati, and a series of large plaques (approximately 26 inches square) depicting a variety of scenes from Shaiva mythology and the epics. These plaques portray Shiva destroying Daksha's sacrifice, his assumption of the fearsome form of Bhairava, his ascetic form as Dakshinamurti, and several scenes of battle. The taut, lively quality that characterizes the plaques contrasts with the mannered sophistication of the river goddesses, suggesting that we have here the work of different artists or guilds.

The size of both the panels and the goddesses indicates that the temple they once adorned must have been of impressive proportions. The excavation report, however, has never been published, and the only information we have on the structure is both scanty and unsatisfactory. All that we know is that it was a "massive brick structure" and that it was built "in several tiers diminishing upwards, like a gigantic staircase."[20] The large plaques were apparently fixed in a frieze running around the upper terrace, while the images of the river goddesses were installed in niches "flanking the main steps leading to the upper terrace."

Ahichchattra apparently had more than one brick temple, of which one at least seems to have been dedicated to the mother-goddess, probably in her awesome aspect as Durga. An emaciated torso of Chamunda with scorpions and lizards on her body, a seated Chamunda with corpses at her feet, and several figures of Durga killing the buffalo demon were found in one place. A well modeled figure of Agni and a fragmentary head of Narasimha also come from this area. These terracottas reveal variations in style and workmanship, indicating that they belong to shrines of varying dates. Unfortunately, in the absence of a scientific excavation report, Ahichchattra may never be adequately evaluated.

Harwan

Far to the north, at Harwan, just above the Dal Lake in Kashmir, are the excavated remains of several brick Buddhist structures built into the terraces of a steep hillside.

On the highest terrace is the most important and earliest of these monuments, an apsidal brick temple surrounded by a spectacular pavement of sculpted terracotta tiles laid in a pattern of concentric circles. Measuring 160 x 125 feet, this courtyard contains tiles decorated with a variety of motifs, including spirals, floral and leaf designs, geese, ducks, cocks and pheasants, fighting rams, elephants, suckling calves, musicians, soldiers, and dancing girls. Each tile is stamped, in the northern Kharosh-thi script, with numerals, suggesting that the pavement was carefully planned by the master architect. Surrounding the courtyard is a platform decorated with a set of identical plaques. Because these plaques depict an emaciated man in an ascetic pose, it has been suggested that the site may originally have been a retreat for Ajivikas, an extremist ascetic religious cult founded shortly before Buddhism.[21] Since use of the Kharoshthi script ceased prior to the fifth century, Harwan may be placed during the period of Gupta rule, although Kashmir was not part of the Gupta kingdom.

Other Gupta Brick Temples

A brick temple that collapsed in 1897 existed at Dah Parbatiya in Assam. Although possibly post-Gupta in date,[22] it was similar to Gupta temples in having its walls decorated with terracotta plaques. Those plaques discovered during clearance were in a poorly damaged state, but seated human figures were discernible.[23]

Surface finds in the villages of Rangmahal and Barapal along the dry bed of the Ghaggar River indicate that brick temples decorated with terracotta plaques were also built in the area of Bikaner. Among the striking plaques found there is one portraying a powerful image of Shiva as Gangadhara;[24] others depict Shiva Ekapada and Krishna, the latter holding up Mount Govardhana in one instance and demanding milk from the *gopis* in another. There are also several figures of men and women with drapery revealing a marked influence from the Gandhara region.

Other sites that had brick temples during the Gupta period include Kasia (ancient Kusinagara), Mathura, Chausa, and Barehat. These temples were all apparently decorated with carved and molded bricks and with terracotta plaques.

The Chinese pilgrim Hsuan Tsang, who traveled through northern India in 636 and 637 A.D., wrote of at least two major Buddhist brick shrines, one at Sarnath and the other at Bodh Gaya. He also spoke of a brick temple with a large image of Tara at Nalanda.[25] Of the Sarnath temple, he wrote:

> Within the great enclosing wall was a temple above 200 feet high surmounted by an embossed gilt *an-me-lo* fruit: the base and steps were of stone: in the brick portion above were more than 100 rows of niches each containing a gilt image of the Buddha; inside the temple was a *t'u-shi* (?) image of the Buddha representing him in the attitude of preaching and as large as life.[26]

Hsuan Tsang's description of the temple at Bodh Gaya confirms that, although extensively renovated by the Burmese Buddhists, the shrine as it stands today approximates to the temple of 636. He reports that it was built of bricks and coated with lime, that it had tiers of niches with images, and that its finial was a gilt copper *amalaka*.[27]

At Sankissa, Hsuan Tsang reported a stairway of brick and stone 70 feet high with a Buddhist temple of unspecified material on top.[28] The massive brick platforms

excavated at Shravasti, Nagari, and Pawaya suggest that he was not exaggerating the stairway's size.

In general Hsuan Tsang was not sufficiently interested in architecture to give us descriptive details of the temples he saw; however, the few instances he recorded accord well with the picture of Gupta India gleaned from excavation reports.

Stucco-decorated Shrines

In eastern India, where stucco work was more common, an unusual circular brick shrine dedicated to the *naga* cult at Maniyar Math near Rajgir was decorated with stucco sculptures. Though these figures have disintegrated today, old photographs of them reveal a sensitive modeling that suggests a Gupta date.

The stucco sculptures of post-Gupta date adorning the *stupa* at Nalanda are well known. Of about the same period are the elegant stucco relief panels depicting scenes from the *Ramayana* that decorate the base of what appears to have been a Vishnu temple at Apsadh.[29]

Brick Temples in Areas outside Gupta Influence

In parts of India not under Gupta rule or influence, we find less-decorated brick temples, with none of the terracotta plaques that add such charm and vitality to the Gupta structures. For instance, a massive brick platform similar to those at Shravasti, Nagari, and Pawaya was uncovered at Nagra, on the outskirts of the town of Nagpur. Several levels of moldings follow the recesses and projections of this platform, which stands 12 feet high and measures approximately 142 x 84 feet, with only plain brick pilasters to break up the monotony of the long stretches of undecorated brickwork.[30] Nothing like the terracotta plaques of the Gupta sites exists here.

At the site of Mandhal, 70 kilometers from Nagpur, is a unique temple in which the brickwork is entirely encased in stone masonry. A copper plate of the fifth year of the Vakataka ruler Rudrasena that was recovered at the site indicates that the temple was erected at a time corresponding to the Gupta period of the north. But what prompted the encasement of a brick shrine with stone slabs remains a mystery.[31]

Brick temples have also been found in Gujarat; for instance, a temple probably of sixth century date existed at Karwan, some 35 kilometers from Baroda.[32] Only the base moldings of this temple remain intact, but it appears that here, too, terracotta plaques were not part of the decorative scheme.

Later Development

Brick Temples in Kosala and Orissa

Perhaps the finest example of a post-Gupta brick temple is the elegant Lakshmana shrine at Sirpur, which has a stone doorway and stone pillars in its hall (see fig. 12). There is some uncertainty regarding its exact date, despite its foundation inscription, due to controversy regarding the dates of the Somavamsi rulers. It has been variously

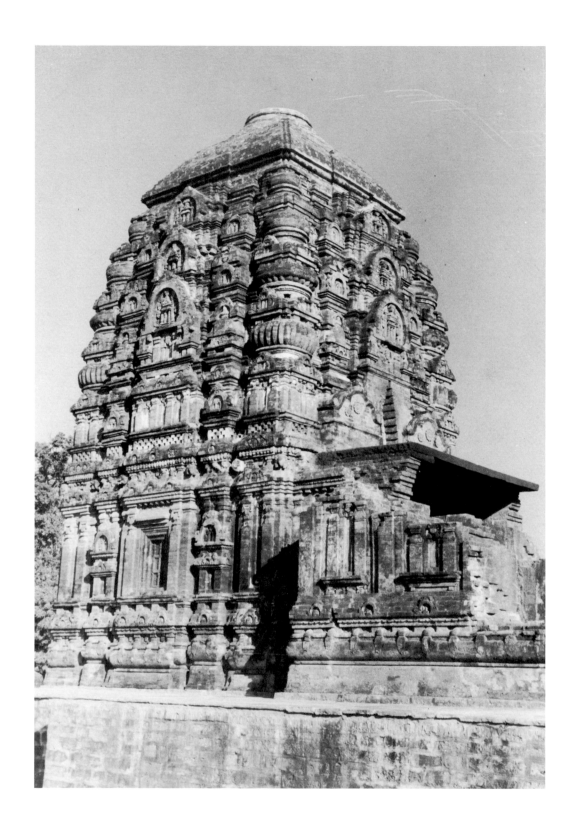

Figure 12
Southern view of the Lakshmana shrine at Sirpur,
constructed circa seventh century A.D.

dated to 595-605 A.D., to between 600 and 650, or to the end of the seventh century.[33] But its sophisticated conception, its *pancha-ratha* plan in which the temple wall is divided into five vertical segments, its base moldings with a leaflike strip draped over the rounded pot-shaped *(kumbha)* section,[34] its elegant "blind" windows executed entirely in brick, its flat, fluted cushion-like stones *(amalakas)* at the corners of the temple tower, and its exquisitely carved stone doorway all suggest a later rather than an early date. The Gupta style of enlivening the walls with terracotta plaques has been abandoned here, and the decoration is architectural in nature, consisting of pilasters and of *chaitya* arches that frequently enclose miniature shrines. These arches decrease progressively in size as the temple tower rises, unlike Bhitargaon, where a logical progression is absent. Much of the brick carving at Sirpur is the result of chiseling the bricks after they were laid in place, rather than of carving them into patterns prior to baking.

Later brick temples in the region further elaborate on the scheme of Sirpur while also introducing a modified stellate plan. In the Siddhesvara temple at Palari,[35] the *chaitya* arches along the temple wall enclose figures of deities. These figures are built up of plaster over an armature of rough brickwork—a technique that in both Kosala and Orissa replaced the Gupta terracotta plaques. In the Kosaleshvar temple at Baidyanath in interior Orissa, which was built partly of stone and partly of brick, this technique was used to build up roughly carved brick serpent pilasters. This temple appears to have been erected early in the ninth century.[36] To the ninth century as well may be assigned an impressive brick temple at Ranipur-Jharial, also in interior Orissa (see fig. 13). This temple is *pancha-ratha* in plan, and the treatment of its walls approximates closest to the Mukteshvar Shiva temple at Bhubaneshvar, with serpent pilasters placed in the recessed *(anuraha)* section between the niches of the corner *(konaka)* and the niches of the central projection *(raha)*. The wall is in two sculptural levels divided by a band of molding; however, the serpent pilasters ignore the division, with their bodies in the upper level and their tails in the lower. Displayed in the niches and *chaitya* arches are images of various gods; those clearly identifiable include Varaha, Narasimha, a dancing image (presumably Shiva), and a seated image with a *yoga patta* band tied around his knees (perhaps Lakulisa). An application of plaster over an armature of brickwork completed these figures, and ample traces of

Figure 13
The brick temple at Ranipur-Jharial, constructed in the ninth century A.D.

the plaster are visible in photographs taken before the present restoration. The interior of the shrine is 10 feet square, and the inner roof is constructed of stone slabs. The 90-foot-long platform on which the temple stands suggests that the temple's small porch must have led to a hall. The bricks of the temple measure 13 x 9 x 2½ inches.

Bengal Shrines

It is in Bengal that we find the latest extension of the Gupta terracotta plaque tradition.[37] The great cruciform *stupas* of Somapura at Paharpur and of Vikramashila at Antichak, both some 360 feet square, are decorated with large numbers of terracotta plaques (see cat. nos. 114, 116, and 117). At Paharpur some two thousand of these remain *in situ* while another eight hundred have been found loose in excavations. They were placed in two or three rows forming continuous friezes, with the larger panels (13 x 11 inches) decorating the basement and the smaller ones inserted along the first terrace. At Antichak, there is but a single row of the larger-sized plaques.

No clear thematic scheme is evident in the placement of these terracotta panels at either Paharpur or Antichak. Human figures, monkeys, geese, conches, fish, and fables are interspersed with a number of Buddhist images as well as with Hindu deities including Brahma, Krishna, and Shiva. Ornamental bricks placed above the plaques are carved into lotus petals, dentils, and a rope motif. Compared to the finely crafted Gupta plaques, these eighth-century examples appear somewhat crude; however, the action is frequently lively and animals in prticular are well portrayed.

A third cruciform *stupa* decorated with terracotta plaques may be seen at Mainamati. There, an unusual technique was used in the preparation of the plaques: the clay was allowed to dry before carving, so that the plaques resemble the art of a stone carver.[38] These plaques, which generally portray animals (see cat. no. 115), are not as animated as at Paharpur or Antichak. A sixth-century inscription at the site suggests that Mainamati may in fact be an antecedent and model for the two better known cruciform *stupas* of Bengal.

Postscript

By 1000 A.D., the glorious age of the brick temple was over. The architectural *Shilpa* texts now said that the first "brick" of a temple could be of stone,[39] and other texts claimed that it was more meritorious to build a temple of stone than of brick:

> He who builds a brick temple shall live in the heaven of the gods a hundred thousand crores of years; But he who builds a temple of stone shall enjoy the heavens ten thousand times as long.[40]

In Bengal in the seventeenth and eighteenth centuries, however, the art of terracotta temples was revived under the patronage of the Malla rulers.[41] The bricks in these temples vary in size from approximately 9½ inches in length to 6¾; in addition to the standard shape, some are flat and long and others are triangular. There are also plaques covered with exuberant decoration. In fact, the entire gamut of scenes from Hindu mythology may be seen on these temples, along with numer-

ous scenes of everyday life, including portrayals of Europeans (see cat. nos. 124 and 125). In one case, an entire series of plaques was placed together to produce a complete sculpted wall. The architectural style of these temples is distinct and, with a few exceptions, unrelated to earlier temple architecture, having borrowed heavily from the Islamic tradition.

The Tamil country is the only other area in India where brick was used extensively in temples after 1200 A.D. There it was employed in the construction of the massive gateways, or *gopuras,* that are such a prominent feature of the large temple complexes built from the thirteenth century onwards. While the vertical lower levels of these pylonlike gateways are built of stone, the pyramidal superstructures—which frequently reach heights of more than 150 feet—are constructed of corbeled brick and decorated with stucco or terracotta figures finished with plaster and bright paint. Due to the destructible nature of these materials, the upper stories of the many *gopuras* of south India have been regularly restored. Occasionally one comes across an unexpected modern addition, such as an American cowboy,[42] in the midst of the many thousands of figures from the inexhaustible resources of Hindu mythology.

Notes:
1. Bhandarkar/Chhabra/Gai 1981, pp. 380–381.
2. Basham 1983, pp. 103–105. He finds it strange that a temple built of solid blocks of masonry should need repair so soon. Williams 1982, p. 137, suggests the possibility of wooden architecture.
3. If one prefers the translation in Fleet 1970, p. 86 ("white as the mass of the rays of the risen moon"), then one may visualize a brick temple with white plaster.
4. Hiralal 1911-12, pp. 184–201. The stone slab was discovered during clearance of the collapsed debris of the brick temple.
5. *Mayamatam,* chap. XV, verses 113-120, 215-217, ed. Sastri 1966, p. 120.
6. Staal 1982.
7. Kramrisch 1946, I, pp. 104–105.
8. Khare 1967, pp. 21–27. See also Irwin 1974, pp. 1–11.
9. Bhandarkar 1920, p. 131.
10. Härtel 1973.
11. Information from Dr. V.C. Ohri of the Simla Museum and Mr. Garg of the Chamba Museum: large brick platforms excavated near the Lakshmi-Narayan temple are of post-Gupta date (bricks are now in the Chamba Museum); bricks from Duttanagar, Kangra, are 16 inches long and appear to be of Gupta date (the mound has yet to be excavated).
12. Sarkar/Misra 1966, p. 72.
13. Cousens 1902-03.
14. Mehta/Chowdhary 1966, pp. 67–68.
15. Jones 1956, p. 112. See also Mishra 1975, p. 11.
16. Vogel 1908-09, pp. 5–16. See also Zaheer 1981.
17. Vogel 1907-08.
18. Bhandarkar 1920.
19. ASIAR 1924-25, pp. 165–166.
20. Agrawala 1947-48, p. 167.
21. For further details on Harwan, see Fisher 1982.
22. Williams 1982, pp. 170–171.
23. ASIAR 1924-25, pp. 98–99; Ibid. 1925-26, pp. 115–116.
24. Mankodi 1983, pp. 243–246. See also ASIAR 1917-18, pp. 21–23.
25. Watters 1904, II, p. 171.
26. Ibid., II, p. 48.
27. Ibid., II, p. 116.
28. Ibid., I, p. 334.
29. Asher 1980, p. 53.
30. Information from Dr. A.P. Jamkhedkar, Director of Archaeology for Maharashtra.
31. Idem.
32. Information from Dr. Kirit Mankodi, Project for Indian Cultural Studies, Franco-Indian Pharmaceuticals, Bombay.
33. The date of 595-605 is suggested in Stadtner 1981, pp. 49–56; the first half of the seventh century is proposed by Williams 1982, p. 160; the end of the seventh century is suggested by Dikshit 1960, p. 18.
34. Such moldings are to be seen also in the Orissan stone temples, where they started to appear around 650.
35. Stadtner 1981, pp. 49–56.
36. Dehejia 1979, pp. 136–138.
37. K.N. Dikshit 1938. See also Asher 1980, p. 92.
38. Ibid., pp. 98–99.
39. See, for instance, the *Silparatna of Sri Kumara,* chap. XII, verses 14-15, ed. T.G. Sastri 1922. Although this is a late compilation of the sixteenth century, one assumes that, as in many other instances, the author is repeating the tenets of earlier texts.
40. *Mahanirvana Tantra,* chap. XII, verse 25, ed. Woodroffe 1971, p. 318.
41. Michell 1983.
42. Harle 1963, p. 5, on the *gopura* of one of the smaller temples at Tiruvannamalai.

Terracotta Traditions in Nineteenth- and Twentieth-Century India

Stephen P. Huyler

Terracottas are vital to the customs and rituals of India today just as they have been in the past. Crafted from the most readily available material, they are employed in countless ceremonies in nearly every area of the subcontinent. Because their use is an expression of the continuity of ancient traditions, studying their production and many functions helps us understand Indian society itself more fully.

Throughout India's ancient history, craftsmanship was prized, and up until the last few centuries, craftsmen, including the potters and artisans who made terracottas, held honored positions in society. This situation changed radically, however, as a result of the general impoverishment and greater social rigidity that accompanied foreign domination, first by the Mughals and then by the British. As India, once regarded as a primary source of desirable trade goods, became primarily an exporter of raw materials, the exportation of crafts drastically decreased and craftsmanship became localized. Although terracotta production was less obviously affected than other crafts because few Indian terracottas were ever made for export, widespread poverty decreased the demand for potters' work, most refined patronage waned, and the potter's position in society became less honored. In order to rule a complex and confusing array of peoples, the British further formalized the inherent social order of castes, thereby confirming potters in an inviolable position of fourth-class citizens.[1] In this century, the increased use of steel and alloyed metals for vessels (followed more recently by plastics) has greatly reduced the market for pottery, forcing thousands of potters to seek alternative employment. Moreover, when India gained independence in 1947, the priorities of the new nation were unification and modernization, often at the expense of local traditions, customs, and styles. In the

thirty-nine years since then, modern methods, techniques, and materials have replaced many traditional ones. Yet, despite these effects of recent history, terracotta sculpture remains integral to rural culture all over India.

The magnitude of India's contemporary terracotta production reflects the size of its rural population. India, which is eighty-two percent rural, contains more than 580,000 villages whose total population accounts for one-seventh of all humanity. Each of these villages, or group of two or three villages, has at least one potting family engaged in making terracotta images at some point every year. A practical map pinpointing nineteenth- and twentieth-century terracotta sites would thus be impossible to make: its whole surface would be covered. The terracottas themselves are immensely varied, ranging from the crude to the highly refined, the elemental to the ornate, the minute to the grandiose. The diversity of techniques and shapes reflects the many distinct traditions that have evolved throughout India's long history.

Although terracotta sculptures are mass-produced by some potters, most are the products of specific commissions by village or townspeople who require images for ritual purposes. In some villages, such as those of Tamil Nadu, the principal god in worship is made of clay, and all over India each Hindu household requires images of deities for certain religious festivals (such as Ganesha for Ganeshpuja, Shiva or one of his manifestations for Shivaratri, or Saraswati for Saraswatipuja). Often these images are terracotta. Even the poorest Hindu can afford to display a simple clay image in his household shrine, and ancient holy scriptures encourage this practice by extolling clay as one of the purest substances.

Though brightly colored clay toys abound at carnivals and fairs throughout India and are the focal point of children's play in rural areas, the most common purpose for which terracottas are made in India today is as votive gifts to shrines. Sanctuaries found in almost every district in India, often outside and simply adorned, contain clay images of animals or humans that have been given to the presiding deity in return for the god's favor: healing an illness, conceiving a child, or granting good crops or other good fortune. This Hindu custom is so widespread that even some rural eastern Indian Muslims place votive terracotta animals beside the tombs of their saints in return for blessings, a ritual that orthodox Muslims would deem idolatrous. Since numerous nineteenth-century accounts of Hindu shrines describe votive terracottas similar to those used today, it may be assumed that their contemporary production continues hereditary craft traditions. Although the precise use and meaning of most ancient terracottas are a matter of conjecture, many must have been made to be used as votive offerings.

Contemporary Indian terracottas can be divided into two basic categories: some are temporal, responding to the immediacy of a new set of values, while others are so basic to the core of Indian civilization that they seem primordial. The forms of temporal-style terracottas reflect transitory fashions and styles, while the shapes of primordial-style terracottas echo archetypes that have remained similar throughout each age.[2]

Nineteenth- and twentieth-century Indian terracottas tend to differ from those of earlier periods largely due to the influence of Western artistic ideals. As these ideals began to permeate India in the nineteenth century, whole schools of craftsmen in urban centers, particularly Calcutta, began sculpting realistic terracotta figurines for house decorations and for export (see fig. 14). In this century the influence of the media, especially the film industry, has been so great that contemporary terracottas

Figure 14
These life-size terracotta figures commissioned in
Calcutta by American sea captain Benjamin Shreve of
Salem, Massachusetts, in the early 1800s portray
Shreve buying textiles in India. The figures are now in
the Peabody Museum in Salem. (Photograph courtesy
of the Peabody Museum)

frequently suggest the faces of popular film idols. Although thousands of potters still
create sculptural images by hand, employing techniques passed down for countless
generations, the demands of the commercial age have greatly increased the mass
production of terracottas. Most of these mass-produced terracottas are cast in a
double-mold technique similar to that used for Satavahana terracottas in the second
and third centuries, but in contrast to those ancient clay sculptures their shapes are
uniform and uninspired.

Good examples of temporal terracottas from the nineteenth century may be
seen in the sculpted brick temples of eastern India (mostly Bengal), which carried on
traditions begun in the sixteenth century. Patronage of this highly specialized art
dropped off entirely by the end of the century as eastern India grew increasingly
impoverished due to severe overpopulation and the demands placed upon the people
by Imperial Britain and as terracotta modeling began to be replaced by stucco and,
later, cement.

Other temporal terracottas prevalent in Bengal during this time, and still
popular today, are large images of Kali, Durga, and other deities made of clay applied
to a core of straw-wrapped bamboo. Brightly painted and clothed, they are carried in
procession as the centerpieces of religious festivals. Although meticulously designed
according to proportions prescribed in ancient craft texts *(shilpashastras),* these
urbanized terracottas display distinct stylistic influences of the Indian cinema and
Western fashion.

Still further examples of stylistically unique terracottas in Bengal are elaborate votive sculptures dedicated to the snake goddess Manasa in Bankura District. Built entirely by hand and standing as high as 5 feet, these sculptures act as storytelling devices depicting Manasa and other related gods. They are unpainted, with a black hue created by reducing the oxygen supply to the kiln (see fig. 15).[3]

Figure 15
Terracotta images of Manasa, the snake goddess, surrounded by the hooded forms of her snakes, in a tree shrine at Panchmura in Bankura District, West Bengal. Manasa is believed to be a granter of miracles, particularly the curing of snakebites.

Some of the most interesting temporal terracottas in India today are made by the rural potters of Puri District, Orissa. In forms that reflect the architecture of local classical temples, these potters construct 3-foot-high terracotta planters to hold the sacred *tulasi,* a basil bush essential to daily Vaishnavite worship. The sides of these planters are decorated with relief images of the donor couple and their ancestors (the latter on horseback), while the top is adorned with the gods of the four directions (*mandiracharuni*) and addorsed lions.

Temporal-style terracotta plaques depicting local legends, gods, and symbols are made by the Maru potters of Molela, a village in Rajasthan. These plaques are twentieth-century counterparts of the sculptural plaques made for the monumental temples of the Gupta period, and the bright colors that the Maru craftsmen use to finish their work suggest the brilliant hues that once covered those classical terracotta temples (see fig. 16).

By far the most widespread and elaborate temporal terracottas in India today are the votive figures given to the rural god Ayyanar in Tamil Nadu (see cat. no. 129). Scriptural research indicates that Ayyanar was originally a Tamil folk hero who began to be worshiped as a deity in the far south in the seventh and eighth centuries. Identified with Harihara, he is the son of both Shiva and Vishnu (as Mohini) and as

60

Figure 16
The clay plaques made by this Maru potter of Molela,
Rajasthan, are painted with bright colors after firing.
Contemporary rural counterparts to classical temple
plaques, they depict Revanta, a local hero-god, on the
left and center and Ganesha on the right.

such is honored by both Shaivites and Vaishnavites and by all castes.[4] Although rarely
associated with major temple sites, his cult has spread throughout all areas of Tamil
influence. Ayyanar shrines are usually placed at the edge of a village, for it is believed
that the god protects village boundaries from evil. Terracotta images of horses and
elephants are given annually to such shrines in return for blessings like the curing of a
sick child or a bountiful harvest after a period of drought. Built by hand, usually
employing the coil technique, these hollow animals average 3 feet high; some,
however, made in a single piece and fired on the spot, are gigantic, reaching 16
feet—the largest terracottas ever recorded anywhere. Images of Ayyanar himself are
only occasionally made of terracotta, but those of his hero warriors, the Veeran (see
cat. no. 130), and of donor couples or other human votive figures given to him are
often made of clay. Once created and dedicated, they are left outdoors to disintegrate
slowly, their major function fulfilled in their donation. Almost every Ayyanar
shrine—and there are thousands still in use throughout Tamil Nadu—contains

alongside its new sculptures the neglected remains of earlier terracottas, some only broken remains, others complete horses or elephants or figures one or more centuries old. Nineteenth-century Ayyanar terracottas and those earlier remains still extant display a variety and sophistication of decoration clearly related to classical south Indian sculpture in stone and bronze (see fig. 17). Those of this century, however, are simpler in design, suggesting that the dwindling of patronage has forced potters to spend less time and care in their creation.[5]

Figure 17
In village shrines all over Tamil Nadu, terracotta horses are given each year to Ayyanar, the god of protection, as mounts for his guards in their nightly patrols against evil. Most shrines are filled with many examples, old and new. These nineteenth-century ones at Ramapuram in South Arcot District are more detailed and highly fired than most of those made today.

Although the styles of many terracottas have been adapted to nineteenth- and twentieth-century India, primordial terracottas are still more common than temporal ones. Frequently labeled "primitive," these terracottas are by nature elementary in form and decoration, conveying with minimal devices the figures they are intended to represent. They are almost always made by hand and usually consist of basic lumps of clay to which dowels and pellets have been added to form appendages. Their simple features are pinched or incised. Some start as pot shapes thrown on the wheel and are adapted and added to so that they become abstract depictions of animals or humans.

Traditional Indian craftsmanship is not egocentric; since the clay the potter sculpts is his spiritual link with the Divine—the bond between man, matter, and ritual—his products are a form of devotion, not merely an expression of personal creativity. His works become essential to local rituals, and consequently the potter himself often takes part in his community's religious functions. The highest ideal for an Indian craftsman is to re-create perfectly his traditional prototype. Thus a Gujarati sculpture of a horse will reproduce as closely as possible the form established by the craftsman's ancestors. Terracotta sculptures have no signatures and few identifying marks to separate one man's products from those of his co-workers or ancestors. Signatures are unnecessary and undesirable. The images a potter creates, whether deities, votive offerings, or simple clay toys, are often immediate and ephemeral, intended to be used and then discarded.

Among the most common primordial-style sculptures made by traditional Indian craftsmen are images of the mother-goddess. Although the feminine principle, or goddess, is frequently ignored in Western conceptions of Hinduism—which tend to recognize only two major sects, Shaivism and Vaishnavism—she is one of the primary deities worshiped throughout rural India. In classical Hinduism she is called Lakshmi, Parvati, Durga, Kali, and Ganga, but most villagers know her simply as Ma, or Mataji (Mother). Her representation is often minimal: simple, undelineated clay lumps of full-figured forms suggestive of pregnancy. In Bengal, her features are pinched to resemble a bird's, similar in form to archaic terracottas found throughout the Gangetic plain. In Tamil Nadu she is manifested as seven sisters, often seven simply delineated female forms fired as a single unit on a common base, while in Midnapur District, West Bengal, she is Manasa, the snake goddess, portrayed as a plain pot to which a human face and coiling snake forms have been added. In Uttar Kanara District, Karnataka, an ancient terracotta tradition has just been discovered in which the mother-goddess is shown as a double pot with a raised face and rudimentary breasts and legs, a form reminiscent of Kushan pot figures.[6]

The deities to which primordial-style sculptures of humans and animals are offered differ from region to region, but the sculptures themselves follow similar archetypes. Their antecedents can be found in ancient terracottas from prehistoric to medieval times, and when recently made but weathered primordial terracottas—collected from any of thousands of sites throughout the subcontinent—are placed beside these ancient counterparts, they are often indistinguishable except by scientific testing.

Archetypal human figures are usually intended to represent specific people requiring divine aid (see fig. 18). At one shrine—in Adilabad District, Andhra Pradesh—villagers beseeching cures give elementary sculptures of the injured or diseased parts of their bodies, such as feet or arms. In Surat District, Gujarat, human votive sculptures have crude bodies with molded faces that give them a striking resemblance to early Gangetic figures, while in Ganjam District, Orissa, they have the pinched faces of ancient "bird goddesses." Sculptures of sick children seated with their legs stretched before them—often dedicated to the goddess Mariaman—are placed in sanctuaries all over Tamil Nadu, while in both Salem District in that state and in West Bengal small walled rectangles made of clay and containing one or more human figures are given to the gods. These latter sculptures are remarkably similar in form to "votive tanks" excavated at Kaushambi that are believed to date from the first to the second century A.D.

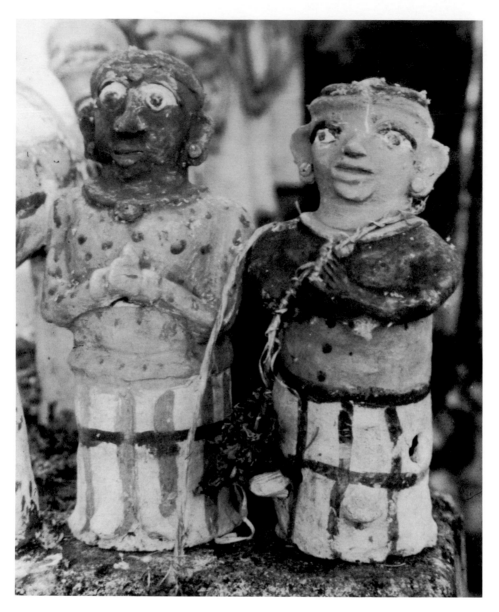

Figure 18
These contemporary pot figures in a shrine at Yarlan-
dakullam in Madurai District, Tamil Nadu, represent
a donor couple. The bright organic paints used to
decorate them were probably also used on the ancient
Kushan pot figures they resemble.

The most common animal represented by primordial-style terracottas is the
horse. Because there are few, if any, horses in many of the rural areas of India, the
frequency with which they are represented in sculpture may seem odd. Mytho-
logically, however, horses have long been associated with both gods and royalty. The
origin of the horse in India is a matter of constant dispute: some scholars are
convinced that the remains of horses have been found in pre-Aryan sites, while others
insist that the first horses arrived in the subcontinent with the Aryans. In any case,

horses are commonly thought of as honorable mounts for the gods and nobility and are in demand even today as the most suitable conveyance for Hindu grooms to their weddings. Villagers throughout India give terracotta horses to their local gods, believing that the spirits of the gods enter the horses at night and that the gods ride these horses around to protect the villages. In lowland Orissa and Deccani Andhra Pradesh, clay horses given to the mother-goddess are small and solid. In southern Puri District, Orissa, they are larger and hollow and have the human faces so characteristic of Orissan animal sculpture and ancient Harappan terracottas, while in West Bengal they are tiny and are formed of five plain clay dowels joined together to create four legs and a torso, almost duplicating pre-Maurya examples on display at the Patna Museum. Two-foot-high votive horses made in Deoria District, eastern Uttar Pradesh, are remarkably similar in their abstract form to ones made in an entirely different culture over eight hundred miles away in Baroda District, Gujarat. In both places, the legs, torsos, necks, and heads of the horses are thrown on potters' wheels before being joined together, and pinches and pellets of clay are applied as decorations and facial features. In the tribal villages of Baroda District, as many as a hundred horses a year may be given by a single family in order to placate the spirits of malevolent ancestors believed to be causing the family's problems.[7]

Other archetypal animal forms frequently sculpted in clay include tigers and elephants. Round, wheel-thrown images of tigers are given to the tiger goddess in the coastal hills of Uttar Kanara District, Karnataka, in the hope that she might protect the villages from these much feared beasts. Similarly, brightly painted tiger images are still made and dedicated for protection to shrines in Udaipur District, Rajasthan, even though there are few remaining tigers to endanger the lives of Rajasthani villagers. Terracotta elephants are most prevalent in Bihar and eastern Uttar Pradesh. Usually made of components thrown on a wheel (four round pot legs surmounted by a smoothed-over torso and a pot head with a long tube for a trunk and two half-plates for ears), they are placed on rooftops for weddings and under sacred trees as votive gifts to the goddess, usually Kali or Durga. In the local Chhatra festival dedicated to the Sun God, Surya, they are submerged in a river or pond as the culmination of days of fervent prayer and arduous fasting.

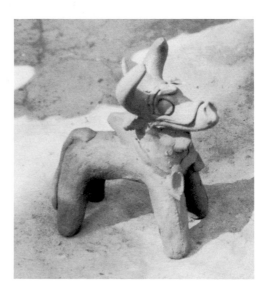

Figure 19
This bull made as a children's toy by a tribal potter in Koraput District, Orissa, is primordial in shape and comparable to bulls from several early historical sites.

Such rituals may once have been in danger of dying out, but the very existence of a museum exhibition of this kind, which attempts to show for the first time the development and continuity of terracotta traditions in India over the last four thousand years, demonstrates a basic change in attitudes toward terracottas in both India and the West. Within the past few years, Indian government agencies have begun to encourage selected terracotta craftsmen to produce their inherited crafts for a broader market (invariably resulting in more terracottas of the temporal variety), and in the folklore and ethnology departments that are springing up in universities throughout the subcontinent a few students are documenting traditional rural terracottas. Sophisticated urban Indians are beginning to buy terracottas of both the primordial and the temporal varieties as decorations for their homes. With this newfound interest in the art of simpler, indigenous cultures, it is possible that the decline in production of terracottas over the past two centuries will be halted and that future generations will still be able to share in the customs and rituals of giving low-fired clay sculptures to the gods.

Notes:

1. Numerous histories of India of the seventeenth through the twentieth centuries corroborate this brief synopsis. Two references for further reading are Smith 1982, II, chaps. 8–19, and Schweinitz 1983. See also Behura 1978, p. 181, where he writes, "Terracotta production immensely flourished as a lucrative profession in the past owing to the lavish regal patronage it had received from the landlords, zamindars, and rulers. With the merger of the princely states and abolition of zamindari, this patronage has more or less passed on to the national government, but with a change. However, this art draws perpetually a vigorous incentive from the general masses, since it has structurally an inextricable function in the regional culture[s]. . . . On various religious occasions, during the year, Hindus invoke many of their deities through the medium of clay images. And all these images are supplied by potter-artists."

2. A full discussion of these two basic types of Indian terracottas may be found in Kramrisch 1939, ed. 1983, pp. 69–84.

3. A further description and photograph may be found in Bussabarger/Robins 1968, p. 38.

4. Kramrisch 1985, p. 264.

5. Suggested further reading: Kramrisch 1968, pp. 94–96.

6. For an in-depth examination of the mother-goddess, see M. C. P. Srivastava 1979.

7. The most thorough book concerning rural Indian terracottas and the culture that has produced them, including extensive material on primordial tribal terracottas, is Shah 1985.

Technical Examination
of Terracottas

Dr. Lambertus van Zelst

In the solution of major questions of archaeological or art historical nature, technical examinations and chemical or physical analyses can be of great assistance. When interpreted properly in a collaborative venture of humanist and scientist, art historian or archaeologist and chemist or physicist, such scientific studies add an extra dimension to the information already available.

The four most often asked questions in a technical study are what, where, when, and how. Of these the first is generally the easiest to answer. Although the proper identification of the materials that constitute an object is of prime curatorial importance, and the labels in many museum galleries arc a sorry testimony to the need for much more work in this area, it is generally only when coming to the aid of a conservator that the museum scientist is asked to deal with this particular question. For the present purpose, therefore, it will be left alone. Where art historical or archaeological problems form the frame of reference for a project, as they do here, it is more likely that one deals with one or more of the other three questions: how, when, and where.

Technological studies of ceramics such as terracottas can cover many aspects of the manufacturing technology. These range from the preparation of the raw materials (washing, mixing, tempering, or plasticizing of the clay) to the forming process (modeling, molding, pinching, coil building, or wheel throwing) to the firing technology (firing temperature, kiln type, oxidizing or reduction fire) to the surface decoration (slip, glaze, paint, application technique).

Such information not only aids in the description of an object but can also help to put it in its proper historical perspective. For archaeologists and anthropolo-

gists, definition of the technological traits of production in a given cultural group is particularly useful because identification of the same traits in another group may be construed as evidence of information exchange.

While determining a ceramic's major chemical and mineralogical components is generally of great help in evaluating the technology involved in its manufacture, analyzing its concentrations of trace elements is of eminent value in solving questions of geographical provenance. Because the concentration patterns of these elements are determined by the geochemical history of the rocks from which the clays were derived, they tend to be highly characteristic for a clay source. Thus, trace element analysis of ceramics and clays, especially in combination with petrographic studies of these materials, can help to evaluate whether different types of ware from a given site were made locally or imported, and if the latter, from where. This information allows for archaeological conclusions regarding trade.

The importance of a scientific dating technique for ceramics is self-evident, both from an art historical and from an archaeological perspective. As the most abundant excavated material, ceramics are used to date the layers in which they are found, and hence a reliable and accurate direct dating technique for them would be of preeminent value. Regrettably, however, the only available technique for direct dating of ceramics, the so-called thermoluminescence dating, does not always provide a date with enough accuracy to be of much help in the answer of art historical or archaeological questions. Because it relies on the measurement of a small amount of light emitted by a heated ceramic sample, a phenomenon caused by the unleashing of energy stored through the absorption of radiation from naturally occurring radioisotopes in the clay since the last firing, the technique is susceptible to a number of complicating factors that can affect the accuracy of the obtained date rather severely. Although a precision of about five percent has been reported in the dating of ceramics that have a favorable mineralogical composition and have been excavated from a properly documented context, one should expect no better than twenty to twenty-five percent precision in the case of a ceramic object with an unknown environmental history. Still, even though such a margin of error makes the date quite useless in many historical contexts, the technique is useful in solving questions of authenticity, where the precision of the date is of less importance than its approximate value. Moreover, when ceramics made from the same clay and with a common environmental history are dated, the relative dating of the group can be much more precise than the absolute dates obtained for the individual objects.

Indian terracottas pose a variety of questions for which an answer might be facilitated by the application of scientific techniques of examination and analysis. Some preliminary work in preparation for this exhibition has already shown results that promise success for the major effort we hope to undertake concurrent with and following the exhibition. While the limited work done so far has been mainly oriented to individual objects that pose questions of authenticity, date, or technique, it is our intention to launch a comprehensive study that will correlate stylistic analysis with provenance, technology, and date. We are extremely grateful to the Archaeological Survey of India, which has agreed to let us sample and study materials from well documented archaeological contexts. With the background data provided by study of these materials, more can subsequently be concluded from the study of objects without a complete history, such as most Indian terracottas in Western museum collections.

An illustration of the kind of findings our preliminary examinations have yielded is offered by the case of a terracotta representing an elephant with three riders, one of a number of objects tested at the Research Laboratory of the Museum of Fine Arts, Boston. Although a thermoluminescence test performed at the time of its sale on a sample taken from the elephant's body had given a correct date of firing, stylistic considerations had led to suspicions regarding the object's authenticity. The whole object was therefore placed under a low-power stereomicroscope and studied in detail at magnifications between 10x and 40x. It was found that the black surface was due not to a slip, as is the case on other black-colored terracottas, but rather resulted from the application of black paint. Moreover, a filler material with a rubber consistency was found to be present at the connections between the rider bodies and the elephant. This evidence led to the conclusion that the object had at least been extensively restored. Because the suspicions centered around the number of riders and the stylistic attributes of the rear rider as compared to the two in front, separate thermoluminescence tests were performed on all three figures. The results showed that although all the riders date to antiquity the rear rider is up to a thousand years younger than the two in front. One must thus conclude that the object is a pastiche, made up of ancient parts that do not all belong together. The value of this finding is not only in the evaluation of the individual piece but also in the confirmation of the stylistic judgment and therefore the applied criteria.

The limited study done so far has also yielded some preliminary information with regard to such technological attributes as surface decoration with slips, the application of separately modeled or molded parts, and the pinch forming of faces on goddess figurines. In our more systematical, comprehensive study we want to combine the description of such attributes with a chemical characterization of the clays from different sites, in order to arrive at as complete a characterization of groups of terracottas as possible. An investigation of the literature on the geology of the Ganges Valley shows that a discriminating characterization of sites along the river may well be possible. Although the valley floor is a continuous alluvial deposit, a reminder of the time when the valley was open to the waters of the Indian Ocean, local variations in the composition of the river clay should be expected due to the contributions of tributaries, which drain very different geological formations to the north and south of the valley.

Such technical studies only yield really successful results when they are performed by an interdisciplinary team of scientists and art historians or archaeologists. Such an approach ensures that the objects chosen for study are representative of the sites and periods under investigation, that the questions asked are not only amenable to technical analysis but also historically relevant, and that the results of study are properly interpreted. We expect that our technical examination of Indian terracottas will have all of these attributes and will thus be worthy of the beautiful objects in the exhibition that triggered it.

Chronology

Dates are approximate since the dates of reign differ according to the varying interpretations of texts or the geographical extent of any reign. Further, the periods may not accord strictly with political history; rather, they follow common usage among art historians, who refer to a stylistic era by the name of the rulers most prominent during that period, even if their rule did not span the entire period.

North and Northwestern India
Indus Valley Civilization
 circa 2500–1800 B.C.

Transition period
 2nd–1st millennium B.C.

Maurya period
 circa 320–200 B.C.

Shunga period
 circa 200–50 B.C.

Kushan period
 circa 50–300 A.D.

Gupta period
 circa 300–550 A.D.

Eastern India
Pala period
 765–1175 A.D.

Sena period
 1095–1206 A.D.

Eastern Ganga period
 750–1250 A.D.

Period following the Muslim invasions
 13th–19th centuries

The Deccan
Satavahana period
 circa 200 B.C.–225 A.D.

Ikshvaku period
 175–200 A.D.

Map of India

AFGHANISTAN
- Hadda
- Harwan
- Uskar
- Sar Dehri
- Charsadda
- Taxila
- Sirkap
- Akhnur

JAMMU·KASHMIR

CHINA

- Chamba
- Kangra
- Rupar

- Harappa

PAKISTAN

- Rangmahal
- Kalibangan
- Suratgarh

UTTAR PRADESH

- Hastinapur
- Ahichchattra
- Sirthal

NEPAL

Delhi

- Mathura
- Atranjikhera
- Sankissa
- Sonkh

RAJASTHAN

- Mohenjo-Daro

- Shravasti
- Lauriya Nandangarh
- Kopa
- Kasia
- Chirand
- Vaishali
- Sonpur

- Chanhu-Daro

- Bhitargaon
- Jhushi
- Bhita
- Kaushambi
- Sarnath
- Rajghat
- Chausa
- Buxar
- Patna
- Bulandibagh
- Vikramashila

- Bangarh

Brahmaputra River

- Dah Parbatiya

ASSAM

- Mirpur Khas

- Pawaya

Allahabad **Varanasi**

- Nalanda
- Maniyar
- Bodha Gaya

BIHAR

BANGLADESH

- Mahastan
- Baidyanath
- Paharpur

Indus River

- Nagari

- Panna

- Devnimori

I N D I A

- Besnagar

- Pandu Rajar Dhibbi

WEST BENGAL

- Mainamati
- Berachampa
- Chandraketugarh

Hooghly River

Calcutta

- Tamluk
- Hooghly

- Mandhal

GUJARAT

- Karwan

Narmada River

BURMA

ARABIAN SEA

- Sirpur

- Nagra

MAHARASHTRA

- Ranipur

BAY OF BENGAL

- Paithan

- Nevasa
- Inamgaon

Bombay

- Dhulikatta
- Peddabankur
- Kondapur

- Ter

- Kolhapur

Krishna River

- Sanatti

- Nagarjunakonda

- Amaravati

- Yelleshwaram
- Chezaria

- Malavalli
- Banavashi

Madras

- Kanchipuram

- Gudithangioham

- Uraiyur

SRI LANKA

Lenders to the Exhibition

Allahabad Municipal Museum, Allahabad
Allahabad University Museum, Allahabad
Mr. and Mrs. James W. Alsdorf
Archaeological Survey of India, Patna
The Asia Society, New York
Asutosh Museum of Indian Art, Calcutta University
Mrs. Robert M. Benjamin
Bharat Kala Bhavan, Banaras Hindu University, Varanasi
The Brooklyn Museum, New York
The Cleveland Museum of Art
Deccan College, Pune
Samuel Eilenberg
Robert H. Ellsworth
Mr. and Mrs. John G. Ford
Government Museum, Mathura
Harry Holtzman
Indian Museum, Calcutta
Mrs. Pupul Jayakar
G. K. Kanoria
The Kimbell Art Museum, Fort Worth
The Metropolitan Museum of Art, New York
Museum of Fine Arts, Boston
National Museum, New Delhi
S. Neotia
Patna Museum, Patna
Cynthia Hazen Polsky
Pritzker Collection
Dr. Bertram Schaffner
Staatliche Museen Preussischer Kulturbesitz, Museum für Indische Kunst, West Berlin
State Archaeological Museum (West Bengal), Calcutta
State Museum, Lucknow
Victoria and Albert Museum, London
Doris Wiener
William H. Wolff
Private Collections

Catalogue

In the dimensions of the objects in this catalogue, height precedes width precedes depth. Dimensions for some objects were not available when the catalogue went to press. Full citations for abbreviated references are given in the bibliography. The collection is given in italics.

Sanskrit names, words, and phrases are transliterated without diacritical marks, following the system in *Webster's Third New International Dictionary*. Place names generally follow the form in Joseph E. Schwartzberg, ed., *Historical Atlas of South Asia* (Chicago, 1978).

Unless otherwise indicated, all sites are in India. However, many of the objects that belong culturally and historically to Indian art originated in regions now part of Pakistan, Afghanistan, and Bangladesh. For the convenience of the reader, present-day political boundaries have been respected.

Indian sites, towns, and cities are followed by the name of the modern state (in parentheses). When a specific locale is unknown, the name of the state alone appears.

1 Standing Female

Pakistan, Mohenjo-Daro
Indus Valley Civilization,
ca. 2500–1800 B.C.
Gray hand-modeled terracotta
with applied ornaments,
23.0 x 6.5 x 4.0 cm.
National Museum, New Delhi

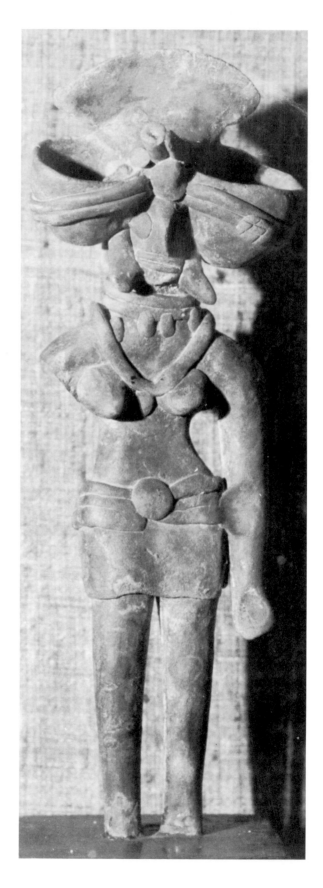

Terracottas found at Indus Valley sites include numerous cult and animal figures, as well as gaming objects such as dice. The antiquity of such works, whether in complete or fragmented form, is quite well established from excavations such as those conducted at Mohenjo-Daro in the northwest. Although the exact function of these figures remains problematic, the presence of ornamentation suggests that they were auspicious objects of abundance and fertility and probably served a religious purpose.

This hand-modeled figure with its appliqués of pellets and strips is worked into a formal pattern of great sophistication. Although the body structure is simple and the stance hieratically frontal, the elaborately worked headdress, with its central fan and vessel-like extensions on each side, enhances the design. The bands and circular elements of the headdress echo those in the girdle as well as in the collar and pendant necklace that form a triangular shape above the prominent breasts. The figurine's long left arm hangs stiffly at her side; the right arm is missing.

References:
Mackay 1937, p. LXXV, no. 21; Sivaramamurti 1974, figs. 28 and 187; Taddei 1970a, fig. 1; Paris 1978, no. 3.

74

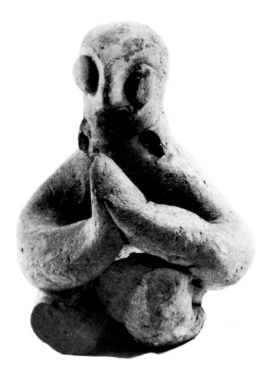

3 **Male Figure
in Yogic Posture**

Indus Valley Civilization,
ca. 2500 B.C.
Red hand-modeled terracotta
National Museum, New Delhi

Human figures with animal heads and ani-
mals with human characteristics are com-
mon at Harappan sites. The former is repre-
sented here by a standing female with a
globular, pot-shaped body (cat. no. 2). Her
face is crudely modeled, with a pinched nose
and applied pellets for eyes; her other ana-
tomical details are only suggested.

The well preserved arms of the squat-
ting male seen here (cat. no. 3) reveal clasped
hands, which indicate a devotional attitude.
This type of male figure, although rarely
encountered in early Indian art, may be a
precursor to the Maurya-period ascetic fig-
ure (see cat. nos. 16 and 17). Although the
Harappan figure lacks the traditional em-
bellishment of costume, ornament, or head-
dress, its facial features are modeled in the
style of the period.

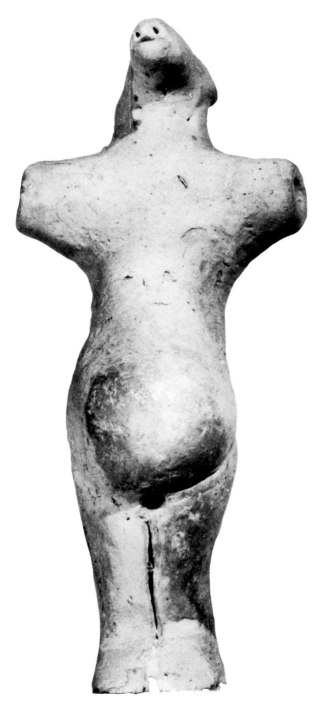

2 **Pregnant
Animal-Headed Female**

Indus Valley Civilization,
ca. 2500 B.C.
Red hand-modeled terracotta,
9.5 x 4.0 cm.
National Museum, New Delhi

4 Climbing Monkey

Pakistan, Mohenjo-Daro
Indus Valley Civilization,
 ca. 2500 B.C.
Red hand-modeled terracotta,
 5.5 x 4.3 x 3.0 cm.
National Museum, New Delhi

Representations of animals in Indus Valley art are often more naturalistically fashioned than those of human figures. Combined animal-human types, like the pregnant monkey-headed female (see cat. no. 2), may take on different human postures, while the terracotta animal figures are generally shown as standing creatures. Nevertheless, the representation of a climbing monkey is atypical.

The animals include a variety of types —horses, bulls, camels, and rams—whose purpose remains a puzzle, but whose artistic merit is great. The highly worked miniature monkey shown here conveys a rare sense of vitality and personality with its realistically rendered face, anatomy, and fur. Such delicately delineated facial details as the pierced and carved eyes and nostrils are rare even in other naturalistic animal figures of the early Indus Valley Civilization. Even though no particular species of monkey is portrayed, the playful asymmetrical pose shows careful observation of nature.

Reference:
London 1982, no. 20.

5 Bull

Rajasthan (?)
Indus Valley Civilization,
 ca. 2000 B.C.
Red hand-modeled terracotta,
 3.8 x 7.6 cm.
The Brooklyn Museum 83.64;
 Anonymous gift

Throughout Indian culture, the bull is a complex symbol from both the historical and psychological points of view. In ancient Indian religions, the bull was a symbol connected with atmospheric deities, its bellowing sound associated with rolling thunder. As represented on Harappan carved intaglio seals, the bull expressed the idea of power and was linked with the active masculine principle.[1]

Terracotta figurines representing bulls, along with auspicious female images (see cat. no. 1), constitute the best known early examples of terracotta art from prehistoric sites throughout the Indian subcontinent. At many sites, bulls, universal symbols of virility, have been found at even earlier stratified levels than female figurines.[2]

This hand-modeled figurine reveals a naturalistic treatment of the bovine form, even to the indication of a flaccid dewlap. Deep ridges mark the torso and shoulders to emphasize the fleshiness of the body. The applied clay around the neck represents a garland.

Notes:
1. The sanctity of the bull is alluded to in many studies of village and tribal life in modern India. See, for example, Hutton 1946; Thurston 1909; Das 1953, pp. 232–241.
2. For a comparable bull figurine from Kalibangan, see Dhavalikar 1977, pl. 2, pp. 5–7. Other noted sites that have yielded bull figures are in Rajasthan, Maharashtra, etc., but The Brooklyn Museum's work is the only example of such an early date in an American collection.

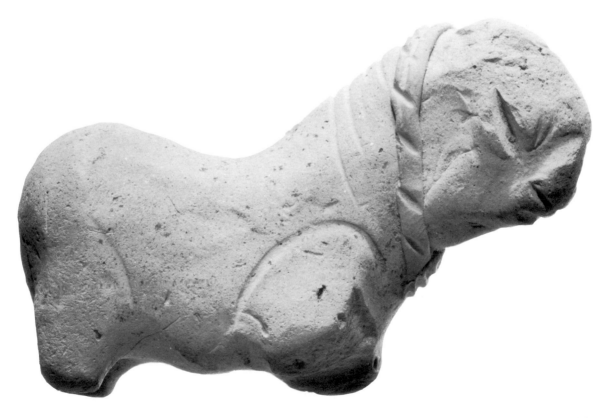

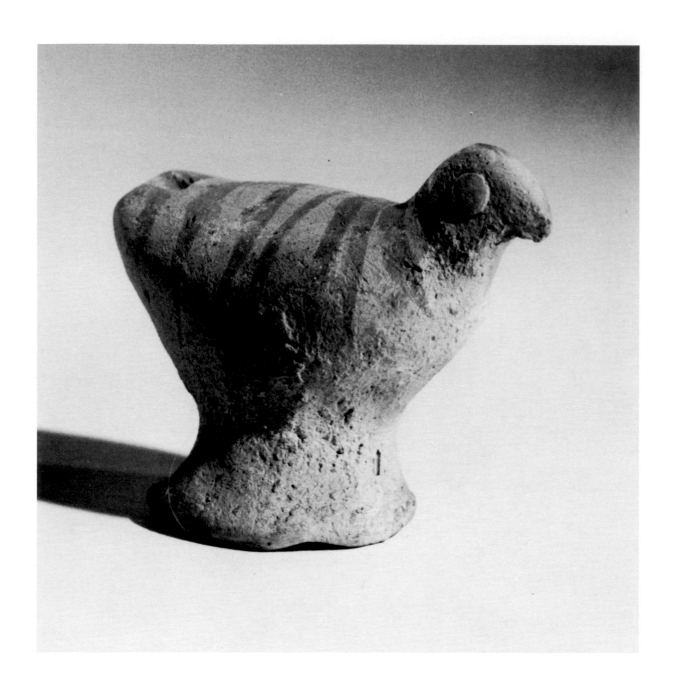

6 **Toy Whistle**

Pakistan, Chanhu-Daro
Indus Valley Civilization,
 ca. 2000 B.C.
Red hand-modeled terracotta
 with red painted decoration,
 6.4 cm.
The Brooklyn Museum 37.38;
 A. A. Healy Fund

These miniature items are from a group of
sixty-nine objects excavated at Chanhu-
Daro during 1935–36 by the joint expedi-
tion of the American School for Indic and
Iranian Studies and the Museum of Fine
Arts, Boston; the group was purchased by
The Brooklyn Museum in 1937.[1]

The toy whistle in the form of a dove
or a hen (cat. no. 6) is hollow, with a flat
base and a hole at the tail. Applied pellets
function as eyes and painted red lines of

7 Toy Cart with Two Wheels

Pakistan, Chanhu-Daro
Indus Valley Civilization,
 ca. 2500 B.C.
Red hand-modeled terracotta,
 4.5 x 19.0 x 7.5 cm.
*The Brooklyn Museum 37.103–105;
 A. A. Healy Fund*
(Illustrated in color on page 11)

uneven thickness represent feathers. The toy cart (cat. no. 7) demonstrates the level of technology of the period. The frame consists of a thick, curved rectangular slab of clay pierced with six holes on each side for sticks of wood, holes for a driving shaft, and a crosspiece to support removable wheels and the axle. The wheels are solid pottery, with projections around the holes on the inner side, probably to keep them from rubbing against the side of the cart. They

compare to wheels on similar carts found at Mohenjo-Daro.[2]

Notes:
1. See Marshall 1931, II, pp. 551, 554, and III, pl. CLIII, figs. 17 and 18, for comparable bird-shaped hollow objects identified as whistles and found at Mohenjo-Daro.
2. See Mackay 1943, pl. 58, nos. 21, 23, 25.

References:
Poster 1973, nos. 1 and 5.

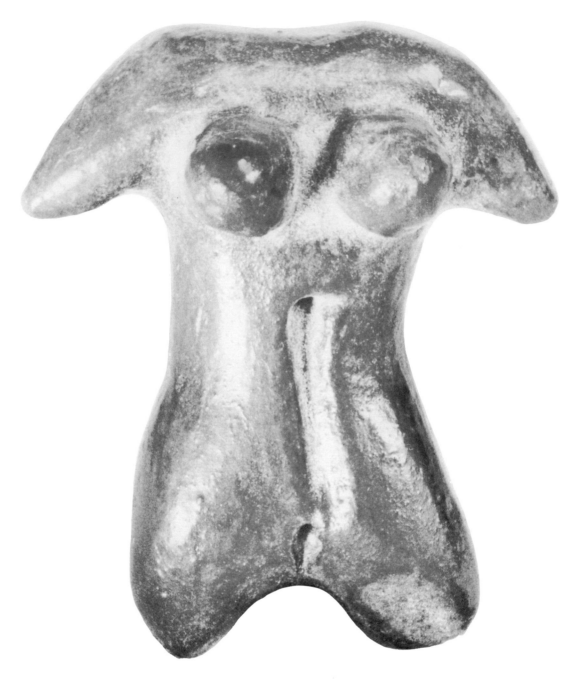

8 **Female Figure**
Inamgaon (Maharashtra)
Ca. 1300–1200 B.C.
Unfired clay, 4.0 cm.
Deccan College, Pune
(Replica of original in exhibition)

These clay models of a headless female figu-rine and a fragment of a bull figure were recently found in the Chalcolithic site at Inamgaon, an early farming settlement oc-cupied from circa 1600–700 B.C. and located near Pune. All of the Inamgaon fig-ures are crudely modeled, the bodies typi-cally flat, with stumpy arms and legs.

The post-Harappan period saw a de-cline in urban culture and simultaneously a decline in terracotta production. As a re-sult, few terracotta or clay figures have been

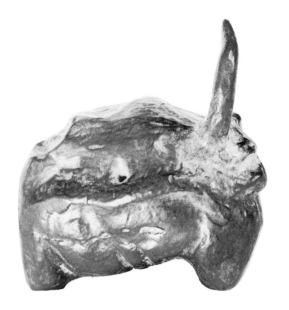

9　**Bull Figure**

Inamgaon (Maharashtra)
Ca. 1300–1200 B.C.
Unfired clay, 4.7 cm.
Deccan College, Pune
(Replica of original in exhibition)

found in excavated sites of this period. These two objects, discovered together in a corner of one of the excavated structures in the village, were made from the hard compact black clay of the region, even though, as M.K. Dhavalikar has observed, this material is unsuitable for making figurines.[1]

Dhavalikar, the chief excavator at Inamgaon, points out that the recent investigation at this site has yielded material of considerable importance—a number of the female figurines offer definite evidence of religious functions. The two most important were found, carefully deposited, in a small pit in the corner of a house. One, with a head, was kept in an oval clay box, and the other (cat. no. 8), without a head, sat on top of the box along with a bull (cat. no. 9). A clay ring served as a stand for keeping the figure upright. The bull has a hole in its back, and a similar hole appears in the belly of the female figurine without head.[2] This fact, together with the careful deposition of these objects, all made of black, unbaked clay, suggests that they were not playthings, but objects of ritual import for those who buried them. (In India today, clay figurines of gods and goddesses are made for occasional worship and are ritually immersed after the ceremony.)

While the mother-goddess *(matrika)* type was connected with fertility, it is not always easy to associate other early figurines with specific functions; they have been identified through the locations in which

they were discovered. For example, at Inamgaon, an isolated unevenly baked female figurine was found in the center of three large pit silos in a very large house with several rooms. Even today farmers in Andhra Pradesh place a mother-goddess clay figurine in the bin or silo and then store the grain in it—the idea being that the silo should always overflow with grain, something that the worship of the mother-goddess is meant to assure.

As the present works attest, bull figurines could have a direct relationship to those of the mother-goddess in Chalcolithic sites. When a stick is inserted in the holes in each piece, the mother-goddess sits snugly over the bull. Since the bull is symbolic of virility (see cat. no. 5) it should be seen as completing the fertility symbolism of the goddess—a quite common pairing in early cultures in India and West Asia. In fact, the two figures may constitute an early representation of a deity on its mount *(vahana),* a typical feature of later Hindu deities.

Notes:
1.　This entry is largely adopted from a longer unpublished essay on Deccan terracottas by M.K. Dhavalikar of Deccan College, Pune. We are grateful for Dr. Dhavalikar's permission to utilize a portion of his work and for his first-hand knowledge of the site at Inamgaon.
2.　Dhavalikar 1977, pp. 16, 49.

References:
Dhavalikar 1977, pl. 10; S.P. Gupta 1980, fig. 83b.

10 Female Figure

Nevasa (Maharashtra)
Ca. 1200 B.C.
Red hand-modeled terracotta,
 16.2 cm.
Deccan College, Pune
(Replica of original in exhibition)

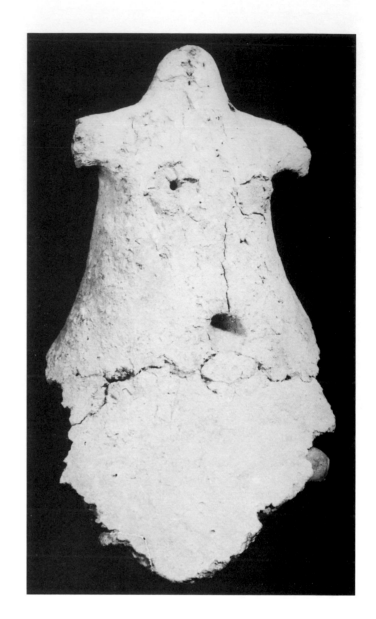

Some of the female terracotta figures from central or south Indian early farming communities (see cat. nos. 8 and 9) decorated the sides of huge storage jars, which again associates them with a fertility cult and identifies them as mother-goddesses. This figure from Nevasa has a wide tapering base and short stumpy hands, which makes it suitable for affixing to a jar.[1] Another from Bahal (Maharashtra) is quite flat and therefore might also have been applied to a storage jar. A storage jar from Inamgaon (Maharashtra) is adorned with a figure of a panther, an animal later associated with the mother-goddess. The tortoise on a jar from Prakash (Maharashtra) and the zoomorphic bottles from Nevasa and Chandoli (Maharashtra) are also relevant in this context.[2]

Although the only distinguishing female feature of the present fiddle-shaped figurine are the breasts, formed as pinched protrusions, there is no doubt about the gender. Lacking surface ornament, the shape is simply modeled into a crude flat piece consisting of a semicircular protuberance at one end representing the "head," two outstretched arms, the torso fanning outward and ending abruptly at wide hips, and a lower body.

Notes:
1. M.K. Dhavalikar provided this amplification of his earlier analysis.
2. Thapar 1967, pl. XVII, p. 12.

References:
Dhavalikar 1977, pl. 9; S.P. Gupta 1980, fig. 83a.

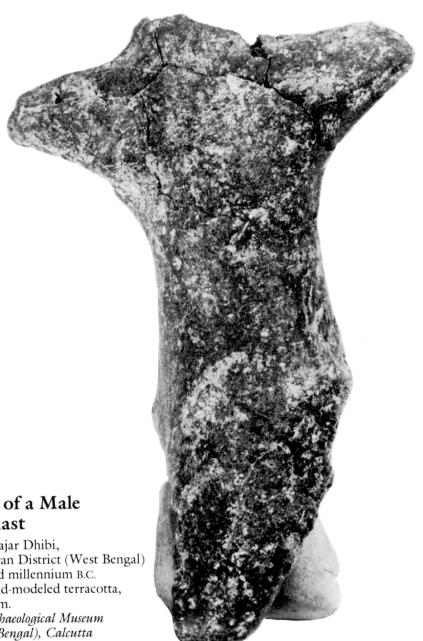

11 Torso of a Male Gymnast

Pandu Rajar Dhibi,
 Burdwan District (West Bengal)
Early 2nd millennium B.C.
Gray hand-modeled terracotta,
 10.0 cm.
*State Archaeological Museum
 (West Bengal), Calcutta*

One of the earliest terracotta figures from eastern India is this expressive torso of a male figure in the round. Discovered at Pandu Rajar Dhibi, it is dated on the basis of stratigraphic evidence to the second millennium B.C.[1]

Notes:
1. Biswas 1981, p. 29, refers to the site excavation report, 1962–65, for Period II, with other more typical Chalcolithic finds.

Reference:
Biswas 1981, pl. Ia.

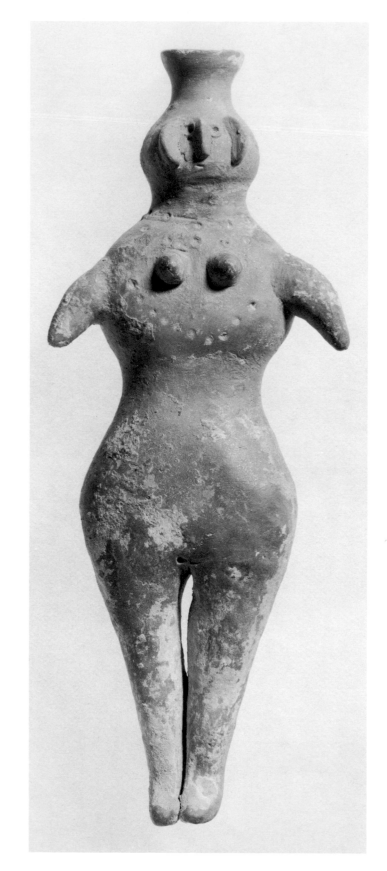

12 Female Figure

Pakistan, Swat Valley (?)
1st millennium B.C.
Red hand-modeled terracotta,
 23.5 cm.
*The Metropolitan Museum of Art,
 New York; Seymour Fund, 1984*

This abstracted female form is consonant
with similar figures identified as mother-
goddesses throughout the ancient world, as
well as in modern tribal and village Hindu
cultures in India and elsewhere. The vessel-
shaped head surmounts a large, solid hand-
formed torso with massive hips, small prom-
inent protruding breasts, short stumpy
arms, and long, tapering legs. The nose and
ears are applied, while the eyes and mouth
are incised. The nude figure's only orna-
mentation consists of pierced dots encir-
cling the breasts.[1]

Note:
1. For a comparable form, see Taddei 1970,
 pl. 21, identified as a terracotta figurine from a
 tomb at Katelai, Swat, Pakistan, now in the
 Museo Nazionale d'Arte Orientale, Rome.

84

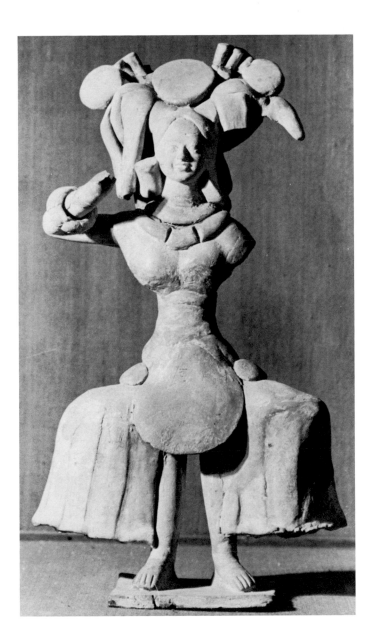

13 Dancing Female

Bulandibagh (Bihar)
Maurya period, ca. 320–200 B.C.
Red hand-modeled terracotta
 with molded face and applied
 ornaments, 27.5 cm.
Patna Museum, Patna
(Illustrated in color on page 12)
(Not in the exhibition)

detail. They are generally represented standing, with one arm raised and the other held akimbo at the waist. The innovative character of these figures in Indian terracotta art lies in their relatively large size (ranging from 22 to 28 cm.) and in the technique of combining molded and hand-formed parts. The face of this figurine, with its enigmatic smile and naturalistic details, is mold-made, while the body and applied ornaments are formed by hand.

The repeated, flat, disk-shaped ornaments worn in her hair and on her skirt contrast dramatically with the subtle planes of the torso and the wide, stiff, pleated garment. The baroque arrangement of hair ornaments and jewelry results from the integration of simple individual elements into geometrical patterns that are reminiscent of similar stylistic conventions seen in Indus Valley female figurines (see cat. no. 1). A visual comparison of Indus Valley and Bulandibagh female figurines suggests possible material, visual, and conceptual continuities, despite the absence of extant examples to link them.

The Bulandibagh figurines are often identified as dancers on the basis of their posture and costume.[2] Certainly the pose, with one arm raised and the other bent at the waist, suggests potential movement.

This graceful female figure is a fine example of the elegant style of the Bulandibagh horde. Located near Pataliputra (now Patna), the ancient capital of the Maurya dynasty, the site yielded a group of distinctive terracotta figurines in 1912–16. These figurines not only represent a vital artistic link between the civilizations of the Indus Valley and the Ganges Valley during the Maurya period but also reflect, in some of their stylistic features, the impact of Hellenistic art.[1]

The female figurines discovered at Bulandibagh are distinguished by their fine craftsmanship and profusion of naturalistic

Notes:
1. See Desai 1978, pp. 148–149.
2. Both Dhavalikar and Gupta, cited below, compare the lower garment to the stiff and elaborate modern costume of the Kathakali dancers of Kerala.

References:
Spooner in ASIAR 1920, pt. XVI. 4; C.C. Dasgupta 1961, pl. 61, p. 134; Shere 1961, no. 1, Dhavalikar 1977, pl. 20; S.P. Gupta 1980, pl. 81e, p. 159; Huntington 1985, p. 55, fig. 4.14; Poster 1985, p. 24.

14 Head of a Smiling Child

Bulandibagh (Bihar)
Maurya period, ca. 250 B.C.
Red molded terracotta,
12.5 x 11.0 x 6.5 cm.
Patna Museum, Patna

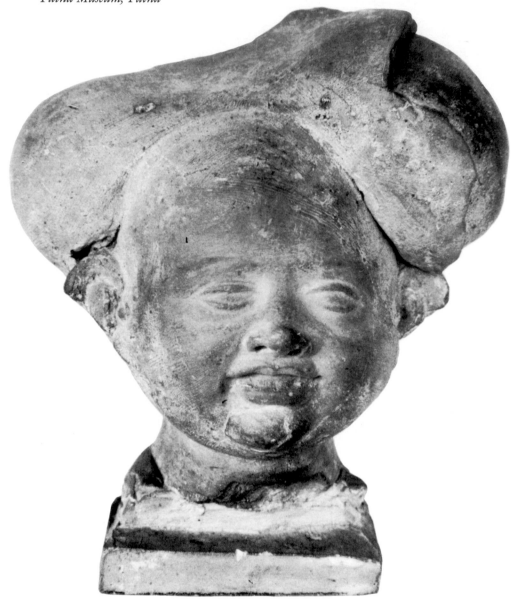

This child, with young fleshy cheeks and smiling lips that idealize the face, exemplifies a subject not widely known in earlier terracottas. Such careful attention to detail suggests that the face may have been intended as a portrait. As in other Bulandibagh terracottas, the face is molded, while the smooth, undulant, turbanlike headdress curving gently over the left forehead and tied at the back is rendered by appliqué technique. The well-defined ears are partially damaged.

References:
Shere 1961, no. 10; Dhavalikar 1977, pl. 23; S.P. Gupta 1980, fig. 19, p. 161.

15 Horse

Bulandibagh (Bihar)
Maurya period, ca. 320–200 B.C.
Red hand-modeled terracotta
 with applied ornaments,
 18.0 x 15.0 x 6.0 cm.
Patna Museum, Patna

The distinction between toys and votive animal figures in early terracottas is not often clear. Although frequently called toys, such figures as the Bulandibagh horse bear a striking resemblance to terracotta horses made in some Indian villages today as offerings to protective village deities.

This Bulandibagh horse is hand-modeled with stamped, incised, and appliqué decoration in a manner similar to human figures of the same region and date (see cat. nos. 13 and 14). The mane, various details of the bridle, and the garland around the horse's neck are clearly articulated. The holes at the bottom of the legs may indicate that sticks were inserted to support wheels. This is one of a variety of Bulandibagh animal figures—including birds, roosters, mongooses, and an elephant—whose details have been added with a painted slip (see cat. no. 22 for a Maurya example from Kaushambi).

References:
Shere 1961, no. 12; Dhavalikar 1977, pl. 26B.

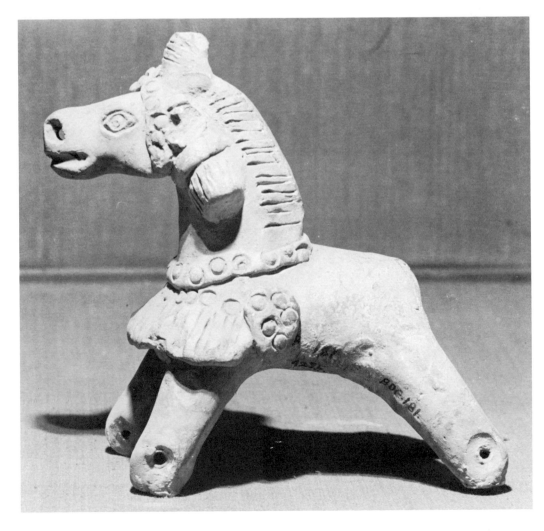

16 Seated Ascetic

Patna (Bihar)
Maurya or Shunga period,
 ca. 200 B.C.
Red hand-modeled terracotta,
 12.2 cm.
Patna Museum, Patna

Ascetics are represented in Indian art throughout its history, in pieces from the Indus Valley Civilization and in such celebrated examples as the Gupta-period terracotta relief tiles from Harwan (Kashmir) (see cat. nos. 63–65).

 This ascetic, seated on a flat plinth, has an unidentified object in front of him. He is modeled in the round, and his torso is hollow. Part of the original earrings remains on his shoulders. His posture reflects the emphasis on physical control characteristic of figures seeking enlightenment in the meditative lotus position. This figure relates stylistically to two other male terracotta figures in the Patna Museum, there identified as unspecified religious figures.[1] They are nude, a characteristic of their ascetic religious nature, but wear jeweled belts and loose collars.

Note:
1. C.C. Dasgupta 1961, p. 135.

Reference:
Shere 1961, no. 13.

This seated ascetic, bent over with his rib-cage emphatically delineated at the back, shows how appropriate a medium clay is for the portrayal of a supple figure. Typical of Mathura terracotta figures of the period, the face is molded, while the body is hand-formed. Careful examination reveals that the figure was constructed in two parts rather than from one long piece.

Few terracotta male figures from the Mathura region are known. The present figure, however, is not a unique type. A similar male figure, holding a bowl and seated on a stool, is in the Government Museum, Mathura.[1] Unlike the Brooklyn terracotta ascetic—nude and with shaved head—the bearded Mathura Museum figure is dressed in a *dhoti* with an animal skin draped over his left shoulder and his hair formed in rows of curls. This piece is generally considered to be of Shunga date, even though it has the characteristically Maurya-style molded face and hand-modeled body. It has been described as a foreigner; no connections to religious rituals have been suggested.[2] (Both figures are surface finds.)

Notes:
1. See R.C. Sharma 1976, fig. 8.
2. See R.C. Sharma 1972, p. 148.

Reference:
Fisher 1982, p. 40.

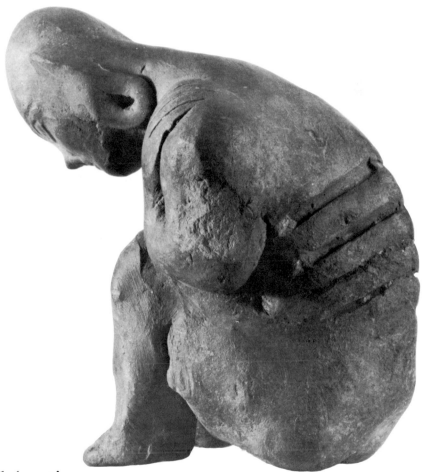

17 **Seated Ascetic**
Mathura region (Uttar Pradesh)
Maurya period, ca. 320–200 B.C.
Gray hand-modeled terracotta
 with molded face, 8.2 x 7.0 cm.
*Collection of Dr. Bertram Schaffner;
 on loan to The Brooklyn Museum*

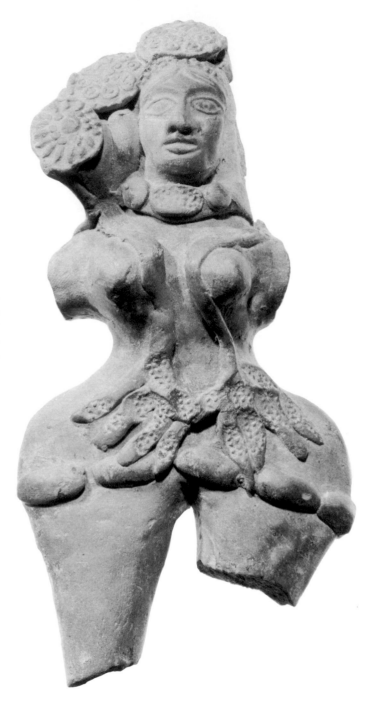

This highly stylized female figurine (cat. no. 18) and related head of a goddess (cat. no. 19) are typical of the gray Maurya terracottas from Mathura, which have molded faces and high cheekbones, almond-shaped eyes, arched brow ridges, and hand-modeled flat, fiddle-shaped torsos. The figure, with both arms and the left leg broken off, has protruding breasts, a narrow waist, and broad hips. Its ornaments consist of a headdress with stamped rosettes, large earrings (only on the right side), a necklace, a long garland with stamped petal-shaped ornaments, and a girdle made of a row of applied lozenge shapes. The back is flat and undecorated except for strips of clay applied to indicate hair plaits.

Such figures have usually been identified as mother-goddesses *(matrikas)*; their existence in large numbers in Mathura has encouraged speculation that a cult of female fertility figures was widespread during the Maurya period.[1] There is little substantive evidence to support this theory, but the rich ornamentation strongly suggests an auspicious character continuous with earlier female figurines from the Indus Valley (see cat. nos. 1 and 2).

(Cat. no. 18 was submitted to thermoluminescence analysis in 1984. None of the attachments have been reglued; all are parts of the original terracotta.)

Note:
1. Desai 1975, pp. 10-12; S.K. Srivastava 1979, chap. 2.

References:
(Cat. no. 19) Coomaraswamy 1927, p. 92, fig. 5; Coomaraswamy 1928, fig. 18; Boston 1977, no. 21.

18 **Female Figure**
Mathura region (Uttar Pradesh)
Maurya period, ca. 320–200 B.C.
Gray hand-modeled terracotta
 with molded face and stamped and
 applied ornaments, 17.8 x 8.8 cm.
Collection of Dr. Bertram Schaffner;
 on loan to The Brooklyn Museum
(Illustrated in color on page 13)

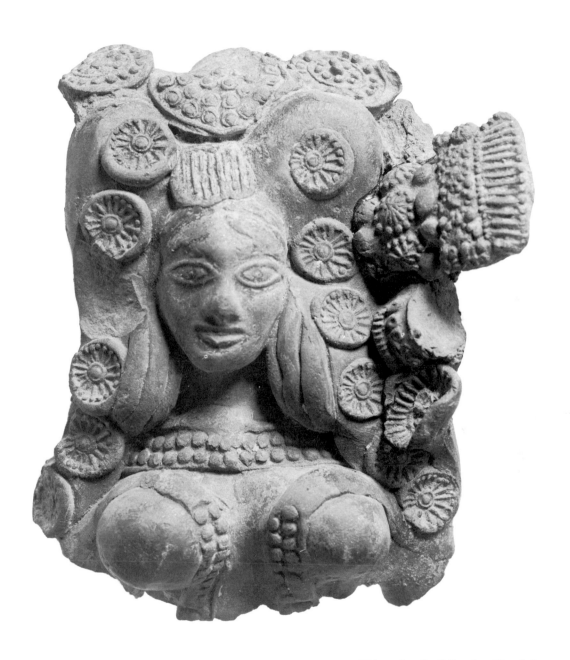

19 **Head of a Nude Goddess**
Mathura (Uttar Pradesh)
Maurya period, ca. 320–200 B.C.
Gray hand-modeled terracotta
 with molded face and stamped and
 applied ornaments, 10.3 cm.
Museum of Fine Arts, Boston;
 Harriet Otis Cruft Fund

20 Female Figure

Uttar Pradesh
Maurya period, ca. 320–200 B.C.
Gray hand-modeled terracotta
 with molded face and stamped
 and applied ornaments,
 29.7 x 11.0 cm.
The Brooklyn Museum 84.200;
 Anonymous gift

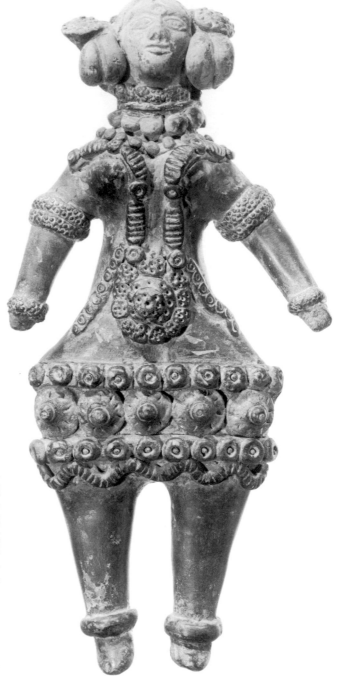

This nude female figure has a torso of ex-
aggerated length emphasized by stamped
and rolled appliqué ornaments and a bur-
nished slip surface. Her head is raised, and
she has high prominent breasts, a long
slender waist, wide fiddle-shaped hips, and
straight legs. Her molded face has a fore-
head mark, an unusual addition to the char-
acteristic Maurya decoration.

 The components of the ornamenta-
tion are far more complex than those on the
usual Maurya-period figure from Mathura
(see cat. no. 18). The most prominent or-
nament is the girdle, which consists of four
rows of stylized applied rosettes of varied
size. There are three necklaces instead of the
usual one, two armlets, and a particularly
intricate pendant. On the reverse side are
three plaits of long braids.

 (A thermoluminescence test done
on a sample of the torso in 1984 showed the
piece to be authentic. However, the attached
ornaments were not tested, and their un-
usual form has yet to be explained.)

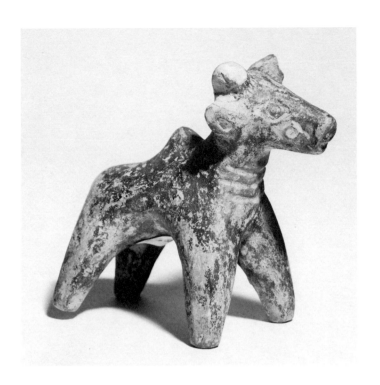

21 Bull Figure

Uttar Pradesh
Maurya period, ca. 320–200 B.C.
Gray hand-modeled terracotta
 with burnished black slip
 surface, 9.5 cm.
*The Brooklyn Museum 73.99.53;
 Gift of Dr. Bertram Schaffner*

This modeled figure represents a bull with its hump and horns, the latter now missing. The facial details—diamond-shaped eyes and mouth—are incised, and three additional incised lines appear at the neck. The figure's lively style recalls the earliest terracotta bull images (see cat. no. 5) and thus documents the continuous tradition of terracotta animal sculpture in India.

22 Head of an Elephant

Uttar Pradesh
Maurya period, ca. 320–200 B.C.
Gray hand-modeled terracotta
 with black slip and reddish-tan
 polychrome, 6.3 x 7.5 cm.
Collection of Samuel Eilenberg

This hand-modeled elephant's head has large tusks, a trunk with down-curved snout, two beadlike eyes, and flat, squared-off ears. Although images with a burnished surface are common (see cat. no. 21), few Maurya terracotta objects with such a slip (made of finely grained clay) have been found.[1] In this case, the artist used two colors, painting light reddish-tan stripes over the shining black surface.

Note:
1. For comparable examples from Kaushambi, see Kala 1980, figs. 223, 224, 268. Kala also mentions an example excavated at a Mathura site, assignable to the period circa 300–200 B.C.

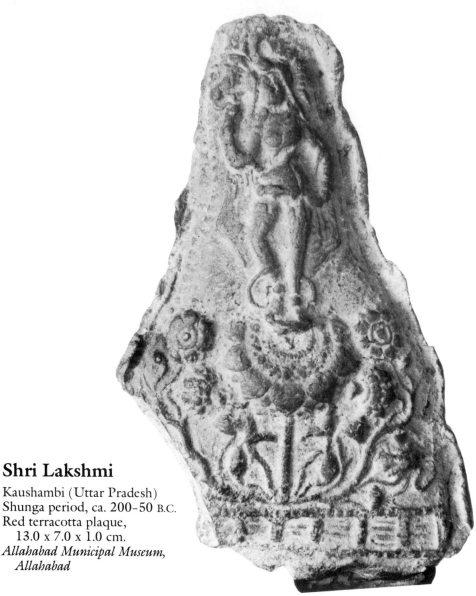

23 Shri Lakshmi

Kaushambi (Uttar Pradesh)
Shunga period, ca. 200–50 B.C.
Red terracotta plaque,
 13.0 x 7.0 x 1.0 cm.
*Allahabad Municipal Museum,
Allahabad*

By the Shunga era, a variety of iconographically distinctive goddess types had appeared in terracotta art. Shri Lakshmi, the goddess of good fortune and prosperity, is the subject of this charming plaque. Lakshmi plaques in terracotta are among the most common finds from this period throughout the Ganges River Valley, other gods and goddesses being less frequently depicted. Here Shri Lakshmi emerges from a pool, as she symbolically stands on a full-blown lotus. In other terracotta plaques of the period, this goddess is often shown with two elephants who bathe her with water from vessels held in their trunks. Her association with water is further emphasized by the lotus in her right hand.

Kaushambi, where this plaque is from, is located on the Yamuna River southwest of Allahabad. The site was one of northern India's principal centers from the sixth century B.C., and excavated terracotta remains reveal a dynamic and culturally advanced civilization during the Shunga period. Flat molded plaques were used for the depiction of many subjects in a skillful style marked by simple compositions and intricate details of dress, headdress, and jewelry. Compositions feature either frontal figures of deities, as here, or secular groups in poses taken from everyday life.

Reference:
Kala 1983, fig. 69, p. 31.

94

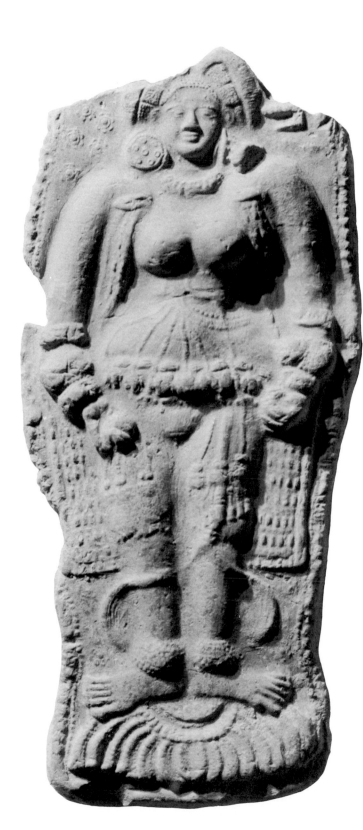

24 **Shri Lakshmi**

Kaushambi (Uttar Pradesh)
Shunga period, ca. 200–50 B.C.
Red modeled terracotta plaque,
23.0 x 10.5 x 2.0 cm.
Collection of G. K. Kanoria

Here Shri Lakshmi stands on a lotus with
her arms by her sides, the rigid pose noted
on Kaushambi plaques depicting the god-
dess (see cat. no. 23). Her ample form and
the details associated with the lotus convey
abundance and auspiciousness, attributes
of the goddess.[1]

Like cat. no. 23, the plaque exhibits
stylistic features of Kaushambi terracottas,
such as the rigid swirl of drapery at the
figure's ankles and the pendant jewel ele-
ments emphasizing the belly.

Note:
1. For a comparable plaque, see Dhavalikar 1977,
 pl. 30.

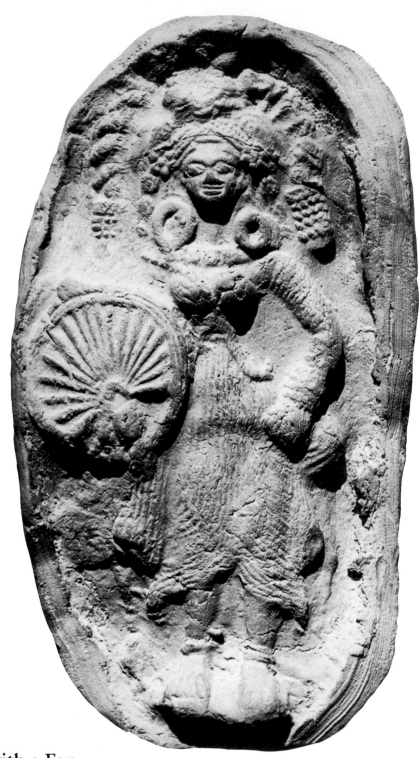

25 Goddess with a Fan

Mathura (Uttar Pradesh)
Shunga period, ca. 200–50 B.C.
Red molded terracotta,
 18.0 x 10.0 x 3.5 cm.
Government Museum, Mathura

26 Goddess with a Fan

Mathura (Uttar Pradesh)
Shunga period, ca. 200–50 B.C.
Red molded terracotta,
 18.0 x 10.4 x 4.0 cm.
Collection of Robert H. Ellsworth

In contrast to the more conventionally stylized Maurya-period figurine, this Shunga female type—generally depicted with a fan, parrot, or mirror—has sometimes been said to portray a character from secular life. However, secular and religious boundaries in Indian art are often blurred, and this female type probably has a religious dimension.[1] Because she wears in her headdress the symbolic hairpins *(panchachuda)* associated with the goddess Lakshmi, she has been identified as a nature divinity, Apsaras Panchachuda.[2] The two plaques here are almost identical; they appear to have come from the same mold. The artist's fingerprints on the border of the Ellsworth plaque (cat. no. 26) serve as a signature.

The rhythmic energy of these depictions of Apsaras, the celestial nymph, is derived from an integration of formal and symbolic elements. Through the layering and repetition of linear details, the isolated standing image becomes a composite symbol of regenerative growth. The fan on the left defines the circular theme of the composition, which is repeated in the headdress, bristling with jewels, the weapon-shaped *panchacuda,* and the palm fronds. The large, pronounced earrings make a complementary focal point. The linear aspect of the taut fan and headdress sets off the modeling of the torso, which is revealed under the closely draped and pleated garment.

A comparison of Mathura Shunga terracottas with those produced contemporaneously at other centers along the Ganges River, such as Kaushambi or Chandraketugarh, reveals a distinctive physiognomy and an affinity to figures on stone sculpture from the same region. By contrast, a fragmentary plaque from Kaushambi, depicting the torso of a woman holding a fan, emphasizes sculptural form,[3] and complex surface overlay dominates plaques from Chandraketugarh (see cat. nos. 30, 32, 35, 37, and 39).[4]

Notes:
1. Desai 1975, p. 16.
2. Kramrisch 1939, ed. 1983, pp. 75-76. Kramrisch's discussion revolves around this piece and other terracotta plaques of the same period discovered at Kaushambi.
3. See Kala 1980, fig. 93. Kala has noted elsewhere (1950, p. 35) that female figures holding fly whisks, fans, or other objects may represent attendant figures. Such figures occur either independently or flanking central figures of deities.
4. The regional aspect of Shunga-period terracottas and their comparison to the jeweler's art is discussed in Kala 1980, p. 5.

97

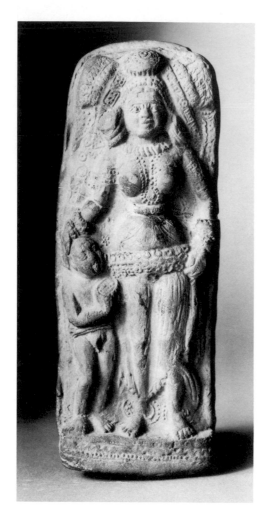

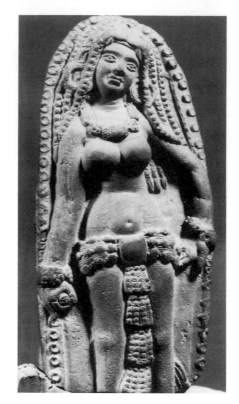

28 Female Figure

Dig (Rajasthan)
Shunga period, ca. 200–50 B.C.
Red molded terracotta, 12.7 cm.
Government Museum, Mathura

27 Standing Female and Attendant

Mathura or Kaushambi
 (Uttar Pradesh)
Shunga period, ca. 200–50 B.C.
Red molded terracotta plaque,
 15.0 cm.
*Private Collection; on loan to
The Brooklyn Museum*

The standing female with a diminutive male attendant is a standard Shunga terracotta type. This finely detailed example is elaborately dressed in an ankle-length garment belted at the waist and accentuated with a girdle at the hips. She wears a bicornate headdress covered with strands of beads, a style typical of the period. The male holds an unidentified object, perhaps an offering to the female. Other Shunga plaques from the same region show the male carrying a mirror, fan, or other object.

This graceful standing female is completely molded. Use of the mold to form terracotta images is known from as early as the Maurya period, when faces were pressed out of prepared molds and the remaining body was hand-modeled (see cat. nos. 17–20). Among the molded terracotta plaques found throughout central and eastern India in this period, representations of standing females holding plants, weapons, or other objects are the most common type.

The nudity of the figure, molded in high relief, is further accentuated by the jeweled veil and girdle. The articulated elements of the necklace, girdle, and bracelets, and the long, flowing decorated strands of hair under the long veil frame a full-breasted figure, resulting in a unified depiction of the auspicious female, symbolic of earth's fertile, maternal character.

Reference:
R.C. Sharma 1976, fig. 9.

29 Mithuna Couple

Mathura region (?) (Uttar Pradesh)
Shunga period, ca. 200–50 B.C.
Molded terracotta plaque,
 11.0 x 7.0 cm.
Collection of G. K. Kanoria

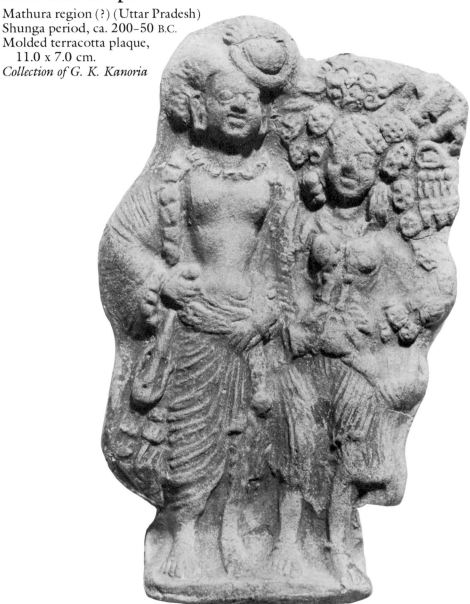

The male and female shown as a couple *(mithuna)* symbolize fertility and abundance. If one of the figures wears sacred ornaments—such as the *panchachuda* hairpins in the floriate headdress of the female here (see also cat. nos. 25 and 26)—it indicates divine status. Thus this female divinity and her male partner may have had a votive function.[1]

In this plaque, the figures are posed in the traditional grouping seen, for example, in the monumental sculpture of a couple at the Buddhist rock-cut site at Karle—standing together each with a hand on hip. The male shows conventional Shunga features: an asymmetrical turban, an upper scarf, and a *dhoti* wrapped with a knotted sash, as well as the necklace and other jewelry that represent a richly appointed male. The female, in turn, is covered with elaborate ornaments, jewelry, and closely fitted drapery.

Note:
1. See Desai 1975, p. 13.

99

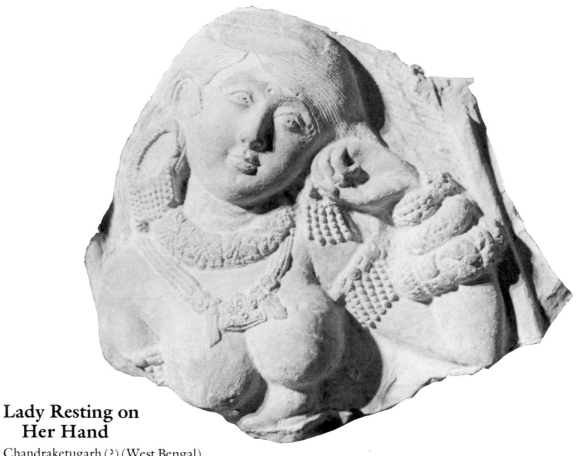

30 Lady Resting on Her Hand

Chandraketugarh (?) (West Bengal)
Shunga period, ca. 200–50 B.C.
White molded terracotta plaque,
 3.0 x 10.0 x 2.5 cm.
Collection of G. K. Kanoria

Supple and personal in style, this outstanding plaque fragment of a richly adorned young woman reflects ideals of feminine beauty, as well as contemporary fashion.[1] The pose suggests the imagery of Sanskrit love poetry, in which the longing woman waits for her lover. A lady with her cheek resting on her hand is a convention in such poetry, as in this description of the heroine Shakuntala's yearning for her husband by the Gupta-period poet Kalidasa:

> With her face resting on her
> hand, our dear friend looks
> like a picture. She is thinking
> about her husband's leaving,
> with no thought for herself.[2]

This plaque is closely related to finds at Chandraketugarh, an excavated site in eastern India northeast of Calcutta. Although molded terracotta plaques from the Shunga period are found throughout central and eastern India, those from this region are distinguished by a subtle modeling of flesh and a profusion of surface detail. Considerable skill is evident here in the minutely carved details of the jewelry, face, and hair, in the movement of the figure expressed by her raised arm, in the tender facial expression, and in the extraordinary variety of bangles, pearled armlets, necklaces, and earrings. Female plaques of the period found at Kaushambi and Mathura seem rigid by comparison.

Notes:
1. For a discussion of the various types of jewelry represented in Shunga-period terracotta plaques from sites in eastern India, see Biswas 1981, pp. 119–129.
2. Ed. Miller 1984, p. 123.

31 Yakshi with Panchachuda

Berachampa (West Bengal)
Shunga period, ca. 200–50 B.C.
Molded terracotta plaque,
9.5 x 10.3 x 2.2 cm.
*Asutosh Museum of Indian Art,
Calcutta University*

32 Yakshi with Panchachuda

Chandraketugarh (?)
(West Bengal)
Shunga period, ca. 200–50 B.C.
Molded terracotta plaque,
4.5 x 9.0 x 2.5 cm.
Collection of G. K. Kanoria

These two fragments of plaques depict *yakshis,* auspicious females associated with the power of nature. They wear rich ornaments, including the five emblematic hairpins *(panchachuda)* associated with the goddess Lakshmi. The jewelry is also precisely delineated: on one plaque (cat. no. 31), bands of alternating symbols *(shrivatsa)* and open six-petaled flowers are repeated in the hair ornament, on the ear plug at the right ear, and as the border decoration; on the other (cat. no. 32), the hairpins depicted on both sides of the headdress radiate from rounded chignons and are held in place by a faceted band that is wrapped at the forehead and surmounted by a large rosette at the top center.

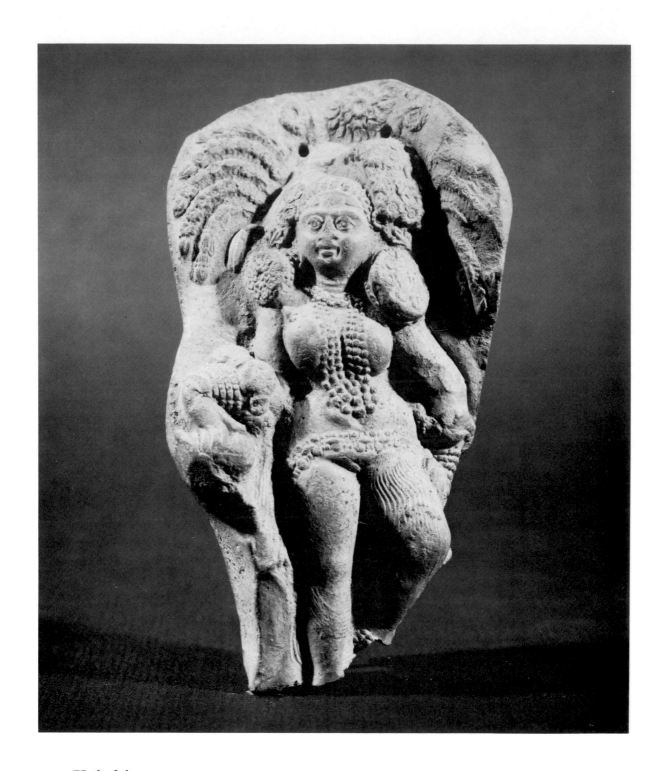

33 **Yakshi**

North or eastern India
Late Shunga period, 1st century B.C.
Red molded terracotta plaque,
 11.5 cm.
The Cleveland Museum of Art;
 Gift of Eleanor and Morris Everett

102

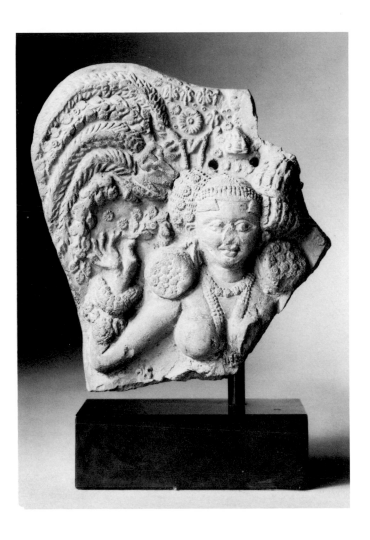

34 Yakshi

North or eastern India
Late Shunga period, 1st century B.C.
Red molded terracotta plaque,
 12.0 cm.
Private Collection
(Illustrated in color on page 14)

The style of ornamentation on these *yakshis* shows eastern Indian terracotta conventions (see cat. nos. 30–32). The facial type—eyes wide open and cheeks full—as well as the naturalism of the posture and forms, especially the full breasts and the rounded belly and thighs, demonstrates how universal the mode of representing the goddess in terracotta was throughout the artistic centers of the Shunga period in the upper Ganges Valley, including Kaushambi (cat. no. 24) and Dig (cat. no. 28), and in eastern India.

As one examines the facial features, the ornamentation that emphasizes the weight of enormous circular earrings and pearl necklaces, the leaf and garland fronds, and the modeling of the figures, a late Shunga female type becomes apparent. Plump bodies with elaborate condensed detail convey the energy of the auspicious fertility goddess. The fronds behind the figures, which relate the subject to tree goddesses *(shalabhanjikas),* are similar to those on contemporaneous plaques from Kaushambi.[1]

The second plaque (cat. no. 34), broken off above the waist, has a more ornate headdress than the first, with flowers, decorated plaits of hair, and sacred *panchachuda* symbols. The figure's right arm is raised to pluck a flower petal between her thumb and forefinger. Two holes at the top of the plaque are thought to be intended for mounting it on a wall.

Note:
1. Poster 1973, no. 27.

References:
(Cat. no. 33) *Bulletin of the Cleveland Museum of Art,* 61 (1974), fig. 177; (cat. no. 34) Neven 1980, no. 5.

35 Enshrined Goddess and Attendants

Chandraketugarh (West Bengal)
1st century B.C.
Molded terracotta plaque, 13.3 cm.
*State Archaeological Museum
(West Bengal), Calcutta*

The upper portion of this relief plaque depicts an enshrined goddess flanked by two female attendants, one holding an umbrella above the goddess's head and the other holding a fly whisk.[1] The divine status of the unidentified goddess is indicated by the hairpin *(panchachuda)* implements worn in her bicornate headdress; the umbrella and fly whisk are also divine insignia.[2] The three figures stand in the architectural framework of a decorated pavilion that may indicate the style of contemporaneous religious architecture; the building type appears in another plaque from the site (cat. no. 36). In the present work, the shrine is framed by two pillars decorated with chains of beads and surmounted by addorsed animal-shaped capitals; above is a flat roof with repeated triangular parapet elements. The profusion of pearl beads and chains gives the entire relief a shimmering quality that resembles the form and style of jewelry designs from Bengal that were popular in the nineteenth century.[3]

Notes:
1. Biswas 1981, pl. XXVI, suggests that the subject may represent an ancient Jain legend of Vapra, whose startling beauty halted an invading army; the army capitulated, predicting that she would be the mother of a saint, the Tirthankara Neminatha.
2. The goddess with *panchachuda* in her hair and two attendants with umbrella and fly whisk also appears in earlier Shunga molded terracotta plaques from Kaushambi; see Poster 1973, no. 27.
3. See London 1979, no. 211, pl. xiii, for a necklace formed of pendant chains of pearls and gems.

Reference:
Biswas 1981, pl. XXVI.

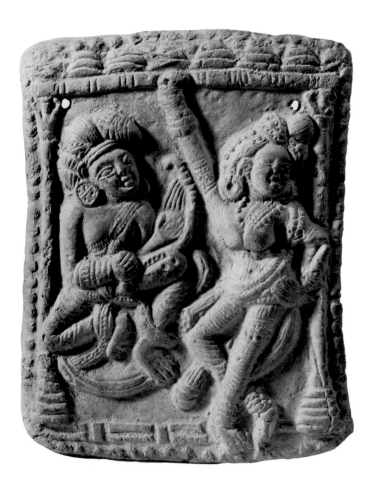

36 Dancer and Musician

Eastern India
1st century B.C.
Red molded terracotta plaque
 with applied ornaments,
 12.7 x 9.2 cm.
Collection of Samuel Eilenberg;
 on loan to The Brooklyn Museum

The couples depicted in Shunga-period plaques do not always signify a religious or ritual function. Terracottas often show scenes of the favorite pastimes of the cultured population. The Eilenberg plaque (cat. no. 36), for example, presents a secularized version of a ritual theme.[1] This courtly and erotic scene, like others from Chandraketugarh, shows a male musician playing the Indian lute, or *vina,* to accompany a lady's dance.[2] Although richly attired, the figures do not maintain the gestures or wear the ornaments generally associated with sacred terracotta plaques. The pavilion setting evokes the distinctive roof-and-pillar construction of contemporaneous architecture (see cat. no. 35).

The plaque fragment (cat. no. 37) shows a head and upper portion of a male figure with his left arm raised. The type of turban differs here, possibly indicating the figure's occupation or a local variation of turban types. The piece is from Chandraketugarh and is probably a fragment of another narrative theme as yet unidentified.

Notes:
1. See Desai 1975, pp. 14–17.
2. For two similar plaques, see Biswas 1981, pl. XLIXd and e.

Reference:
(Cat. no. 37) Biswas 1981, pl. XXXVa, p. 172.

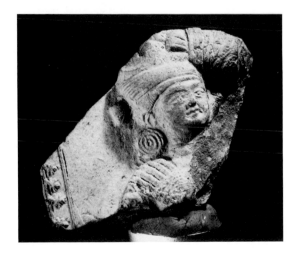

37 Male Figure

Chandraketugarh (West Bengal)
1st century B.C.–1st century A.D.
Molded terracotta plaque, 5.5 cm.
State Archaeological Museum
 (West Bengal), Calcutta

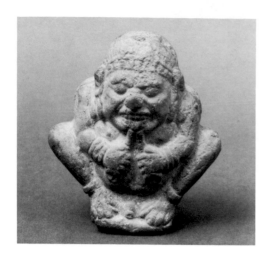

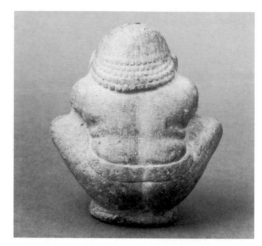

38 Crouching Demon Dwarf

North India
Shunga period or later,
 2nd century B.C.–2nd century A.D.
Double-molded terracotta, 10.2 cm.
The Cleveland Museum of Art;
 Purchase, John L. Severance Fund

The crouching demon *(rakshasha)* relates to a large group of demon figures molded in the round from such sites as Kaushambi, Bhita, and Chandraketugarh.[1] The figure here (cat. no. 38) shows a pot-bellied demon with a fierce facial expression, round eyes, and lips open to reveal its teeth. The demon dwarf is sometimes shown devouring an animal or, as here, holding a double pipe to his mouth.[2] The features of the head are exaggerated to contrast with the squat body. This type is known from numerous examples, some in the form of a cart.

The pot-bellied nude male from Chandraketugarh (cat. no. 39) represents a *yaksha* seated on a low stool and holding an unidentified object in his right hand. His extensive jewelry, high headdress, and decorative trappings suggest the god Kubera, chief guardian of the earth's treasures.[3] Although stylistically related to *yaksha* images of the Shunga period, the figure is dated to the second century A.D. on the basis of excavation findings that revealed terracottas from Kushan-period levels at the site.[4] The hollow figure is one of many examples that are sometimes described as rattles and variously dated from the second century B.C. to the second century A.D.[5]

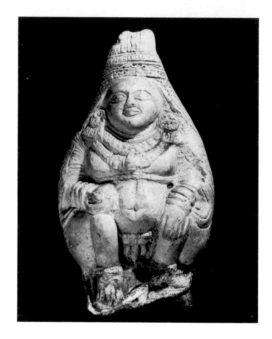

39 Seated Yaksha

Chandraketugarh (West Bengal)
Kushan period, ca. 100 A.D.
Double-molded terracotta, 13.5 cm.
State Archaeological Museum
 (West Bengal), Calcutta

Notes:
1. See Biswas 1981, pl. LIV and p. 188.
2. See Kala 1980, pp. 53–55.
3. See also Biswas 1981, pl. XV and p. 81.
4. See *Indian Archaeology: A Review*, 1956–57, p. 30, and *Lalit Kala*, 6 (1959), pl. XVI, fig. 18.
5. Other similar terracotta figures have been found at Basarh, Kaushambi, etc.; see Boston 1970, p. 28, for additional citations.

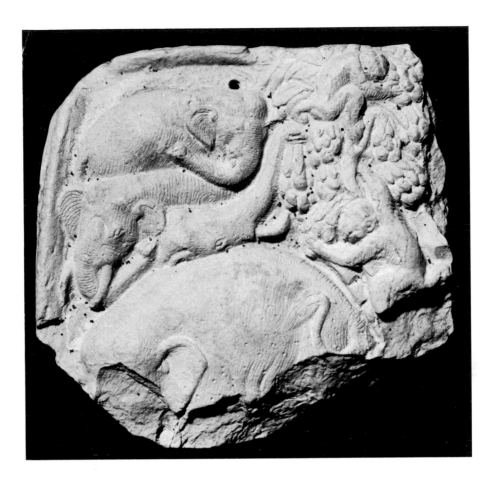

40　Chaddanta Jataka

Eastern India
Shunga period, 1st century B.C.
Molded terracotta, 8.7 x 6.7 x 1.8 cm.
Asutosh Museum of Indian Art,
*　Calcutta University*

This plaque with elephants in a lotus pond is an important example of the manner in which narrative is presented in Shunga-period molded terracotta plaques. The composition is extremely well planned, with four elephants in alternating right and left profiles. To the right, two monkeys climbing a tree function as a decorative leitmotif (see cat. no. 4 for the treatment of a monkey in the Indus Valley Civilization).

　　The plaque is believed to have come from either Tamluk or Chandraketugarh, two of the principal sites for Shunga terracotta plaques in eastern India.[1] It has been described as a representation of the *Chaddanta Jataka,* which relates Buddha's previous life as a white, six-tusked elephant. This story has been suggested here through the depiction of a herd of elephants of which the Buddha was the leader. The sensuous rhythm of the animal contours and the compositional arrangement link the plaque to several large contemporaneous stone reliefs, such as a panel of the *stupa* railing at Bharhut (circa 150 B.C.).[2] In the Bharhut example, four elephants are shown accompanied by a male figure holding the sacred tusk.

Notes:
1.　See Biswas 1981, pl. XXIXa, and *Great Centres of Art,* fig. 51a, for these respective attributions.
2.　For the relief, which is inscribed as *"Chadantiya jatakam,"* see Coomaraswamy 1956, fig. 72.

References:
Great Centres of Art, fig. 51a; Biswas 1981, pl. XXIXa.

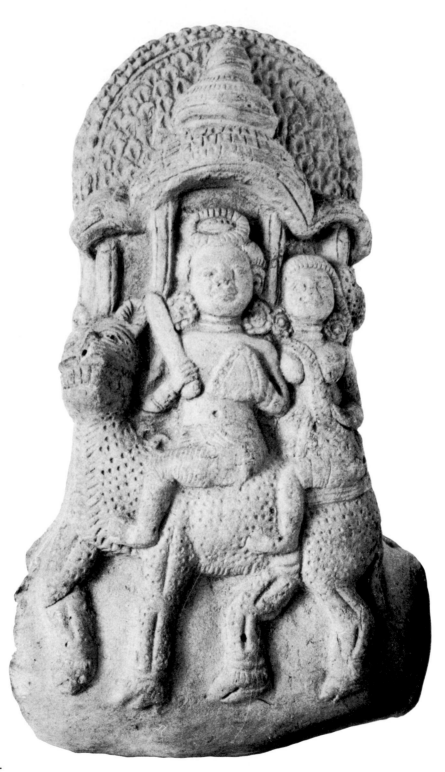

41 Toy Cart
Chandraketugarh (West Bengal)
Shunga-Kushan periods
Molded terracotta, 16.8 cm.
Asutosh Museum of Indian Art,
 Calcutta University

Enter Radanika holding a little boy
Radanika: Come, my child,
Let's play for a bit with your
little cart.
Rohasena (whining): I don't
want to play with a clay cart.
Give me my golden cart![1]

This passage from *The Little Clay Cart,* a fourth-century play by Sudraka, is one of the earliest literary references to the use of clay carts as toys in ancient India. Miniature carts, such as the type represented in cat. no. 7, appear to have been common in the repertoire of Indian terracottas at an even earlier date.

The toy cart has undergone technological and artistic changes throughout the history of Indian terracotta art. Technically more complex than those of the Indus Valley Civilization, the toy carts of the early historical period in the Ganges Valley combine both molding and hand-modeling techniques, their surfaces decorated with ornate compositions. They are classified into the following three general types, which can be dated from the second century B.C. on: fully molded figures often shown mounted on animals; carts made with multiple-piece molds and usually depicting horses, rams, or bullocks; and carts with molded interiors shown from above. The perspective of the third type is an innovation of this period, its realistic depiction of objects and figures inside the cart presenting a "narrative"

approach to relief. Each type usually has a transverse hole for the insertion of a stick to attach two clay wheels or to push the cart; many molded terracotta wheels have also been recovered.

The Asutosh toy cart (cat. no. 41), impressed with a complex design of a regally posed male riding with his consort behind him on a four-legged animal, is a fine example of the first type. The male holds an upright sword and another, unidentified object. He and his consort are heavily ornamented, and she wears a garland across her chest. A canopy shaped like a multi-tiered temple spire covers both figures, suggesting that they are riding in a processional cart.[2]

The Shunga-period double-molded male figure (cat. no. 42) is also of the first type, constructed with holes for a tube to be inserted as an axle. The image depicts the Hindu deity Karttikeya, here represented in his common form as half-man, half-peacock. The peacock tail feathers form a graceful base for the figure. Demonstrating the provenance for this object is not as simple as identifying its subject. The predilection of the artist for surface embellishment (such as the rows of beaded decoration for the bangles, armlets, and sash) may indicate an eastern Indian source, such as Tamluk or Chandraketugarh, but the type of toy cart with a deity on an animal vehicle occurs at other sites during the Shunga period, such as Kaushambi, where the ornamentation and style confirm its origin.[3]

42　**Toy Cart**

Eastern India (?)
Shunga period, ca. 100 B.C.
Double-molded terracotta,
14.0 x 9.0 cm.
Collection of S. Neotia

43 Toy Cart

Kaushambi (Uttar Pradesh)
Shunga period, ca. 100 B.C.
Multi-piece molded terracotta,
10.0 x 10.0 cm.
Collection of Samuel Eilenberg

The second type of toy cart, that made with multiple-piece molds, is perhaps the most common and is found at sites throughout the Ganges Valley. A complete cart of this type from Kaushambi (cat. no. 43) presents four richly caparisoned horses in frontal relief.[4] It is a molded three-sided chariot thought to replicate actual carts of the period even to the rich surface decoration, here represented as stamped flowers covering the surface of the side panels.[5] These flowers follow typical decorative conventions, particularly the garland around the yoke and the stylized rosettes strewn throughout the background of all the sides.

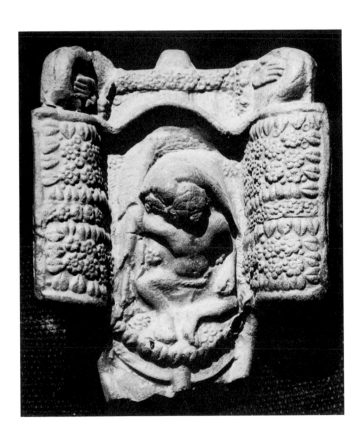

44 Man Seated in Cart

Karra Kerhdev, Mathura
(Uttar Pradesh)
Shunga period, ca. 100 B.C.
Molded terracotta, 8.8 x 8.8 cm.
Government Museum, Mathura

The Mathura plaque (cat. no. 44)—the third type—is especially interesting in that it portrays a narrative interior scene. A male figure is shown from above seated in a decorated cart covered with a pattern of flowers and leaves. A garland is draped across the rear of the cart, where there appears on each of the rear axles the unusual motif of an embossed human hand. The male figure wears the typical Shunga-period turban arranged on one side of the head and a *dhoti* below his bare chest. Holes for wheels are indicated on the reverse of the plaque. A few related toy cart interior scenes dating from the first century B.C. have also been found at Kaushambi and Bhita. These depict larger vehicles with six passengers.[6]

Establishing the correct date for many of the terracotta toy carts is difficult, since most examples are surface finds. The types shown here, for example, occur throughout northern India over a four-hundred-year period, from 200 B.C. to 200 A.D.[7]

Notes:

1. *The Little Clay Cart*, Act VI, verse 120, trans. van Buitenen 1968.
2. See Biswas 1981, p. 137: "Another plaque . . . shows a pavilion on the back of a tiger who is carrying a divine couple identified as Dakshin Ray and his consort. The roof of the pavilion seems to be designed in the thatch style that is still in vogue." Biswas dates the piece to the second century A.D. but offers no justification.
3. See Kala 1950, pp. 51–53, for a characterization of examples of toy carts from Kaushambi.
4. For excavated toy carts from Kaushambi, see G.R. Sharma 1969, pls. XXVIII A–D, XLII.
5. For these carts, see Margabandhu 1983, pp. 164–166.
6. See Kala 1980, fig. 208.
7. Sudraka's Gupta-period play may indicate the continuation of the tradition of terracotta toy carts in later times.

References:
(Cat. no. 41) Biswas 1981, pl. XLa, pp. 137, 177.

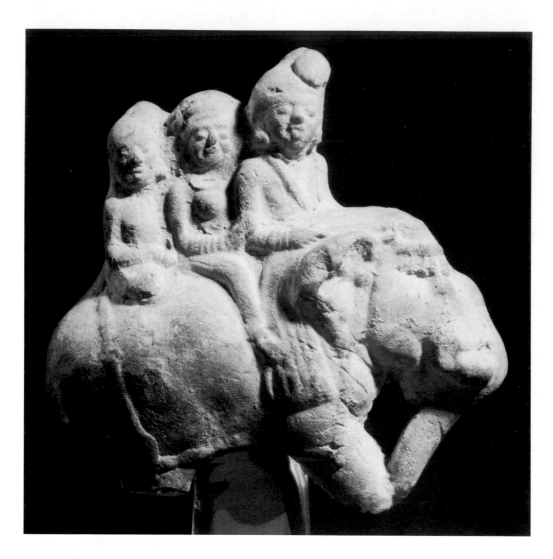

45 Elephant with Three Riders

Kaushambi (Uttar Pradesh)
Shunga-Kushan periods,
 ca. 100 B.C.–100 A.D.
Double-molded terracotta plaque,
 11.8 cm.
Collection of Samuel Eilenberg

The subject of a group of riders on an elephant is a common one in classical Indian sculpture, often depicted in relief decoration on the stone columns of Buddhist *stupas*. It is also known in several terracotta examples.[1] When the subject appears on a molded plaque, it has generally been identified as a scene of royalty, specifically Udayana's elopement with the princess Vasavadatta, attended by a jester *(vidushaka)* as they flee from Avanti.[2] With double-sided Shunga terracottas, as in the present work, another possible identification has been suggested by Sivaramamurti: the Vedic god Indra, riding on his divine white elephant, Airavata, with attendants. This identification is also given to contemporaneous Satavahana sculptures of elephants with royal riders.[3] In the context of Buddhist sites, such works may be considered auspicious symbols, as in the friezes at

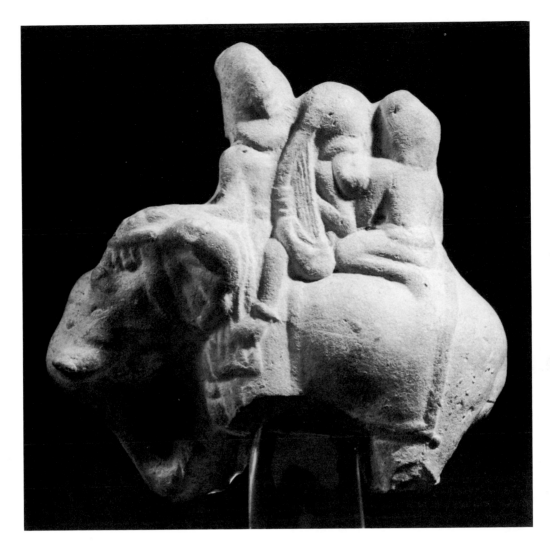

the cave at Bhaja in Maharashtra. As we have shown (see cat. no. 43), the Shunga terracotta carts formed by double-molded elements are often a miniaturization of traditional Hindu compositions. Here, the frontality of the elephant has been eliminated in favor of the profile view more common to terracottas.

A male figure, wearing the typical Shunga turban with a prominent knot, is seated at the front holding an elephant goad. A woman with a lute *(vina),* only visible from the reverse, sits behind him; a second male, with a bag of coins at his side, is at the back. (In other examples, there may be additional figures included in the group.) Stylistically, the figures show several Shunga features such as the masklike character of the faces and the simplicity of the poses, recalling the style of the contemporaneous sculptural reliefs of the railing of the *stupa*

at Bharhut, the most famous monument of the period. The elephant, positioned as if walking to the right, is quite naturalistically modeled, a characteristic that may indicate a dating slightly later than 100 A.D.

This is not the wild elephant exerting its might, or the elephant leading a royal hunt; nor is it the symbol of water (as when the elephant is lustrating the goddess Shri Lakshmi; see cat. no. 23). More likely it is the powerful elephant parading in state with his royal entourage.

Notes:
1. For a comparable terracotta group, see Boston 1970, no. 9.
2. The story, based on Bhasa's play *Svapnavasavadatta,* is identified on several Shunga molded plaques by Kala 1950, pls. XXX and XXXI, and Biswas 1981, pl. XXIXc, an example from Tamluk in the Tamralipta Museum.
3. For an elephant-and-rider group at Bhaja, see Sivaramamurti 1977, pl. 57 and p. 156.

46 Female Head

Kondapur (Andhra Pradesh)
Satavahana period, 1st century A.D.
White double-molded terracotta
National Museum, New Delhi
(Not in the exhibition)

47 Male Head

Kondapur (Andhra Pradesh)
Satavahana period, 1st century A.D.
White double-molded terracotta
National Museum, New Delhi
(Not in the exhibition)

The artists and craftsmen sculpting in clay during the reign of the Satavahanas created a style of small, three-dimensional figures of exceptional quality. As the power of the Mauryans began to wane, the Satavahana, or Andhra, dynasty began to build a strong empire. At their height the Satavahanas ruled most of the Deccan, including both coasts, much of central India extending into Gujarat and Orissa, and parts of the far south jutting into Tamil Nadu. From their many ports they controlled trade routes with the Far East, Western Asia, and Europe, and their central position made them middlemen between northern and southern India.

The Satavahana rulers were orthodox Hindus who exhibited a tolerance for Buddhism, and under their patronage magnificent centers of Buddhist art, such as Amaravati, flourished. Roman traders ventured far into Satavahana territory, bringing with them examples of Western classical art that profoundly affected local Indian styles.[1]

Although the Deccan is largely composed of either dense black or red laterite soil, both difficult to cultivate and to sculpt with, Satavahana craftsmen found pockets of extremely fine clay with a composition much like the kaolin used in fine porcelain.[2] Probably influenced by Roman sculpture, they created hollow terracottas whose very thin and meticulously detailed walls formed delicate sculptures in the round—an innovation in India. They achieved this hollow three-dimensionality by pressing a fine layer of clay onto two different molds, back and front, and then joining the two halves in a fine seam that is still visible on most Satavahana terracottas. The details of the molded sculptures were then perfected by hand.

Such figures have been found at many ancient Satavahana sites: Paithan, Ter, Nevasa, and Kolhapur in Maharashtra; Kondapur, Yellapur, Peddabankur, Dhulikatta, Chebrolu, and Amaravati in Andhra

Pradesh; Banavasi and Sannatti in Karnataka; and even as far south as Kanchipuram and Uraiyur in Tamil Nadu. Most frequently found are miniature human heads. The faces of all the figures are round, with full cheeks and thick lips, and all exhibit a characteristic beatific smile. The headdresses of the women are less elaborate than those in Shunga terracottas: the hair is usually piled high on the head and rolled in a sort of plait or bun, or pulled to one side and fixed by a band and/or jewelry or flowers. The men often wear their hair in small ringlets sometimes surmounted by a topknot and held by a band.

Notes:

1. The *Periplus of the Erythraean Sea* (Anonymous, late first century A.D.) and Ptolemy's *Geography* (circa 150 A.D.) show the extent of classical knowledge of India; see M. Chandra 1977, pp. 97–102. Hoards of Roman coins dating from the first to the fourth centuries A.D. have been found throughout central and southern India. Wheeler 1946, published a distribution map pinpointing the sites of Roman coin finds. He explains (p. 116): "The map emphasizes afresh the remarkable extent of the contact of South India with the western world during the Roman principate, implying incidentally a full use of the south-western monsoon. It would appear that the Roman traders found the smaller South Indian kingdoms more amenable or accessible than the large and powerful Andhra (Satavahana) kingdom of the centre, although the latter, with its abundant mineral sources, may be supposed to have taken some part in the business, and indirect cultural contacts with the Mediterranean . . . are discovered there from time to time."

2. It has been previously assumed that Satavahana terracottas were composed of kaolin because of their apparent similarity to kaolin sculptures from other geographical regions, notably Roman ones. But although Satavahana terracottas are made of highly refined white clay with properties similar to kaolin, kaolin is not geologically indigenous to the Indian subcontinent and, therefore, this identification is technically incorrect.

114

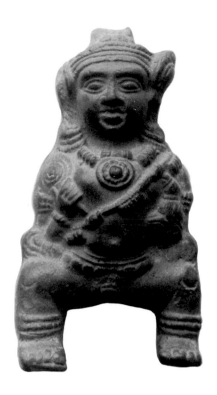

48 **Dwarfish Yaksha**

Chebrolu (Andhra Pradesh)
Satavahana period, 1st century A.D.
Red double-molded terracotta,
 11.5 cm.
Private Collection

Satavahana terracottas are often thought to be stylistically a product of Roman influence. Although it is very probable that the double-molded technique and others were instigated through Roman contact, the sculptural styles are directly linked to those of indigenous Indian sculpture such as that found at the Buddhist site at Amaravati, and from there back to Bharhut and Sanchi.[1] The Western influence may indeed be present, but it should not be overemphasized.

The bodies of most Satavahana terracottas are short and thick, usually nude from the waist up, and adorned with necklaces, armbands, bangles, and anklets. Many appear to be squatting.[2] The two figures shown here are molded of reddish clay and are nude except for their jeweled ornament.

Excavations have also yielded many examples of the double molds used in the sculptures' preparation. The largest number have been found in Yelleshwaram in Andhra Pradesh, along with many unfinished and discarded inferior products, which indicates that this was a major production center.[3] Identical examples of finished pieces have been found in widely separated sites, suggesting that the sculptures were a popular item of trade at that time.

Notes:
1. See Gajjar 1971, pp. 135–138.
2. For more detailed descriptions of Satavahana terracottas, see Dhavalikar 1977, pp. 30–34.
3. See Sastry 1979.

49 **Squatting Woman**

Paithan or Ter (Maharastra)
Satavahana period, 1st century A.D.
Red double-molded terracotta,
 11.5 x 6.7 cm.
Private Collection

115

50 Fertility Cult Figurine

Sar Dehri, Pakistan
Shunga period, 1st century B.C.
Red hand-modeled terracotta
 with applied ornaments, 24.8 cm.
Victoria and Albert Museum, London

The strict frontal and rigid posture of this figurine is characteristic of a common type of hand-modeled archaic fertility figure usually distinguished by such stylistic features as applied slit-pellet eyes, flat bodies with diminutive but prominent breasts and wide hips, legs indicated by an incised vertical line, and stubby outspread arms. The Victoria and Albert Museum piece is one of the more elaborate examples of the type.[1] The combined effect of the flat shape and high relief ornamentation, which consists of applied incised florets and leaves, incised jewelry, and applied costume, is one of geometricized order and form, in contrast to the emphatic form of hand-modeled Maurya terracotta female figures.

Note:
1. The dating of this plaque has ranged from as early as 1000 B.C. (Hallade 1968) to as late as the first century B.C. (London 1982). The controvesy over dating exists because similar figures have been found throughout northern India from these periods as well as later ones.

References:
Hallade 1968, pl. 7; London 1982, fig. 53.

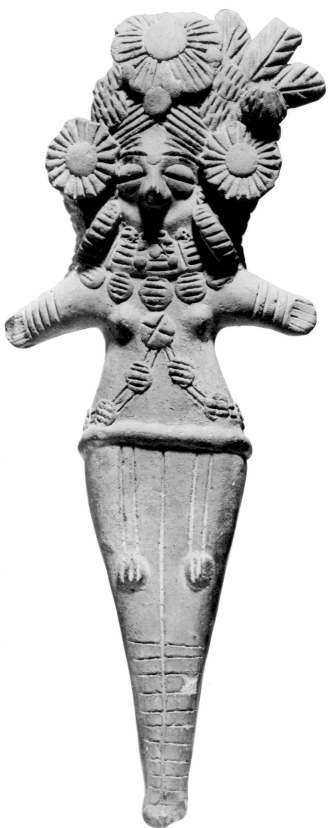

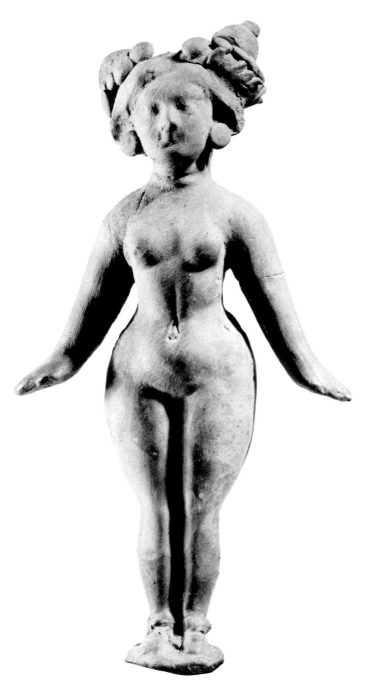

Several standing females like this one have been found at Taxila and Sirkap, now in Pakistan.[1] They were all formed by a double-mold process, and some have additional elements such as a headdress with applied ornaments. With slender upper bodies, prominent bare breasts, slightly protruding bellies, and relatively heavy hips and thighs, they may have functioned as fertility symbols. They stand with legs together in a stiff pose, the arms usually reaching downward away from the body.

Based on stylistic comparisons, this piece is likely to be from Sirkap or Charsadda.[2] It documents the prevalence of the Hellenistic tradition in Indo-Parthian culture in the northwest region during the Kushan period. The type of modeling of the facial features shown here is generally regarded as Hellenistic, and the figure recalls naked Aphrodite figurines of the second to third century B.C.[3]—a comparison that may extend to the religious nature of the subject.

Most aspects of the Brooklyn figure are uninterrupted by detail, save for the hair and its long braid at the back, which accentuates the asymmetrical composition with applied elements.

The Kushan dynasty is marked in terracotta art by a proliferation of many types, forms, and sizes of figures. From this particular region a mixture of Indian religious motifs and Hellenistic plasticity are found in such terracotta specimens as Buddha figures and unidentified male figures with mustaches or beards and Western costumes.[4] A further permutation of the semi-classical influence is also found in all later periods in this region.

51 **Standing Female**
Sirkap or Charsadda, Pakistan
Kushan period, 1st century A.D.
Red molded terracotta, 17.5 cm.
*Private Collection; on loan to
The Brooklyn Museum*
(Illustrated in color on page 15)

Notes:
1. Marshall 1951, III, pl. 132 (nos. 6-9) and pl. 133 (nos. 46-48).
2. For a comparable example, see the *Bulletin of the Cleveland Museum of Art,* 65 (January 1978), fig. 142.
3. See, for example, the terracotta Aphrodite of circa 200 B.C. from Taranto, reproduced in Vafopoulou-Richardson 1981, no. 32.
4. C.C. Dasgupta 1961, pp. 193-195.

52 Rattle (?)
Kaushambi (Uttar Pradesh)
Kushan period, ca. 1st century A.D.
Double-molded terracotta plaque,
 diam. 11.8 cm.
Collection of Samuel Eilenberg

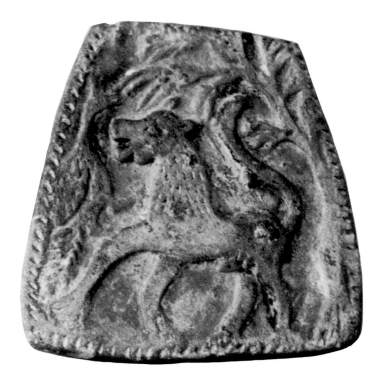

53　**Lion**

Kaushambi (Uttar Pradesh)
Kushan period, ca. 1st century A.D.
Double-molded terracotta plaque,
　9.0 x 9.0 cm.
Private Collection

Double-sided plaques in both circular and rectangular shapes occur throughout the Ganges Valley from the Shunga and Satavahana periods on.[1] The obverse of cat. no. 52 repeats a motif of a dancing female figure emanating from a central point. The reverse displays a simple design simulating a coil of twisted rope. Cat. no. 53 shows a lion beneath a willow tree on the right and a peacock on the left. Repeated registers of chevrons are incised on the reverse.[2]

　　Most of these double-sided plaques have been considered merely decorative in function, and their largely secular subject matter does not offer further clarification. It has been suggested that hollow objects like cat. no. 52 may have functioned as rattles.

Notes:
1.　See Dhavalikar 1977, pl. 55, for a Satavahana-period example.
2.　For a double-sided plaque of the same subject, see Kala 1980, fig. 182. It is an incomplete version.

119

54 **Mother-Goddess**

Sirthal, Bareilly (Uttar Pradesh)
Kushan period
Red hand-modeled terracotta,
 27.5 x 14.0 x 15.0 cm.
State Museum, Lucknow

Such large coarsely formed figures as this
are characteristic of mother-goddess images
of the Kushan and Gupta periods found
throughout central India. They are usually
hand-modeled seated figures with boldly
defined facial features. Great variety occurs
in their attributes and distinctive physiog-
nomies, each the individual creation of the
artist-potter.

Here a female sits on a hassock with
a child at her left breast and an unidentified
object held in her right hand at her knee.
She wears large disklike pendant earrings
and a tiara as well as anklets. The nipples
of her pointed breasts are emphatically de-
fined, while her fingers and toes are indi-
cated only by incised parallel lines.[1]

Note:
1. Terracotta images of mother-goddesses re-
 markably similar to this Kushan figure are still
 being modeled by hand in many Indian villages.
 Stephen Huyler reports that those produced
 today in rural areas of North Arcot, Dharma-
 puri, and Salem Districts in Tamil Nadu pro-
 vide comparable examples.

120

55 Nude Goddess with Flower Head

Jhusi (Uttar Pradesh)
Kushan period, 2nd century A.D.
Red hand-modeled terracotta,
 12.0 x 15.0 x 5.0 cm.
Allahabad Municipal Museum,
Allahabad

This animated female figure with a stylized lotus in place of her head is a variation on the plant- or animal-part human figure popular throughout India. Kramrisch has identified such female figures, with lotus heads and widespread legs, as the goddess Aditi Uttanapada.[1] Bolon has described them as "lotus-women," having lower limbs raised in a birthing pose, like a stylization of the goddess Lajja Gauri.[2] A third view is proposed by Sivaramamurti, who says they represent a form of Lakshmi called Prakrti, the mother who is the origin of all creation.[3] Whatever the case, the widespread legs indicate a fertility function.

 The Allahabad figure is less formally represented than other images of the lotus goddess commonly found in clay or stone.[4] Her legs are not drawn up to her sides but are spread wide in a dancelike pose echoed by her arms. Applied and incised strips represent her girdle, armlets, necklace, and collar. Her breasts are pierced in a floral pattern. The lotus petals are indicated by vertically incised lines encircling the head-like protuberance.

Notes:
1. Kramrisch 1956, pp. 259-270, ed. 1983, pp. 148-158.
2. Bolon, "Problems of the Origin and Identity of a Frog-Goddess Figure in the Victoria and Albert Museum," paper read at the 1983 conference on "Influences and Interaction in Ancient Indian Art," University of Uttar Pradesh, Lucknow.
3. Sivaramamurti in Kala 1980, p. ix, relates the lotus head to the traditional iconography for Lakshmi given in the *Vishnudharmottara Sutra.*
4. Ibid., p. 64.

Reference:
Kala 1980, fig. 164.

121

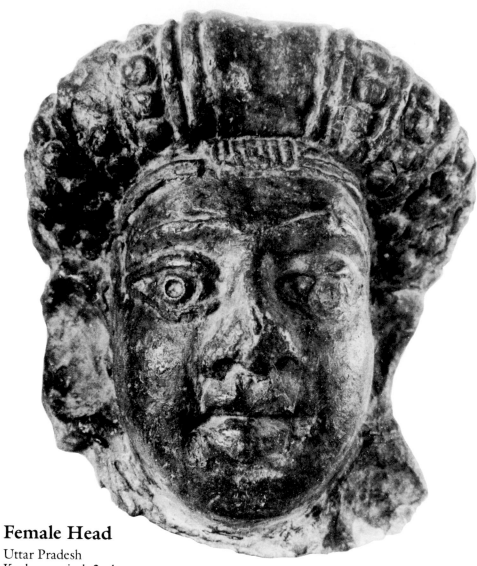

56 Female Head

Uttar Pradesh
Kushan period, 2nd century A.D.
Red hand-modeled terracotta,
 11.0 x 8.0 x 9.5 cm.
Collection of Mrs. Pupul Jayakar

Terracottas often reveal contemporaneous
fashions, as in the elaborate hairstyle of this
Kushan-period fragment. The plaits of hair
are wrapped with alternating strings of
pearls and bands of cloth, forming a
wreathlike tiara above a faceted band at the
forehead.

Though its provenance is uncertain,
the head bears distinctly Kushan stylistic
traits, especially the open staring eyes and
small upturned lips. Whether or not the
head represents a deity remains an open
question.

122

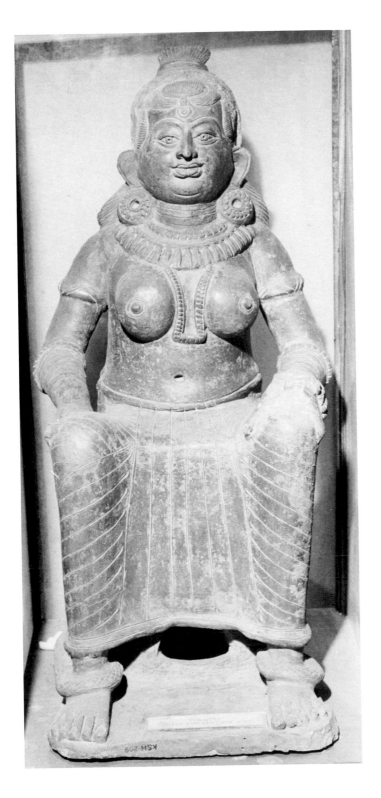

57 Hariti

Ghoshitarama Monastery,
 Kaushambi (Uttar Pradesh)
Kushan period, 1st century A.D.
 or later
Hand-modeled terracotta,
 82.0 x 33.0 x 40.0 cm.
Allahabad University Museum,
 Allahabad
(Not in the exhibition)

Perhaps the greatest technical advance in terracotta production during the Kushan period was the ability to fashion monumental figures. The powerful image of Hariti, goddess of fertility, shown here (cat. no. 57) is just under life-size. It was discovered with two other almost life-size cult images —the head of Hariti's consort, Kubera (cat. no. 58), and a figure of Gajalakshmi—in a shrine of Kushan date at Kaushambi.[1] The Hariti figure is hollow and was fired on a grain core. Traces of the original burnished red slip remain.

 Holding a bowl in her right hand and an unidentified object in her left, Hariti is rigidly frontal in the pose known as *paryankasana*—the "European fashion"—

123

58 Head of Kubera

Ghoshitarama Monastery,
 Kaushambi (Uttar Pradesh)
Kushan period, 1st century A.D.
 or later
Hand modeled terracotta
Allahabad University Museum,
Allahabad

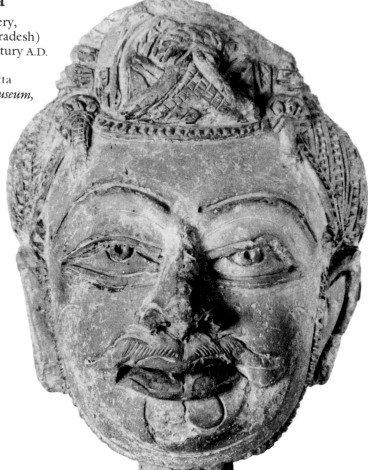

on a circular hassock with legs straight down. She is clothed in an ankle-length skirt and wears various necklaces, armlets, and anklets, as well as a pair of circular plaque earrings that reach her shoulders. Her hair, coiffed in a trifurcated style ending in a high chignon, relates to a type known in other contemporaneous terracotta surface finds. Her detailed decorations also reveal other subtle technical devices used to delineate the face, including incising, appliqué, and a combination of stamping and appliqué.

The head of Kubera would appear to have come from a similar monumental figure. A similar head of a male from Kaushambi, with the turban gear intact, has been dated to the fourth to fifth century. Not only is the turban style typically Kushan, but it also has a noticeable stylistic affinity to the excavated Kubera head.[2]

Notes:
1. The excavations at Kaushambi were conducted in 1957–59 by the University of Allahabad, under the direction of G.R. Sharma (see Sharma 1960 and Sharma 1980). The remains of the main *stupa* were discovered at the Ghoshitarama, a shrine sacred to Buddhists. This source of Buddhist art and the terracotta described above is discussed in Sharma 1980, pp. 8–14. Several inscriptions at the site confirm that it was the shrine mentioned in the *Tripitaka* and other *sutras* that was built by a layman, Ghoshita, as a residence for the Buddha on his stay in Kaushambi. At the entrance to the courtyard there was a shrine of Hariti, dating from about 100 B.C. to 100 A.D. It is here that the three terracotta images representing Hariti, Gajalakshmi, and the head of Kubera were discovered.
2. Dhavalikar 1977, pl. 80.

References:
(Cat. no. 57) G.R. Sharma 1980, p. 13; Jayakar, p. 253, pl. 259; Poster 1985, p. 25.

124

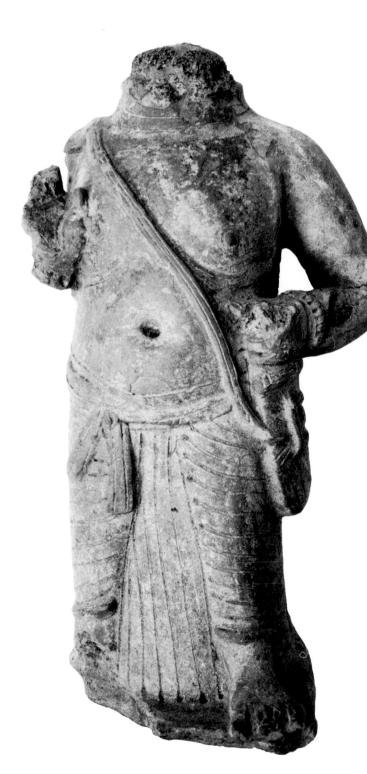

59 Male Torso

Kaushambi (Uttar Pradesh)
Kushan-Gupta periods,
 1st–4th century A.D.
Red hand-modeled terracotta,
 50.0 x 23.0 cm.
Collection of G. K. Kanoria

This figure probably represents Kubera, the god of wealth and the consort of Hariti (see cat. nos. 57 and 58), with his portly torso and with a bottle held in his left hand. His right hand makes the *abhayamudra* ("no fear gesture"), and he holds a sword at his left hip.

The hollow torso is modeled in the Kaushambi style of the late Kushan to early Gupta periods. It compares to a seated male torso of similar dimensions, also identified as Kubera, in the Cleveland Museum of Art[1] and a slightly smaller standing male with legs set apart in the Allahabad Museum,[2] both holding water vessels (*kundikas*). The body of the Kanoria torso is forcefully modeled in the typically crude but detailed manner technically related to the Kushan-period seated Hariti and Kubera head (cat. nos. 57 and 58) excavated at Kaushambi. All three male torsos are clothed in *dhotis* draped and knotted in a similar manner, and their feet rest on flat plinths, continuing the Kaushambi tradition.

Notes:
1. Cleveland Museum of Art accession number 77.175. See Czuma 1985, cat. no. 54.
2. The Allahabad Museum torso is published in Kala 1980, fig. 247.

125

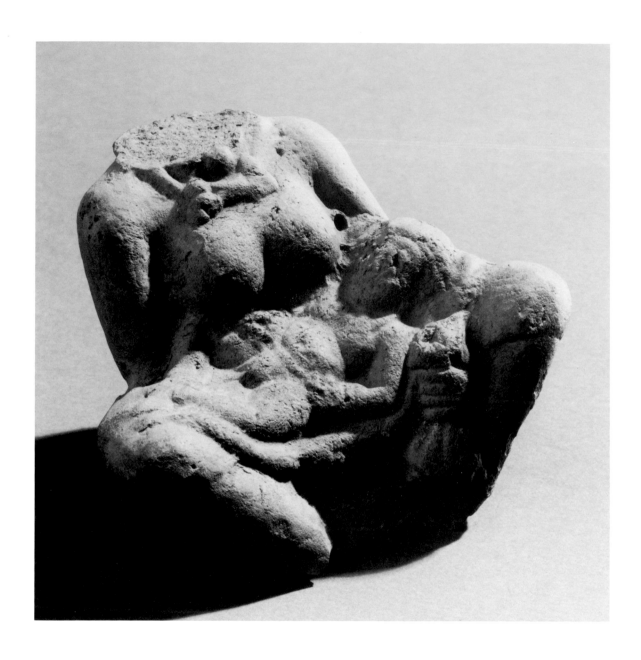

60 **Mother and Child**

North India
Kushan period (?),
 2nd–3rd century A.D.
Red double-molded terracotta,
 11.5 cm.
Museum of Fine Arts, Boston;
 Thomas Oaks Rogers Fund
(Not in the exhibition)

This exceptionally refined molded figure of a mother seated with her legs apart and holding a resting child in her lap is stylistically similar to several other Kushan terracottas. Terracotta objects with such simple detail and naturalistic modeling are difficult to date and are here attributed to the Kushan period on stylistic grounds.

Reference:
Boston 1977, no. 72.

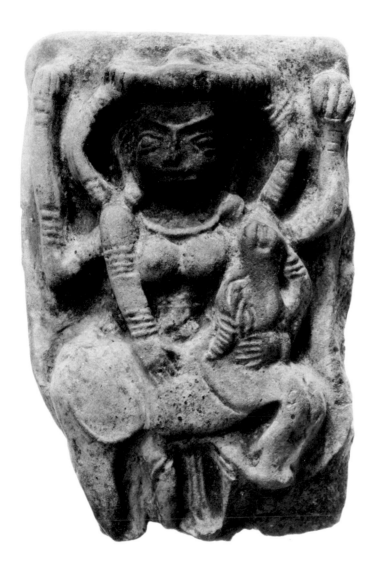

61 **Durga Destroying the Buffalo Demon**

Mathura region (Uttar Pradesh)
Late Kushan period,
 2nd century A.D.
Red molded terracotta,
 17.0 x 10.8 cm.
The Brooklyn Museum 83.172.1;
 Gift of Dr. Bertram Schaffner

The representation of complex, multifaceted deities in terracotta occurs contemporaneously with the production of simple fertility cult images. Here, the goddess Durga strangles the buffalo demon *(Mahishasura)* as she strikes it with her weapons. She is six-armed and holds a garland of victory in her uppermost hands above her head.[1] The posture of the goddess here, strangling the buffalo in an ambiguous caress, is one of several conventional ways of representing this theme.

The cult of Mahishasuramardini (Durga destroying the Buffalo Demon) was generally believed to have originated in the early Gupta period, but terracotta images of the theme discovered in a Kushan-period context suggest an earlier date.[2] The iconography of the Kushan works is different: the demon is strangled rather than pierced with the trident *(trishula)* common in the scene from the Gupta period onward.

Notes:
1. See Harle 1970, for a terracotta image of the same subject attributed to the Kushan period; her weapons are not easily discernible.
2. A similar Mahishasuramardini plaque has been recovered from the Kushan level (period of Vasudeva I) in the excavation at Sonkh in Mathura; see Härtel 1977, p. 92, fig. 36.

127

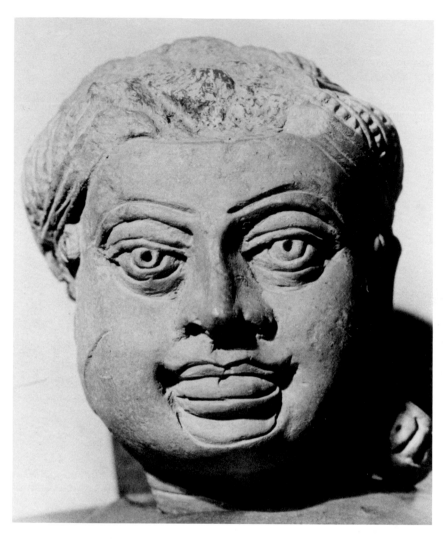

62 Male Head with Turban

Kaushambi (Uttar Pradesh)
Kushan-Gupta periods,
 ca. 100–300 A.D.
Hand-modeled terracotta,
 12.5 x 10.0 x 12.0 cm.
Allahabad Municipal Museum,
 Allahabad

The almost portraitlike quality that characterizes Kushan-period figures is also a vital aspect of the figural terracottas of the early Gupta period. Transitional Kushan-Gupta examples like the one shown here are distinguished by realistic physical form, detail, and expression, here evidenced by the structure of the man's face and especially emphasized by the incised line representing the folds of skin surrounding the chin. Such figures are "drawn" in this way as well as carefully modeled. The head has large open eyes with pupils denoted by pierced holes; separated arched lines over each eye indicate the eyebrows. The aquiline nose has remained intact, as has one of the earrings. Folds of dotted cloth represent the turban. How such figures were used or whom they were meant to represent is as yet unknown.

References:
Harle 1974, pls. 113, 114 (as early Gupta, third century A.D.); Kala 1980, fig. 251, p. 90.

63 **Ascetics**

Harwan (Kashmir)
Late Kushan-Gupta periods,
 3rd–4th century A.D.
Terracotta relief tile,
 40.3 x 33.6 cm.
Collection of Cynthia Hazen Polsky

Harwan is a Buddhist site in central Kashmir dating from the third century A.D. and known for its distinctive decorated terracotta tiles. These tiles covered the pavement of a courtyard and the bases of the walls surrounding three sides of an apsidal temple structure.[1] The stamped terracotta plaque, in the form of such large brick panels, must therefore have been in use at least as early as this period for architectural decoration.

The panels depicting ascetics (cat. nos. 63 and 64) are numbered in Kharoshthi numerals, a numbering system appar-

ently used to arrange the placement of the tiles on the wall section of the temple. Each wall tile contained the image of an emaciated ascetic, in profile, with legs drawn up in front and with long matted hair. The unusual pose of these naked mendicants recalls the Maurya-period terracotta image (cat. no. 17) with its bared rib cage and squatting posture, but here it is even more compelling.[2] The topmost register of each tile shows the heads and shoulders of seven male and female conversants in pairs of confronted profiles. *Hamsas* (geese) appear at the base of the Victoria and Albert plaque (cat.no. 64). Both the profile heads and the geese are familiar conventions in Buddhist art. Although parallels to other Gupta-period sites are commonly suggested, the physiognomies of these busts relate closely to Afghanistan sculpture of the period.

The floor tiles show a varied number of familiar subjects, including animals (cat. no. 65), archers, drummers, and standing human figures carrying baskets or other objects. The antelope is portrayed in the Cleveland relief with a crescent moon at the top left and a stylized lotus at bottom, all in low relief.[3] Kharoshthi numerals are also inscribed on this panel, indicating an early date, probably in the Kushan period, prior to the use of Gupta Brahmi script. Kashmir, lying on a portion of the Silk Route, has had various cultural links to the West from Parthian times on, and remnants of Parthian motifs are still clearly evident in the Harwan imagery, among them this long-horned antelope and an archer on horseback.[4]

Notes:
1. See Fisher 1982, pp. 33–45.
2. Ibid., pp. 39–40.
3. Ibid., pp. 35–36.
4. Ibid., p. 38.

Reference:
(Cat. no. 65) Fisher 1982, pp. 37–38.

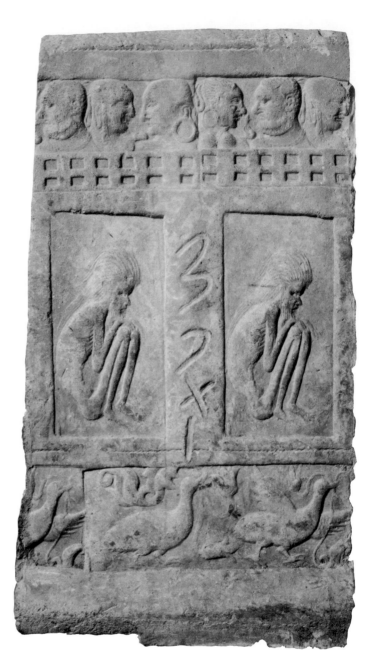

64 **Ascetics**

Harwan (Kashmir)
Late Kushan-Gupta periods,
 3rd–4th century A.D.
Terracotta relief tile,
 54.4 x 29.8 x 6.0 cm.
Victoria and Albert Museum, London

130

65 **Antelope**
Harwan (Kashmir)
Late Kushan-Gupta periods,
3rd–4th century A.D.
Terracotta relief tile,
47.0 x 31.7 x 5.1 cm.
*The Cleveland Museum of
Art; Purchase, Edward L.
Whittemore Fund*

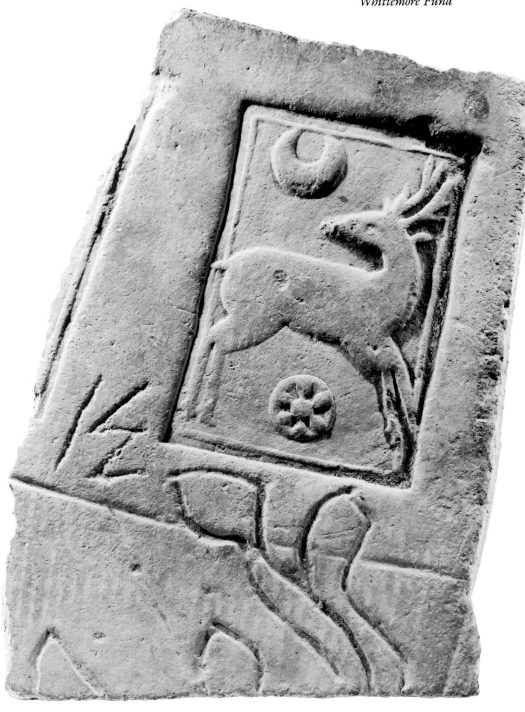

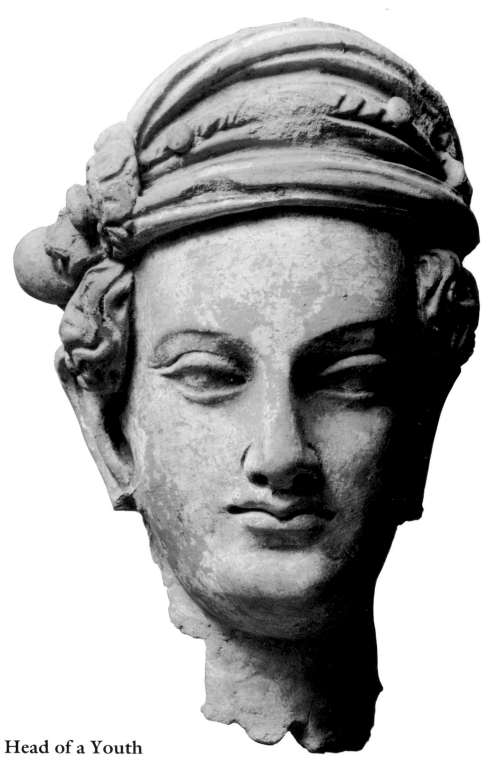

66 **Head of a Youth**
Gandhara region
4th–5th century A.D.
Red hand-modeled terracotta,
 28.3 cm.
Collection of Samuel Eilenberg

132

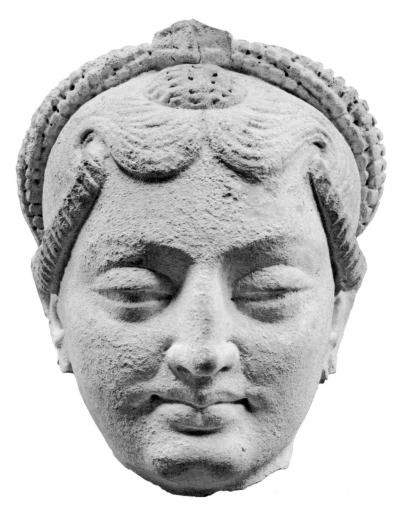

67 **Female Head**
Gandhara region
4th–5th century A.D.
Red hand-modeled terracotta,
　20.3 cm.
*The Metropolitan Museum of Art,
New York; gift of Dr. and Mrs.
Roger Stoll*

The Gandhara region of India, which extends from Bactria to the Punjab, enjoyed a period of outstanding artistic production from the first to the fifth century A.D. In terracotta as well as in stucco and schist, artists developed ideas borrowed from the classical world, creating powerful statements of naturalism.

Rather than idealized types, Gandhara terracottas are highly individualized portraits. This makes identification of their subjects difficult. As depictions of realistic figures, they have often been characterized as donors or attendants. Although some Buddha heads have been found, there are few if any identifiable Hindu divinities.

The large head of a youth shown here (cat. no. 66) exemplifies the Gandhara terracotta style with its classic physiognomy and individualized headdress. The headdress, which is fashioned of a draped textile

clasped at the right, frames facial features that are incised for emphasis. The head shows traces of burial occlusions and remains of polychrome.

A variation of the Gandhara type is also seen in the female head shown here (cat. no. 67). Whitish burial occlusions emphasize this subject's full cheeks and soft lips. Her hair, parted at the center and crowned by a jeweled tiara, is an elaboration of the Kushan style seen at Kaushambi and other sites (see cat. no. 57).

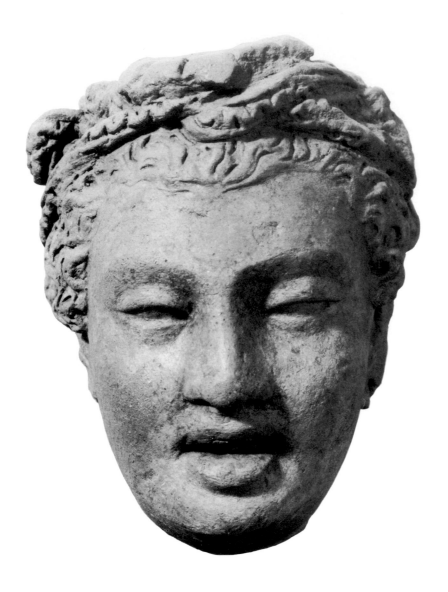

68 Male Head

Gandhara region
4th–5th century A.D.
Red hand-modeled terracotta,
16.5 cm.
*Collection of Samuel Eilenberg; on
loan to The Metropolitan Museum
of Art, New York*

The other male head seen here (cat. no. 68) conveys mood as well as a naturalistic representation, suggesting a sense of meditation with slightly parted lips and half-closed eyes. The smooth surface of the subject's face is contrasted by the finely carved wavy coiffure held in place with a winding fillet.

Because their exact provenance is not known, dating of these objects is problematic. A fourth- or fifth-century date is suggested by their resemblance to Roman sculpture of a slightly earlier period.[1]

Note:
1. Czuma 1985, pp. 220 and 225.

Reference:
(Cat. no. 67) Lerner 1981, p. 75.

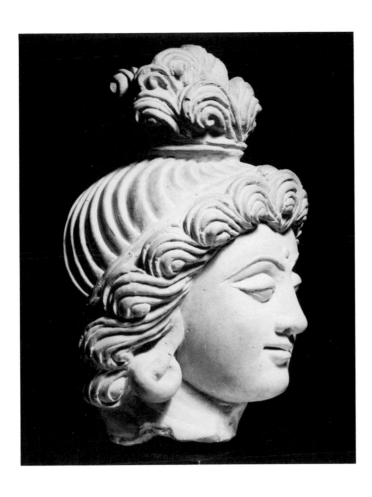

69 Head of a Youth

Afghanistan, Tapa Shotar,
 Gandhara region
Gupta period, 6th century A.D.
White terracotta, 19.8 cm.
Collection of Samuel Eilenberg

During the Kushan and Gupta periods, Gandharan monuments and objects were produced in what is now Afghanistan as well as in northwest India. Although the stone sculptures are generally characterized by flat relief, the terracottas and stuccos are eminently more naturalistic. The related sites of Hadda and Tapa Shotar produced both baked and unbaked clay images in miniature, life-size, and even monumental proportions.[1] These are attributed, on the basis of some Arabo-Sasanian coins, to the seventh to eighth centuries A.D. From the standpoint of both iconography and style, the terracotta figures, mostly in the form of heads and other fragments, are of exceptional value.

The most refined terracottas are a group of heads designed in a "baroque" mode with deeply carved hairstyles, including an idiosyncratic *jata* (topknot). This head of a youthful male displays the *jata* and third eye associated with the portrayal of a *bodhisattva* (enlightened being). The eyes are elongated and almond-shaped, the cheeks plump, and the lips upturned in a slight smile—all conventions of contemporaneous Gandhara Buddhist stone sculpture from the region.[2] The closest stylistic comparisons in stone relief sculptures are mainly to Buddhist works produced in Pakistan (Swat) and Afghanistan.

The Tapa Shotar terracotta differs from the more naturalistic Hadda type in its stylization and arrangement of the hair, with a row of pronounced curls coming out from under a headband, as well as in the simplified details of the earrings and facial features, which follow examples in stucco that generally show a refined, smooth surface. The impact of these elements is what aesthetically sets this work apart from other terracottas of the Gandhara region.

Notes:
1. See the colossal unbaked clay image of Parinirvana Buddha in a shrine at Tapa Shardar, Afghanistan, dated to the eighth century, reproduced in MacDowall/Taddei 1978, fig. 5.64.
2. See, for example, the sculptural remains in stone from northwest Pakistan sites such as Sahri Bahlol, dated to the third to fourth centuries A.D., where stucco and terracotta remains also are found.

70 Female Head

Akhnur (Jammu)
6th century A.D.
Red terracotta,
 16.5 x 15.0 x 13.2 cm.
Collection of Mrs. Pupul Jayakar

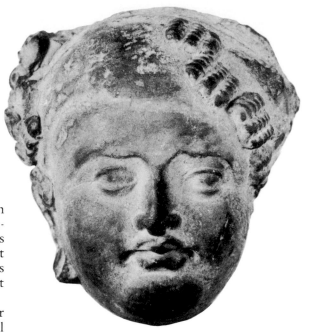

That the Gandhara terracotta tradition extended well into the Gupta period is evidenced by a large group of isolated heads and figures from Akhnur, in the northwest region of Jammu, near Kashmir. Akhnur is believed to have been the site of a Buddhist monastery of late Gupta date.

Sensitively modeled, the Akhnur terracotta heads display a round facial contour common in Gupta sculpture and a realism associated with Gandharan terracottas. Their distinctive characteristics include a prominent rounded chin, delicately curved and everted lips, bow-shaped eyebrows, and shallow incised eyes whose pupils are not pierced as in other terracottas of the northwest region. Hairstyles individualize the heads of females. One of the female heads seen here, for example (cat. no. 70), has a complicated coiffure arranged in rows of curls at one side and freely styled waves at the other. The appliqué technique was apparently used for such detailed work. Another, better preserved female head (cat. no. 71) shows fragile flowers inserted in a band at the forehead and a wreath of curls interspersed with ribbon above. The headdresses of the males also vary significantly, ranging from tight caps covering long curls to stylized rows of curls surmounted by a knot as in the exemplary image illustrated here (cat. no. 72).

Akhnur heads have been dated variously from the fourth to the eighth centuries, slightly later than those found at Hadda and Taxila, although they compare stylistically with the latter group. The heads are apparently baked; the bodies, where extant, are unevenly fired.[1]

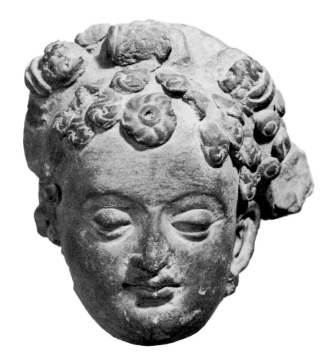

71 Female Head

Akhnur (Jammu)
7th–8th century A.D.
Red terracotta,
 approximately 15.0 cm.
*Collection of Samuel Eilenberg; on
 loan to The Metropolitan Museum
 of Art, New York*

Note:
1. Varma 1970, pp. 115–116, has raised the question of whether the Akhnur fragments were accidentally burned rather than baked.

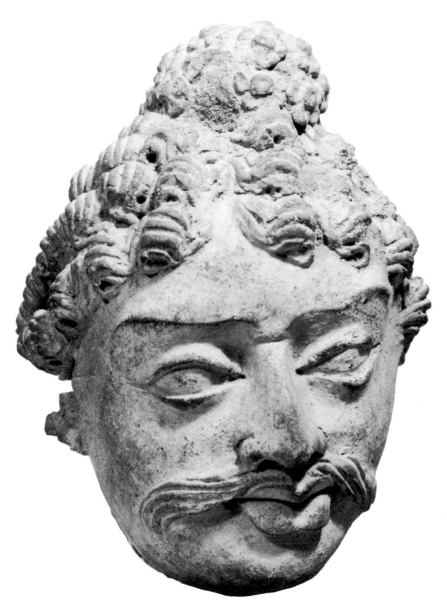

72 **Male Head with Mustache**

Akhnur (Jammu)
7th–8th century A.D.
Red terracotta,
 approximately 18.0 cm.
*Collection of Samuel Eilenberg; on
 loan to The Metropolitan Museum
 of Art, New York*

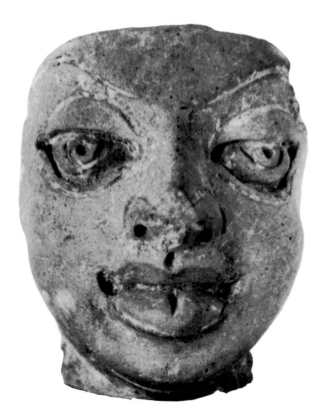

73 Male Head

Uttar Pradesh
Gupta period, 5th century A.D.
Red terracotta,
 6.5 x 5.5 x 4.0 cm.
*Bharat Kala Bhavan, Banaras Hindu
 University, Varanasi*

The exaggerated form and freely modeled
features of this head of an unidentified male
are typical of Gupta-period terracottas. The
wide, staring eyes, bow-shaped brows,
flared nostrils, and full, everted lips make
for a compelling expression. Comparable
to a Rajghat head of Shiva (cat. no. 76), this
relief fragment without divine attributes is a
striking example of Gupta style.

138

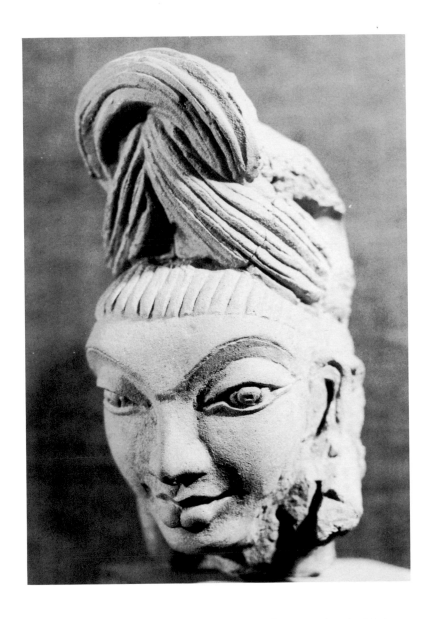

74 Head of Shiva

Ahichchattra (Uttar Pradesh)
Gupta period, 5th century A.D.
Red terracotta relief tile
National Museum, New Delhi
(Not in the exhibition)

The place most often associated with large terracotta plaques is Ahichchattra. Excavations at the site have uncovered terracottas from earliest times, while a Shiva temple there has yielded Gupta-period remains, examples of which are housed in the National Museum in New Delhi.[1]

Certain freely modeled terracottas from Ahichchattra are extraordinarily expressive. One such terracotta is the unique head of a male illustrated here (cat. no. 74), identified as Shiva by his matted locks piled high in a massive knot. This head exemplifies the dynamic terracotta tile decoration of Ahichchattra's Shiva temple by its exaggerated physiognomy carved in sharp angular planes.

139

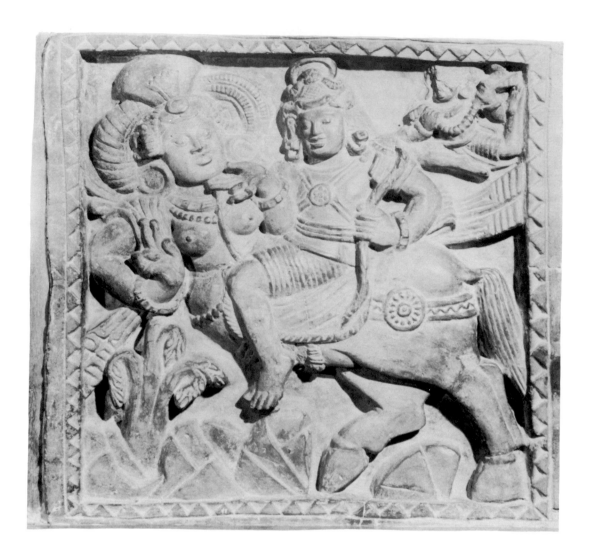

A second Ahichchattra style seems to characterize panels recovered from the basement of the temple, such as the rectangular plaque depicting a *kinnara* couple illustrated here (cat. no. 75). This plaque seems quite two-dimensional in comparison to the head of Shiva. It shows a *kinnari*, or female centaur, carrying her consort, apparently a princely warrior, over a rocky terrain while a celestial being *(gandharva)* floats at the upper right. The subject, which is common in terracottas,[2] is dominated here by the patterned surface of the panel. The plants and trees, which indicate a landscape setting, are carved in the same shallow relief as the pair of figures and instead of being dramatic convey a sense of the emblematic.

Ahichchattra is generally given a date of 450–650 A.D., but it is possible that these divergent styles of sculpture are con-

75 Kinnara-Mithuna

Ahichchattra (Uttar Pradesh)
Gupta period, 5th century A.D.
Red terracotta relief tile,
 66.1 x 66.1 cm.
National Museum, New Delhi
(Not in the exhibition)

temporaneous. If so, they probably represent different ateliers at the site.

Notes:
1. Agrawala 1947–48.
2. Chandra 1971, fig. 61.

References:
(Cat. no. 74) Dhavalikar 1977, pl. 88; (cat. no. 75) Dhavalikar 1977, pl. 86; Harle, 1974, fig. 138.

140

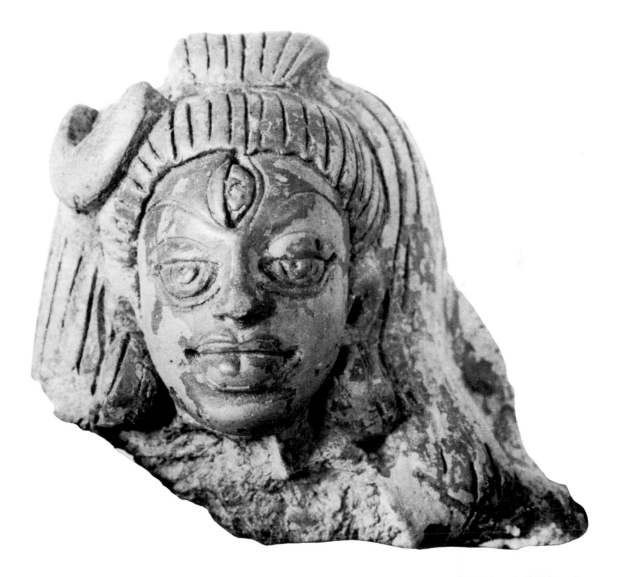

76 Head of Shiva

Rajghat (Uttar Pradesh)
Gupta period, 5th century A D
Red hand-modeled terracotta,
13.5 x 14.0 cm.
*Bharat Kala Bhavan, Banaras
Hindu University, Varanasi*

Carved in high relief, this head of Shiva, the
great ascetic Hindu deity, evokes a power-
ful image. Deeply incised lines define both
the boldly staring eyes and the exaggerated
lower lip. The identifying symbols of the
god are also boldly stated: the vertical third
eye in the forehead, the crescent moon in
the matted hair, and the *jata* (topknot) that
always signifies an ascetic.

References:
C.C. Dasgupta 1961, pl. 34, fig. 132; S.K. Srivastava
1971, fig. 358; London 1982, no. 437.

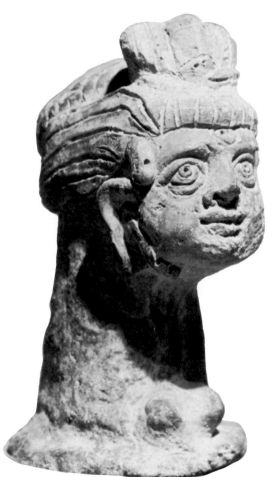

77 Ekamukhalingam

Uttar Pradesh
Kushan-Gupta periods,
 ca. 100–300 A.D.
Red hand-modeled terracotta
Collection of S. Neotia

The *linga,* the primordial symbol of the god Shiva (commonly depicted in the form of a phallus), is here represented with the god's face modeled as a male head *(ekamukha)* on the top of a shaft set on a flat base. Rather than the often shown matted locks of a *yogi,* the god wears a turban, the typical peaked version often seen in Kaushambi terracotta heads of the Kushan period. Shiva is also identified by his third eye. The suggestion of a fillet under his chin may represent part of a beard or some other unidentified attribute. This is an early example of an *ekamukhalingam* in terracotta. There are several Kushan examples in stone.[1]

Note:
1. See Kramrisch 1981, cat. no. 1.

142

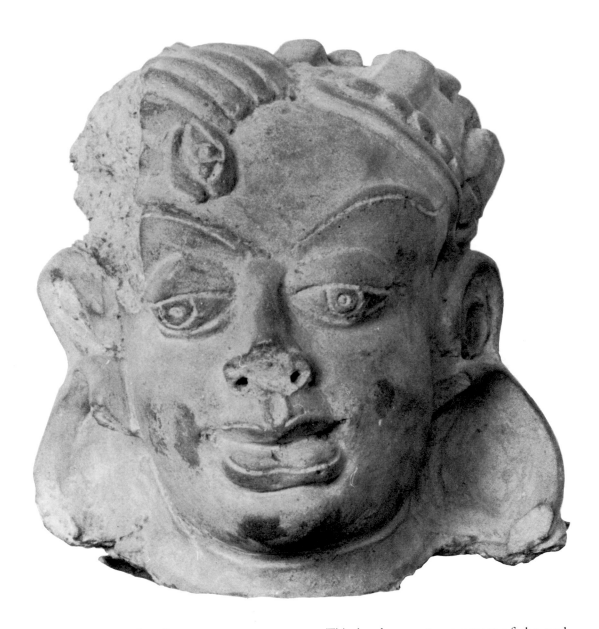

78 Head of Ardhanarishvara

Varanasi (Uttar Pradesh)
Gupta period, 5th century A.D.
Red hand-modeled terracotta,
12.5 x 12.5 cm.
*Bharat Kala Bhavan, Banaras
Hindu University, Varanasi*

This head presents an aspect of the god Shiva in his androgynous state denoting the inseparability of all male and female forms. The male aspect is conveyed on the right half of the head by the third eye and matted locks, while the female aspect is represented on the left by the tiara worn by the goddess Parvati. Careful examination reveals a subtle contrast between the almond-shaped right eye and the elongated left eye, between the shortened lips on the right and the fuller more sensuous lips on the left, and between the bowed arch of the right eyebrow and the raised crescent of the left eyebrow. At the same time, these contrasting aspects are successfully merged in an integrated whole.

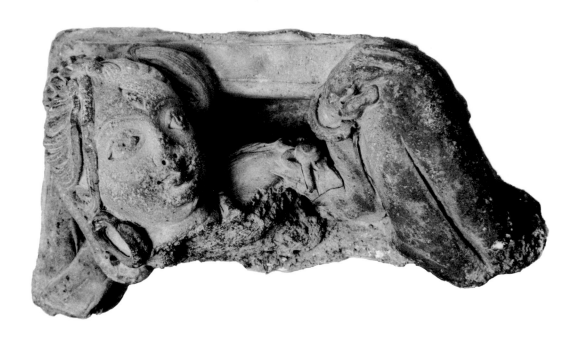

79 Shiva as Ardhanarishvara

Mathura (Uttar Pradesh)
Gupta period, 5th century A.D.
Red terracotta relief plaque,
 18.0 x 30.5 cm.
Government Museum, Mathura

Although the fragmentary remains—merely the head and the left shoulder, arm, and leg—of this image preclude positive identification of the subject, the figure is marked as a divinity by the presence of one-half of the sacred third eye on the left side of the forehead. The deity represented is perhaps Ardhanarishvara, the combined male and female aspects of Shiva. The biunity is less marked than in other examples (see cat. no. 78), but a feminine coiffure consisting of cascading strands of hair at the right side of the head contrasts with the ascetic Shiva's matted locks on the left. The feminine side is closest to the viewer and hence emphasized, an emphasis strengthened by the graceful modeling and attention to jeweled ornament. The presentation of the figure in this asymmetrical composition without the usual attributes further complicates the identification of the relief.

144

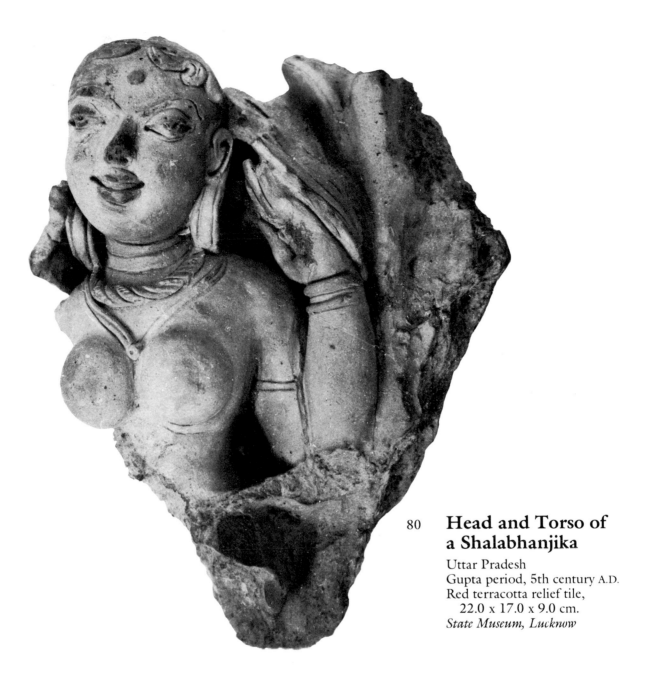

80 **Head and Torso of
 a Shalabhanjika**

Uttar Pradesh
Gupta period, 5th century A.D.
Red terracotta relief tile,
 22.0 x 17.0 x 9.0 cm.
State Museum, Lucknow

Shalabhanjikas, or females associated with trees, are a common subject in early Indian art and are frequently represented in Gupta-period terracottas.[1] The *shalabhanjika* is usually shown with one hand reaching above to hold the branches of a tree, a symbol of fertility; through her touch, the tree is regenerated. When she appears unclothed, her breasts are evocatively prominent, as in earlier fertility icons, and are similarly adorned with a profusion of jewelry and flowers. This fragment, part of a large brick tile, is characteristically modeled and de-

tailed in the Gupta idiom, including the high relief, the smooth transition from one plane to another, and the added element of a seductive mien.

Note:
1. Desai 1978, p. 149. Desai also discusses Magadha (Bihar) terracottas probably associated with the *Shalabhanjika* festival during the Maurya period. For Gupta-period terracottas possibly representing *shalabhanjika* images, see Harle 1974, pl. 147, and Kala 1980, frontispiece and fig. 279.

81 Head with Turban

Shravasti (Uttar Pradesh)
Gupta period
Terracotta, 17.0 x 15.0 x 16.0 cm.
State Museum, Lucknow

The poor condition of this piece makes
dating and identification of the subject
difficult.

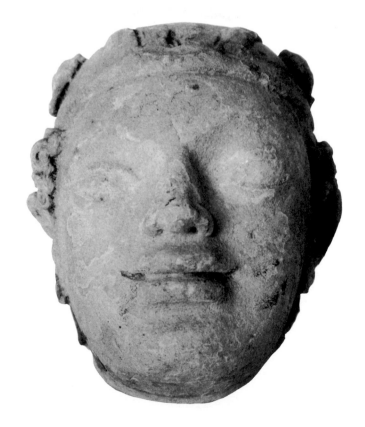

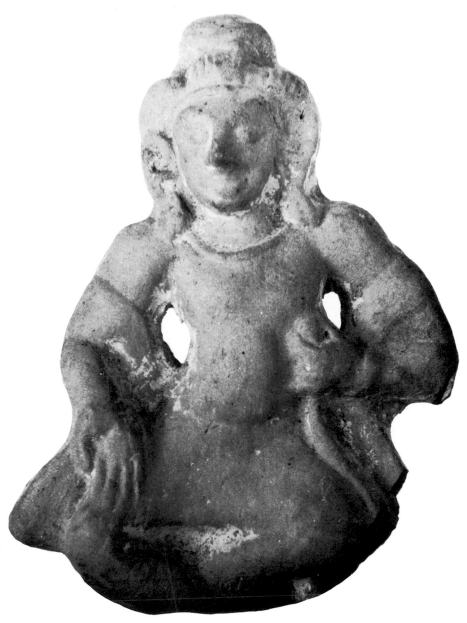

82 **Male Figure**

Rajghat, Varanasi (Uttar Pradesh)
Gupta period, 5th century A.D.
Molded terracotta plaque, 12.5 cm.
*Bharat Kala Bhavan, Banaras
Hindu University, Varanasi*

Molded figures from Rajghat can be rec-
ognized by their gently modeled figures
and stylized coiffures. The cascading curls
usually denote a wig, a convention reflect-
ing Gupta-period royal fashion.

These three examples (cat. nos.
82–84) come from a large hoard of molded
figurines discovered in Varanasi near the
Banaras Hindu University. The site covers
an extensive area, and excavation has
revealed a large center of Hindu art that
flourished throughout the Gupta period.[1]
Figures from the hoard are usually given a
fifth-century date because of the pillar dis-
covered at the site with an inscription dated
to 478 A.D.[2] The pillar is carved with a panel
of a standing Vishnu that is very close in
form to these terracottas.[3]

147

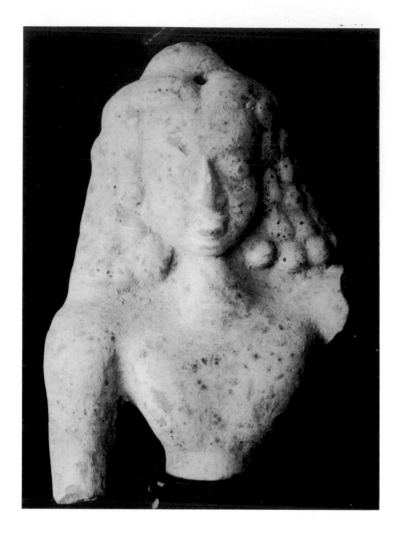

83 **Male Figure**

Rajghat, Varanasi (Uttar Pradesh)
Gupta period, 5th century A.D.
Molded terracotta plaque, 10.0 cm.
*Bharat Kala Bhavan, Banaras
 Hindu University, Varanasi*

84 **Male Figure**

Rajghat, Varanasi (Uttar Pradesh)
Gupta period, 5th century A.D.
Molded terracotta plaque, 6.5 cm.
*Bharat Kala Bhavan, Banaras
 Hindu University, Varanasi*
(Not in the exhibition)

Modeled with a plain body surface, each terracotta represents a standing figure who has his left hand at his waist and wears only a smooth *dhoti* with a sash falling to one side. The body type and drapery recall standing images of *bodhisattvas* (enlightened beings) from neighboring Sarnath and other deities from sites along the Ganges River. The Rajghat figurines follow the Sarnath aesthetic conventions of smooth drapery and drapery arrangement, smooth torsos, and a lack of muscle articulation.

Notes:
1. Agrawala 1941.
2. Williams 1982, pl. 101.
3. Ibid., pl. 103. Williams (p. 81) also mentions a stone image of Kumara from this region, describing it as "representing the deity in an abstract rather than in a specific mythological moment." This abstraction into a generalized form seems a plausible explanation for the iconographic type represented in the terracotta male plaques as well.

85 Pregnant Female

Rajghat, Varanasi (Uttar Pradesh)
Gupta period, 5th century A.D.
Hand-modeled terracotta with
 molded face, 7.0 x 4.5 x 3.5 cm.
Bharat Kala Bhavan, Banaras
Hindu University, Varanasi

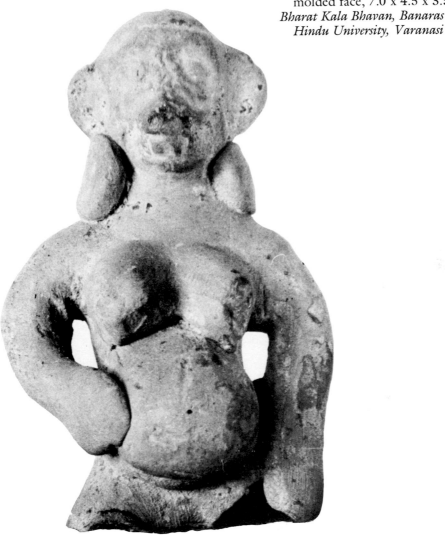

The animal-headed pregnant female, here a
monkey-headed female figure, is a type that
began in the Indus Valley Civilization (see
cat. no. 2). With its squarish face and rudi-
mentary hand-formed body, the Gupta fig-
ure seen here is static, a symbol of stability
and fertility. She is naked from the waist up
and wears large ear plaques and a necklace
indicated by a row of pierced marks at the
base of her neck. Her prominent features
are a fierce monkey face and a protruding
belly.

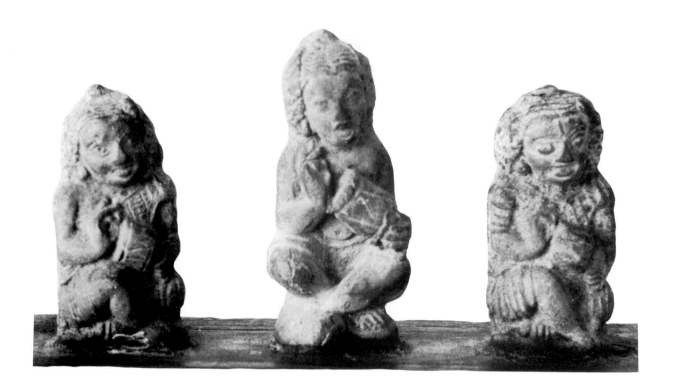

86 **Drummer**
Rajghat, Varanasi (Uttar Pradesh)
Gupta period, 5th century A.D.
Molded terracotta, 4.0 cm.
Bharat Kala Bhavan, Banaras
* Hindu University, Varanasi*

87 **Drummer**
Rajghat, Varanasi (Uttar Pradesh)
Gupta period, 5th century A.D.
Molded terracotta, 5.0 cm.
Bharat Kala Bhavan, Banaras
* Hindu University, Varanasi*

88 **Drummer**
Rajghat, Varanasi (Uttar Pradesh)
Gupta period, 5th century A.D.
Molded terracotta, 4.0 cm.
Bharat Kala Bhavan, Banaras
* Hindu University, Varanasi*

These three charming miniature musicians playing on drums represent typical amusements and relate to the playful *ganas* (dwarf attendants) that are frequently associated with Shiva images. Mirroring the activities of celestial musicians *(gandharvas)*, they indicate the value placed on entertainments by gods, kings, and rich merchants. Their curly hair and short *dhotis* are typical of Rajghat molded terracotta figures.

References:
S.K. Srivastava 1971, figs. 567, 573, 575.

150

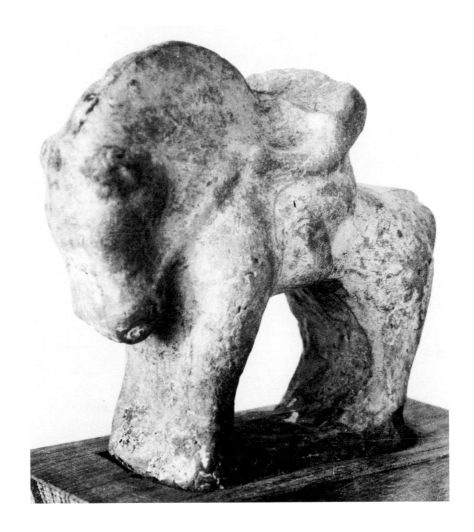

89 **Horse**

Rajghat, Varanasi (Uttar Pradesh)
Gupta period, 5th century A.D.
Molded terracotta plaque,
 7.5 x 8.5 x 3.0 cm.
*Bharat Kala Bhavan, Banaras
Hindu University, Varanasi*

This curved silhouette of a caparisoned
horse with rider invites comparison with
the molded Satavahana terracotta horse-
and-rider figurines of Paithan and Ter (see
fig. 8). The extended arc of the horse's
lowered head produces a compelling ener-
gy enhanced by the characteristic Rajghat
conventions of a majestic body and smooth
surface. The Satavahana terracottas, by con-
trast, are less graceful in proportion, with
their surfaces interrupted by much more
descriptive and ornamental detail.

151

90 Standing Vishnu

Uttar Pradesh
Gupta period, 5th century A.D.
Red molded terracotta plaque,
 25.8 cm.
Collection of Samuel Eilenberg
(Illustrated in color as frontispiece)

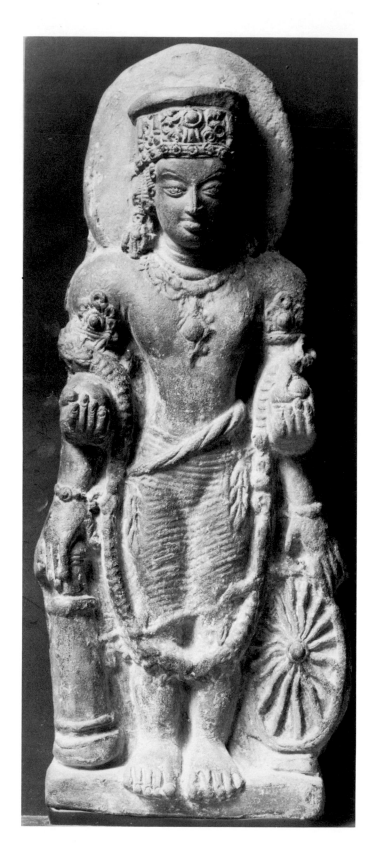

This Vishnu figure is a magnificent example of a terracotta image that follows the style of monumental stone sculpture. The god is identified by the attributes he holds in each of his four hands: the conch, the lotus bud, the mace, and the *chakra* (discus). He wears a pleated lower garment and a garland *(vanamala)* and is richly adorned with a decorated mitered crown, necklaces, earrings, armlets, and bracelets. His broad shoulders, tapered waist, and narrow hips are accentuated by the swelling curves of his torso.

These stylistic elements compare to a powerful fifth-century standing red sandstone Vishnu from Mathura now in the National Museum, New Delhi.[1] While the treatment of the upper and lower hands, the attributes of the divinity, and the stiff-legged stance are comparable to that seen in a fifth-century sandstone figure of Vishnu from Jhusi in the Allahabad Museum,[2] the shape and decoration of the crown are closely related to similar elements in a Bhinmal figure of Vishnu now in the Baroda Museum and Picture Gallery.[3]

What distinguishes this well preserved version in terracotta from the stone images of Vishnu is primarily the elaboration of each crisply delineated decorative embellishment: the Gupta-style curls, the strands of hair, the fingernails, the jeweled inlay, the individual flowers in the garland, and the striated garment are all characteristics of terracotta plaques. A fragmentary plaque found at Rajghat, and now in the Bharat Kala Bhavan, Varanasi, shows the lower part of the same subject, and may in fact come from the same mold.[4] Since the plaque shown here lacks an exact provenance, however, it is impossible to be certain.

Notes:
1. Harle 1974, fig. 49.
2. Ibid., fig. 62.
3. Ibid., fig. 87.
4. Srivastava 1971, fig. 543.

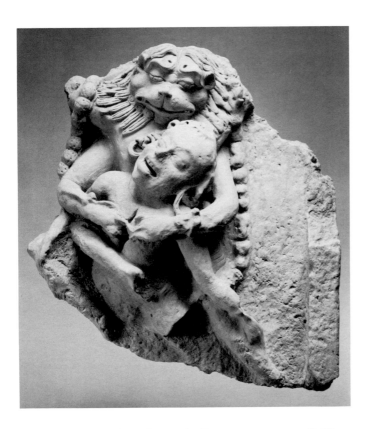

91 **Narasimha**

Uttar Pradesh
Gupta period, 5th century A.D.
Light-red terracotta relief tile,
 43.0 x 37.0 cm.
Pritzker Collection

The dramatically savage story of Nara-simha, the man-lion incarnation of Vishnu who disemboweled the demon-king Hiranyakashipu, occurs in its fullest form in the *Bhagavata Purana*. Hiranyakashipu was a sworn enemy of Vishnu who performed penance in order to be invulnerable to any deity, man or beast. But his invulnerability was only effective during the light of day and the dark of night. Hence Vishnu appeared at twilight, springing from behind a pillar in the form of a man-lion to vanquish the infidel demon-king.

Here Vishnu is shown with the head of a fierce lion and the body of a man, framed by a long garland *(vanamala),* one of his traditional attributes. His two lower hands rip the chest of Hiranyakashipu apart, the act made emphatically vivid by a slash carved in the clay. The facial features of the demon-king, a knarled brow and a strained expression, reveal his agony. According to the *Bhagavata Purana*:

> Narasimha stood before him
> with eyes fierce and fiery like
> molten gold, with matted
> locks and quivering mane,
> projecting tusks and a razor
> sharp tongue that flashed

like a sword, with pointed ears that stood erect and a mouth and nostrils as wide as a mountain cavern and a cleft chin that chilled the blood . . . with multiple arms reaching out in all directions, with claws for weapons.[1]

By the Gupta period, Narasimha's victory was a frequent subject in Indian art. The narrative was often depicted in a dynamic composition similar to the triangular arrangement common in images of Durga beheading the buffalo demon with her trident. In this example, however, the figures are aligned vertically as in late Kushan and early Gupta terracotta relief plaques with the Durga theme (see cat. no. 61). An independent sandstone image of Narasimha dated to the sixth century, now in the Los Angeles County Museum of Art, relates to the Pritzker terracotta in the physiognomy of Vishnu's lion face.[2]

Notes:
1. *Bhagavata Purana,* book 7, chap. 8, trans. Raghunathan 1976, I, pp. 608–614.
2. Pal 1978a, no. 52.

92 Vishnu's Battle with the Rakshashas

Uttar Pradesh
Gupta period, 5th century A.D.
Red terracotta relief tile,
 31.0 x 37.5 cm.
*The Brooklyn Museum 73.124;
 Gift of Dr. Bertram Schaffner*

Vishnu, the Hindu preserver of the universe, rides here upon his eagle mount, Garuda, shown in anthropomorphic form with widespread wings. Vishnu is four-armed and holds a bow in his upper left hand and a conch to his lips with his lower left; the two right hands are now missing. An attendant, who also has a bow in his outstretched arm, is at the deity's left.[1] Banerjee has suggested that the presence of the bow and the conch represents the *Uttarakanda* section (chap. 6–8) of the *Ramayana* (see cat. no. 93), in which Vishnu battles with the demon *rakshashas*. Vishnu, mounted on Garuda, disperses the

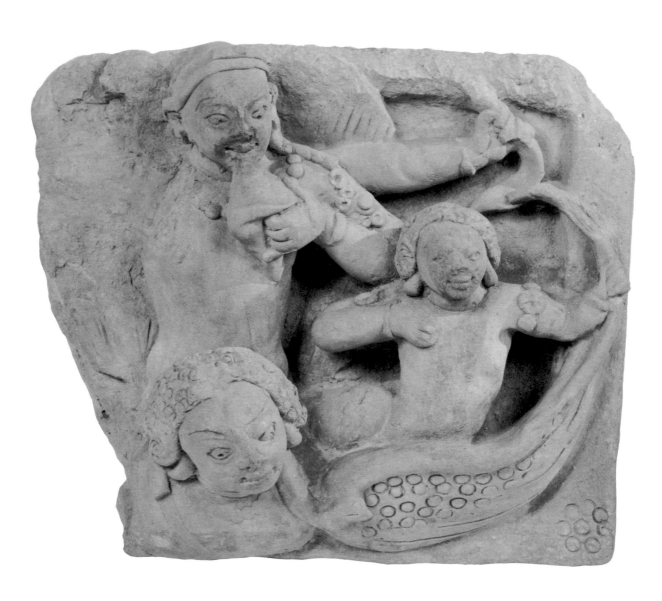

rakshashas (here not visible) with his arrows, using his conch to strike awe and terror in his adversaries.[2]

The Brooklyn panel is crafted in the regional style of Mathura, particularly in the modeling of the figures and in the Gupta-style curled hair, here articulated by stamped circles over the wiglike head-dresses and by circular punch marks over the wing and in the lower right corner. As in other Gupta terracotta reliefs, the hands are summarily modeled, but the heads are fully rendered, with arched brows, pierced eyes, and structured cheekbones—all of which lend expression to the group.

Notes:
1. The subject of Vishnu on Garuda occurs in other Gupta-period terracotta reliefs, including an elaborate version, from the region between the Ganga and Yamuna Rivers, now in the Goenka collection; see Paris 1979, no. 38. The central figure of Vishnu in the Goenka relief has the usual attributes and is accompanied by two attendants, one of whom is haloed. The background is comprised of the outspread wings of Garuda, an impressive addition to the iconographic scheme.
2. Banerjee 1985.

References:
Poster 1973, no. 52; Pal 1978a, p. 81, no. 28; Banerjee 1985; Huntington 1985, p. 216, fig. 10.38.

93 Ramayana Scene

Chausa (Bihar)
Gupta period, 5th–6th century A.D.
Red terracotta relief tile,
 52.0 x 39.4 cm.
Patna Museum, Patna
(Not in the exhibition)

Terracotta panels portraying scenes from the *Ramayana,* the epic describing the heroic exploits of the Hindu god Rama and his monkey cohorts, abound from the Gupta period. These relief tiles correspond to panels in stone, and, like the stone carvings, were used to enliven the narrative content of temple decoration.

The precise *Ramayana* episode portrayed here is not identifiable, but the complex composition of the monkeys and the human figure carrying a bow compares structurally to *Ramayana* scenes in miniature paintings. To the right of the (now headless) main terracotta figure, probably Rama, are four monkeys and two soldiers in high relief. Rama sits with his legs crossed and a long sword fixed at his side.

References:
C.C. Dasgupta 1961, fig. 144; Shere 1961, fig. 1; Dhavalikar 1977, pl. 82.

94 Rama and Lakshmana

Uttar Pradesh
Gupta period, 5th century A.D.
Red terracotta relief tile,
　　41.9 x 42.6 x 11.4 cm.
The Asia Society, New York;
　　Mr. and Mrs. John D. Rockefeller
　　3rd Collection
(Detail illustrated in color on cover)

Two figures, tentatively identified as Rama and his brother Lakshmana, sit together here in a plain arched niche. Their isolation against the background allows one to focus on their interaction: with their bodies turned slightly toward each other, they touch and gesture. Rama, the somewhat larger figure at the left, holds a bow in his left hand, and each figure wears a quiver of arrows attached by straps across the chest. The naturalness of the scene is further emphasized by the way in which the heads emerge from the border arch, enhancing a sense of three-dimensionality.

This tile conforms to the general style of Gupta-period terracotta modeling found throughout Uttar Pradesh, but a more specific attribution would be speculative. The piece was at one time attributed to Bhitargaon, one of the finest brick temples of the Gupta period, and it shares many stylistic affinities with terracotta plaques from that site.[1] Bhitargaon figures are characteristically seen in either frontal or three-quarter views, as here, and when seated they rest on the base of the panel, generally forming long, sweeping curvilinear compositions.[2]

The characteristic physical features of Bhitargaon figures also appear in the Asia Society terracotta: cascading looped curls, full lips, slightly bulging and elongated eyes, long flat earlobes, and long and slightly flattened fingers and toes. The torsos and limbs are also elongated and are modeled in high relief accentuated by incised lines that detail costume and ornament. The surface finish of Bhitargaon plaques is usually refined, although many remains are damaged, and the figures have a stature and presence that match the best of Gupta stone sculpture. Bhitargaon finds clearly depict *Ramayana* iconography, suggesting the hunters Rama and Lakshmana by the presence of a quiver of arrows.

Notes:
1.　　See Pal 1978a, pp. 75, 79, and no. 27.
2.　　The brick temple at Bhitargaon is one of the few surviving examples of Gupta-period brick temple construction. It is noted for large terracotta panels in high relief that were inserted into niches on the outer walls. These molded and carved bricks include representations of various Hindu subjects, as well as a variety of stylized floral motifs and geometric patterns; see Zaheer 1981.

References:
Pal 1978a, pp. 78, 79, and no. 27; The Asia Society 1981, p. 9; Huntington 1985, p. 216, fig. 10.39.

156

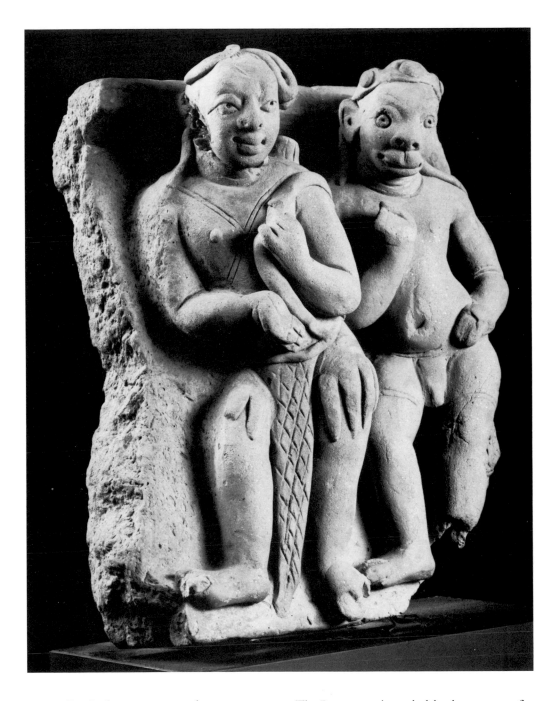

95 **Lakshmana and Hanuman (?)**

Uttar Pradesh
Gupta period, 6th century A.D.
Red terracotta relief tile,
 32.4 x 30.5 x 12.7 cm.
Collection of Mr. and Mrs.
 James W. Alsdorf

The *Ramayana* is probably also a source for the subject of this relief, which depicts a hunter accompanied by a monkey. The figures are most likely Lakshmana and his monkey lieutenant, Hanuman, but the absence of an inscription makes identification uncertain. The turn of the figures' slightly flexed bodies to the right and the projection of their heads out of the border of the tile evoke a rhythmic sense of movement.

157

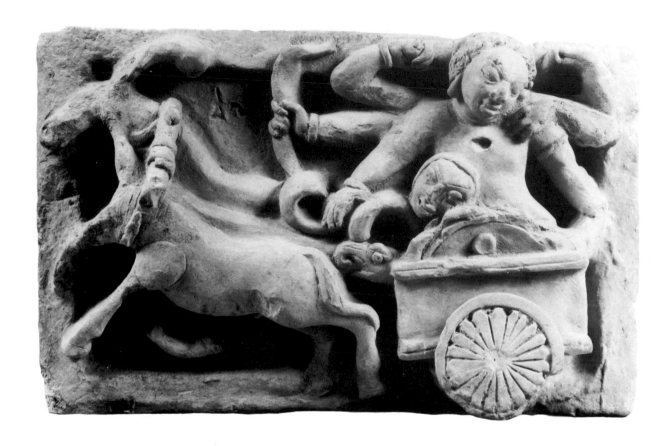

96 Charioteer

Uttar Pradesh
Gupta period, 5th century A.D.
Terracotta relief tile,
 32.0 x 49.5 x 13.0 cm.
Collection of Doris Wiener

The identity of the six-armed charioteer depicted in cat. no. 96 is unknown.[1] He drives a chariot led by plumed horses. The face at the figure's waist may be emblematic, but until the inscription in Gupta Brahmi script at the top center left is deciphered its significance remains unknown. The tile is carved in the typically high relief of decorated bricks from Gupta sites throughout Uttar Pradesh.

One stylistic feature that distinguishes this panel is the interest in defining depth and distance: the recession of the cart and the angle of the rear axle are attempts at perspective. The male with arm extended and bow in hand is a figural type repeated in other Gupta-period relief tiles, such as cat. no. 92, and relates to the pose shown in the archer-type coins of the Gupta emperors.

The panel with two seated figures (cat. no. 97) is here identified as a depiction

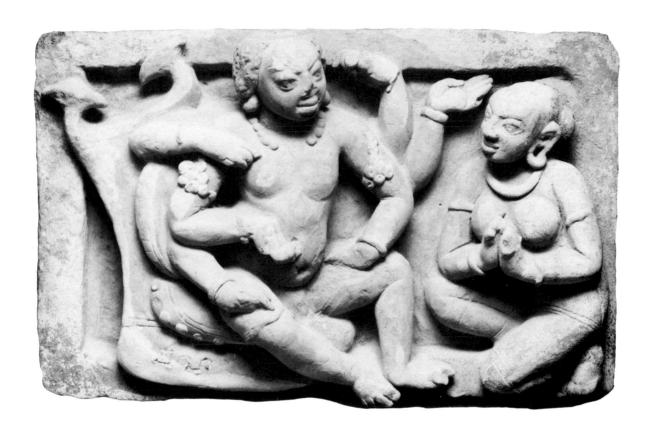

of Uma-Maheshvara (the deities Shiva and
Parvati). It may not be part of the same
narrative scheme, but coincidentally con-
tains, at the lower left, an inscription in
Gupta Brahmi characters similar to those in
the Wiener panel. At left, the six-armed
deity Shiva sits on a throne supported by a
bolster. To the right kneels Parvati, who
holds her hands in front of her in a pose of
adoration. In this distinctive work both fig-
ures are carved in three-quarter profile
within a wide flat border.

Note:

1. A closely related terracotta panel, probably
from the same site and depicting a male and a
female seated in a cart, is in an American private
collection. It has been suggested that this latter
panel may represent the abduction of Sita by
the demon Ravana, but the multi-armed figure
should not be confused with the demon, who is
usually described as ten-headed.

97 **Uma-Maheshvara**

Uttar Pradesh
Gupta period, 5th century A.D.
Terracotta relief tile,
33.0 x 50.8 cm.
Pritzker Collection

159

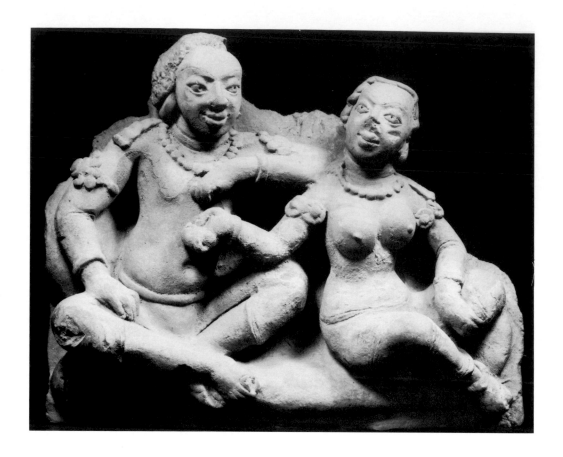

98 Seated Couple

Ahichchattra (?)
(Uttar Pradesh)
Gupta period, 5th century A.D.
Terracotta relief tile,
30.7 x 39.0 x 13.0 cm.
Collection of Robert H. Ellsworth

The Sanskrit word *ramana* (meaning "sensual enjoyment") is inscribed in Gupta Brahmi characters at the lower left of this piece.[1] As with the *mithuna* portrayals on Shunga-period plaques (see cat. no. 29), this sensual couple evokes worldly pleasure embodied in the potent male and voluptuous female, the procreative energy of nature. The representation of their emotion suggests the magic of erotic intoxication and brings to mind the Hindu belief that *kama*, or desire, is one of the four aims of life.[2] Their languorous interaction with arms touching is heightened by the ample forms of their bodies, expressive of the richness of life's pleasure.

The treatment of the faces and full modeling of the figures are features of Gupta style, as are the smooth surface planes, expressive composition, and deep undercarving of the panel. Although it has been suggested that the panel was produced in the region of Ahichchattra, the techniques and stylistic features are common to many sites of the period, and the facial features seem more characteristic of other sites in the region, such as Mathura or Bhind.[3] It is, therefore, difficult to give a definitive attribution to this piece.

Notes:
1. This inscription was read by Barbara Stoler Miller.
2. *The Kama Sutra of Vatsyayana,* chap. III, trans. Burton, p. 69.
3. For a Mathura example, see cat. no. 79; for an example from Bhind, see Harle 1974, fig. 147.

Reference:
Pal 1978b, no. 15.

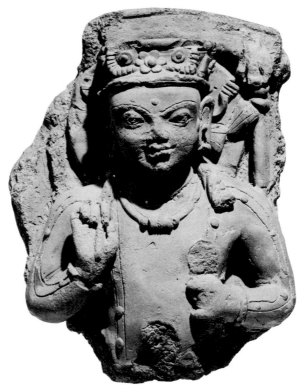

99 Kumara

Uttar Pradesh
Gupta period, 5th century A.D.
Red terracotta relief plaque, 43.0 cm.
The Brooklyn Museum 78.247.2;
Gift of Dr. and Mrs. Robert Dickes

This fragmentary relief tile representing the head and upper torso of a male deity is here tentatively identified as Kumara (also called Skanda or Karttikeya), the first son of Shiva and Parvati, and the general of the divine guards. But because the figure wears a long-sleeved cloak like the coat worn by Surya, the Sun God, we cannot be certain.[1]

Kumara is usually shown with a spear and less often holding a bird in his left hand at chest level—attributes known in early examples from the northwest.[2] He typically wears the northern style of dress (with Scythian tunic and boots). In sculpture from Uttar Pradesh, the deity is generally shown as a pot-bellied, *dhoti*-clad *yaksha* carrying a cup of wine and a purse. This unique image thus combines the northern and central Indian traditions of representation.

The figure is haloed and has a third eye and three folds of the neck, which confirms its identification as a deity; he holds an object (now missing but possibly a pot) in his left hand and a spear or what might be a trident *(trishula)* behind his left shoulder.

His right hand holds the stem of a flower, the flower itself now missing.

The figure appears here as a smiling youth with long, curled hair. His cap is decorated with flowers and garlands affixed by Shahi-type ribbons, which may be a variation of the type of headdress elements, related to Greek precedents, shown in certain fifth-century stone images of Vishnu from the region of Allahabad.[3]

Notes:
1. See R.C. Sharma 1976, pls. 38 and 74, for two Gupta-period stone images of Surya from Mathura.
2. For further information on early prototypical representations of Kumara in the northwest (Gandhara), see Pal 1977, pp. 21–26 and figs 13–15. Pal discusses images that conceptually (as "defender of the faith") and iconographically may relate to the figure here. In the northwest, none of the early images of Kumara has the peacock mount, but he is shown holding a spear and a bird and is depicted not as a pot-bellied figure but as a guardian wearing armor, as prescribed in the *Vishnudharmottara Purana* text.
3. See Harle 1974, p. 20.

The subject of a male riding an animal is known in every period of Indian art. But a youthful figure on the back of a dwarf is more unusual, and probably corresponds to an episode from the *Bhagavata Purana*:[1]

> Pralamba, the great Asura, carried the son of Rohini; and deciding that Krishna would be too formidable a foe to face, swiftly took Him [Rama] much farther than where he should have set Him down. As he carried Him, who was heavy as a mountain, the powerful Asura found the speed of his movement checked; so he assumed his own form. Adorned with gold ornaments as he was, he looked like a cloud lit up by lightning, carrying the moon. On seeing him, with his burning eyes and knitted brows, his fierce tusks and flaming mane, and the wonderful brilliance of his rings and crown and ear-pendants, flying with dizzy speed in the sky, the Bearer of the Plough was somewhat shaken. Then Bala recollected Himself, and as His foe was bearing Him away like a prize along the sky, wrathfully knocked him on the head with His fist with all the force of a thunderclap, like the Lord of the gods striking a mountain.[2]

In the terracotta depiction of the episode shown here (cat. no. 100), the god Balarama (armed with a plow) is dramatically poised with his hand raised to lay the powerful blow to the demon Pralamba. He is seated on the shoulders of the grimacing demon dwarf, whose legs are drawn up to evoke a sense of flying, as if he were a wingless celestial being. Movement is conveyed by the fluttering scarf ends, which reach the dwarf's shoulders; Balarama holds on to the dwarf's hair, which is arranged in rows of tight curls. His eyes are open wide, but the pupils are not indicated. The figure and his demon support were originally isolated against an undecorated ground, but most of the border has not survived.

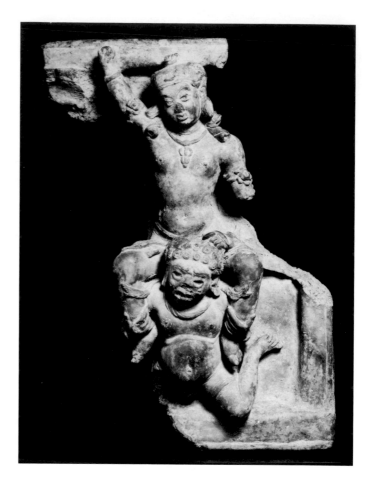

100 **Balarama Abducted by Pralamba**

Uttar Pradesh
Gupta period, 5th century A.D.
Red terracotta relief tile,
 55.8 x 38.0 cm.
Private Collection
(Illustrated in color on page 16)

162

A stylistically related terracotta panel fragment (cat. no. 101) may possibly represent another episode of the *Bhagavata Purana,* Krishna holding up Mount Govardhana:

> Saying this, Krishna plucked the Govardhana mountain with one hand and held it up playfully as a child might a mushroom. And the Lord told the cowherds, "O father and mother, and you, people of Vraja, get in the mountain-hollow with the cattle and settle yourselves there in comfort. Have no fears about the mountain falling from my hand. And you will have no worry from wind and rain. Here is shelter for you."[3]

This heroic aspect of the god Krishna protecting the cowherds of Vraja from Indra's rath and proving his strength is well known in Gupta-period sculpture.[4] In the panel here, the figure wears the same youthful hairstyle and ornaments as Balarama and raises his right arm in a similar manner. The mountain, Govardha, and the figures of the herdsmen or cattle would have been part of the original tile.

In both panels, the deities are depicted frontally, even though the heads of the main figures tilt to one side. They wear short *dhotis* and waving scarves, the latter a convention signifying movement. The actual provenance for these panels is unknown, but they conform stylistically to brick relief tiles of the Gupta period throughout the region of Ahichchattra (see cat. nos. 74 and 75) in their high relief, the naturalism of the figures, and the way in which the limbs of the figures break into the tile border.

Notes:
1. John S. Hawley kindly suggested the identity of the subject as the *Pralambavadha.* See also Kala 1980, fig. 280, for another representation of this subject in a Gupta-period terracotta relief.
2. *Bhagavata Purana,* book 10, chap. 18, trans. Raghunathan 1976, II, pp. 235–237.
3. Book 10, chap. 25; ibid., II, pp. 257–259.
4. See Harle 1974, pl. 63, for a monumental fifth-century example in sandstone.

101 **Govardhan Krishna**

Uttar Pradesh
Gupta period, 5th century A.D.
Red terracotta relief tile, 35.5 cm.
Pritzker Collection

102 **Makara**

Uttar Pradesh
Gupta period, 5th century A.D.
Red molded terracotta brick,
 21.0 x 62.3 cm.
The Brooklyn Museum 69.127.1;
 Gift of Dr. Bertram Schaffner
(Not in the exhibition)

Carved bricks in the form of mythical animals like this *makara*—a sea monster that is part crocodile, part fish—are often points of departure for the craftsman's fancy. In many Gupta-period examples, the *makara*'s tail is beautifully worked into serpentine vine tendrils.[1] Often the sea monster's head and snout resemble that of an elephant, while the body may be covered with punched circles to indicate the reptilian skin. This playful animal with its blunt snout, wide staring eyes, gaping mouth, exposed teeth, and short front legs is often used in Gupta-period temple decoration as the vehicle of the river goddess Ganga. There are many especially fine examples in stone from the period.

Note:
1. See Zaheer 1981, figs. 170–179. A *makara* panel comparable to the Brooklyn panel, except with the monster facing right, is in the collection of the Ashmolean Museum, Oxford.

Reference:
Poster 1973, no. 53.

164

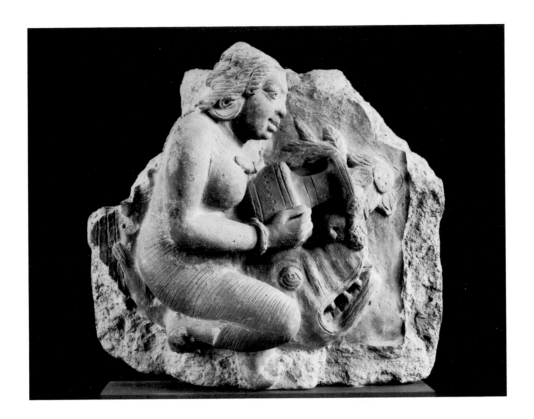

103 Ganga

Uttar Pradesh
Gupta period, 5th century A.D.
Red terracotta relief tile,
 32.5 x 35.4 cm.
Staatliche Museen Preussischer
 Kulturbesitz, Museum für Indische
 Kunst, West Berlin

This terracotta panel, carved in high relief, depicts a female riding a sea monster. The figure represents Ganga, mother-goddess of the sacred river. She holds a water pot with various flowers (including the lotus, her emblem) and straddles the *makara,* her traditional vehicle.

The goddess Ganga appears on temporary clay sculptures for various festivals. Images of the two main river goddeses, Ganga and Yamuna (who stands on a tortoise), usually flank the doorways of Hindu temples as propitious deities. A pair of massive mid-fifth-century terracotta plaques depicting Ganga standing on a *makara* (see fig. 3) and Yamuna standing on a tortoise are part of a large group of terracotta plaques from Ahichchattra in the National Museum, New Delhi.¹ Harle has described these monumental Ahichchattra terracot-

tas—each is 176 cm. high—as the quintessential examples of the Gupta idiom because of their realism, the caricature of the goddesses' diminutive attendants, and the grace of the main figures.²

The Berlin plaque demonstrates similar stylistic qualities and probably comes from a site in Uttar Pradesh. The animated posture of the figure and the reduction of ornament are Gupta-period conventions, but the portrayal of Ganga astride the *makara* is atypical.³

Notes:
1. Harle 1974, pl. 139; Dhavalikar 1977, pl. 87; Huntington 1985, fig. 10.37.
2. Harle 1974, p. 56.
3. Harle 1974, pl. 148 and p. 57 (as "probably region of Mathura c. A.D. 450").

165

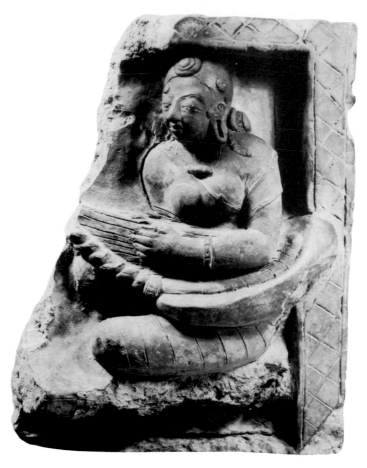

104 **Lady with a Lute**

Uttar Pradesh
Gupta period, 5th century A.D.
Red terracotta relief tile,
33.0 x 23.5 x 8.2 cm.
Collection of Mrs. Robert M. Benjamin

In its conception and pose, this seated female figure bears a striking similarity to the so-called "lyre-type" coin of the Gupta emperor Samudragupta (circa 330–370 A.D.).[1] In ancient India, such high value was placed on musical skill that court ladies and even the emperor himself were taught to perform. Evidence of this practice is given in the plays of Kalidasa,[2] as well as in the *Kama Sutra,* where the performance of instrumental music was considered, after singing, as the second of the sixty-four arts to be practiced by the daughters of princes as well as by courtesans.[3]

The lute depicted in this plaque differs from the modern *vina.* Like similar examples known from sculptures at Bharhut and Amaravati, it has a hollow gourd covered with a board over which the strings are stretched. Stylistically, the figure carved on the panel relates to the Bhitargaon type (see cat. no. 94), but no specific attribution can be determined.

Notes:
1. Altekar 1957, pp. 73–76.
2. Ed. Miller 1984, p. 133.
3. *The Kama Sutra of Vatsyayana,* chap. II, trans. Burton.

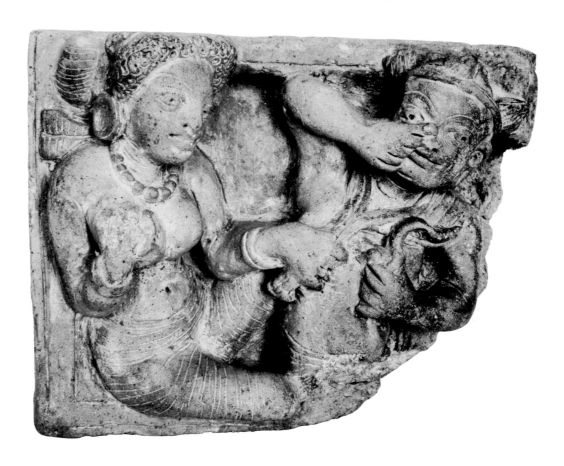

105 Sportive Couple

Jamuna River, near Ishafar
 (Uttar Pradesh)
Gupta period, 5th century A.D.
Red terracotta relief tile,
 22.8 x 29.2 cm.
Government Museum, Mathura

This humorous scene reveals a side of Gupta terracotta art that is rarely found in stone sculpture of the period. The two playfully quarrelsome figures take the viewer into a more immediate world of everyday life. Depicted in high relief, as if on a window ledge, the seated couple has been described as a "lady pulling the scarf of a man who seems busy in a ritual performance *(Pranayama)*. He reminds one of the *vidushaka*, a court jester, who frequently figures in Sanskrit plays, whose duty was to amuse the royal family by his funny speech, overeating, and other humorous actions. . . ."[1] Of perhaps similar inspiration are the Kushan-period stone pillar motifs of figures peering out windows. As in other terracotta plaques, the facial expression, dress, and ornament relate to the current fashion.

Note:
1. R.C. Sharma 1976, p. 27.

Reference:
R.C. Sharma 1976, fig. 14.

106 Bust in a Niche

Uttar Pradesh
Gupta period, 5th century A.D.
Red terracotta relief tile,
 24.2 x 25.0 x 15.0 cm.
Collection of Robert H. Ellsworth

The depiction of the head and shoulders of a male in a niche draws its inspiration from an ancient Indian tradition of architectural decoration dating from the first century A.D. Similar in composition to the row of figures conversing on the wall plaques at Harwan (see cat. nos. 63 and 64), it is a particularly popular convention in Gupta-period brick architecture, where the figure peering out a window is an integral part of the scheme of the upper tiers of temples. There are many well preserved plaques of this type from Bhitargaon and other sites.[1]

Such panels usually show a human head or the upper portion of a figure peering out of a semicircular frame or dormer window. The figures are probably secular, since no divine attributes are indicated. The isolated face in this panel is sculpturally modulated in high relief. The wiglike hairstyle and heavy pendant earrings are common Gupta features of terracottas from Uttar Pradesh.

Note:
1. Zaheer 1980, pp. 77–81.

168

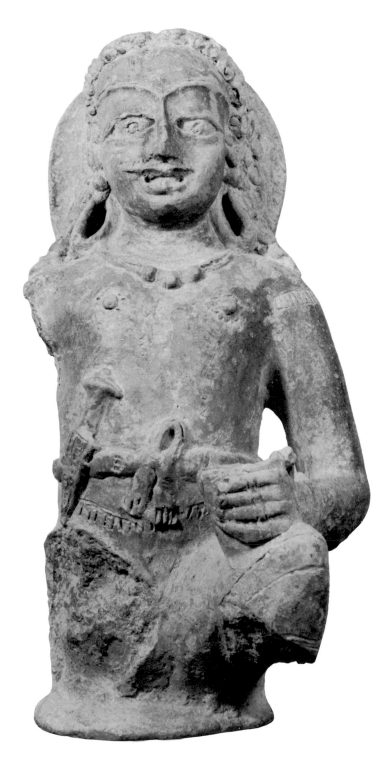

107 Seated Princely Figure

Mathura region
 (Uttar Pradesh)
Gupta period, 5th century A.D.
Red hand-modeled terracotta,
 52.0 x 24.0 cm.
Collection of William H. Wolff

Seated on a hassock in the so-called European posture *(paryankasana),* this figure is similar to seated figures of the Kushan period, primarily those from the region of Allahabad, such as mothers with children, *yakshas,* or the goddess Hariti (see cat. no. 57).[1] Except for the aureole behind his head, he wears the accoutrements of a chieftain rather than those of a deity. (In Gupta imperial coins, the aureole is often used to indicate the king.[2]) The figure's remaining hand rests on his lap holding a cup, an object that may be associated with a ruler's customary participation in the *soma* ritual ceremony. He is simply garbed, with a jeweled ornament and a short dagger tied to his waist. His masklike face lacks the third eye, and he wears a long curled wig and a mustache.

There are several Gupta-period representations in stone of male deities seated in this posture, and Gupta coins often depict reigning kings, like the present figure, seated on a wicker hassock. A second seated terracotta figure of similar dimensions and crude construction exists, but it is also unidentified.[3] Both figures are modeled in the round, and both share certain stylistic characteristics of Gupta-period physiognomy with figures in terracotta relief tiles from Mathura.

Notes:
1. An example of a Kushan-period seated *yaksha,* possibly from Kaushambi, is in the Cleveland Museum of Art (Czuma 1985, cat. no. 54). It, in turn, recalls the Shunga-period seated male figure in terracotta from Mathura published by R.C. Sharma 1976, fig. 8.
2. See Altekar 1957, pls. I–XVI.
3. See Pal 1978a, no. 26.

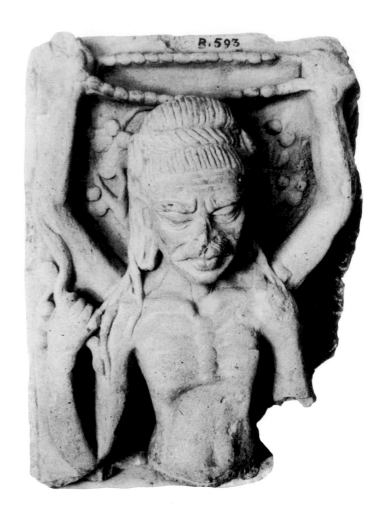

108 Four-Armed Ascetic

Shravasti (Uttar Pradesh)
Gupta period, 6th century A.D.
Terracotta relief tile,
31.8 x 25.3 x 12.1 cm.
State Museum, Lucknow

Narrative motifs are commonly portrayed as intense dramatic images in Gupta temple relief sculpture. The expressive rendering of deities is more characteristic of Gupta-period terracotta sculpture, which does not conform to customary iconographic models, than it is of bronze or stone sculptures of the period.

This poignantly realistic naked mendicant with four arms holds a rosary above his head with his two upper hands and a bow or some other object in his lower right hand. His lower left hand is missing, and the brick ends at the figure's waist. The deep-set eyes, the prominent rib cage, and the sunken abdomen heighten the effect of the ascetic.

The four arms indicate the divinity of this emaciated male. He has been identified as the god Shiva, the supreme ascetic,

performing austerities.[1] Though the god's third eye and other common identifying features—the crescent moon in his hair, the antelope skin, the snakes, and the trident—are not present, the rosary, the matted locks arranged in a *jata* (topknot), and the three incised lines in his forehead (the *tripundra* mark) all point to Shiva. The forest setting, often associated with Shiva's expiation, is suggested by a tree carved in low relief behind the figure.

Note:
1. Dhavalikar 1977, p. 62, refers to the legend of Shiva's wandering as a beggar to expiate his sin of cutting off the fifth head of Brahma, the Hindu Creator.

References:
Harle 1974, pl. 149; Dhavalikar 1977, pl. 83; Huntington 1985, p. 217, fig. 10.40.

170

109 **Goose**

Nagari (Rajasthan)
Possibly Gupta period or later
Terracotta relief tile, 25.5 x 33.0 cm.
Deccan College, Pune

Naturalistic birds and animals, as well as mythical beasts, are portrayed in relief tiles from various Gupta sites. The grazing goose *(hamsa)* is a frequent motif on decorative friezes of Indian temples, earlier instances of which can be found in sculpted panels at Amaravati, a major south Indian Buddhist site active in the first to third centuries A.D.

The present panel is difficult to date. Though assigned to the Gupta period on stylistic grounds, it may be of even later date; a more definitive dating depends on the dating of the Nagari finds, which is still in progress. Comparable animal tiles, such as the decorative plaques depicting geese on the shrines of such sites in eastern India as Paharpur, are dated variously from the Gupta period through the eighth to ninth centuries.[1]

Note:

1. For the terracotta *stupa* of Somepur at Paharpur (Bengal), see K.N. Dikshit 1938, which argues for an eighth-century date. The terracottas discovered at Nagari, on the other hand, were not given a date; see Bhandarkar 1920.

171

110 Four-Armed Ganesha

Uttar Pradesh
Gupta period, 6th century A.D.
Red terracotta relief tile,
 49.1 x 67.0 cm.
The Kimbell Art Museum, Fort Worth

Ganesha, the elephant-headed son of Shiva and his consort Parvati, is humanized in many guises as the god of benevolence in Gupta-period terracotta sculpture.[1] Ganesha is the Remover of Obstacles, bestower of good fortune, prosperity, and health. He may be depicted as an independent standing or seated figure, or as part of a figural group, as when he represents the second son of Shiva and Parvati or the chief of the *ganas* (attendants to Shiva).

This relief shows a seated Ganesha endowed with the usual prominent belly and raised jeweled ornaments symbolizing noble masculine strength. A snake is coiled to form the sacred thread that hangs tautly from his shoulders across his distended stomach. The elephant's thin concave ears and long trunk looped to one side are characteristic, as is the severed right tusk, here only partially visible. Due to the present condition of the relief, it is no longer possible to identify the deity's usual attributes (an axe, a rosary, a bowl of sweetmeats), which would be held in his two raised upper arms or in his lower left hand, now missing.

This dramatically modeled and finely detailed representation surpasses most Gupta-period formalistic portrayals of Ganesha and probably dates from the end of the period.[2] The elaborate aureole and wreathlike crown, as well as the pair of flying attendants (*gandharvas*) at the top corners, are rarely depicted in early stone carvings of the subject. The arrangement of details anticipates the complex compositions of medieval Ganesha reliefs.

Notes:

1. There are several terracotta figures representing a seated Ganesha, such as a fragmented relief plaque from Bhitargaon, as well as a terracotta plaque from the same temple, now in the State Museum, Lucknow; the latter depicts an animated figure of Ganesha protecting the sweetmeats; see Zaheer 1981, pls. 64 and 85, respectively. The prevalence of these two aspects of Ganesha demonstrates the existence of both iconic and narrative subjects in the Gupta repertory of terracotta art.

2. For a sixth-century stone carving representing Ganesha with a serpent-form sacred thread, see Paris 1978, no. 54, and Bussagli/Sivaramamurti 1978, fig. 151, a schist relief from the Museum and Picture Gallery, Baroda.

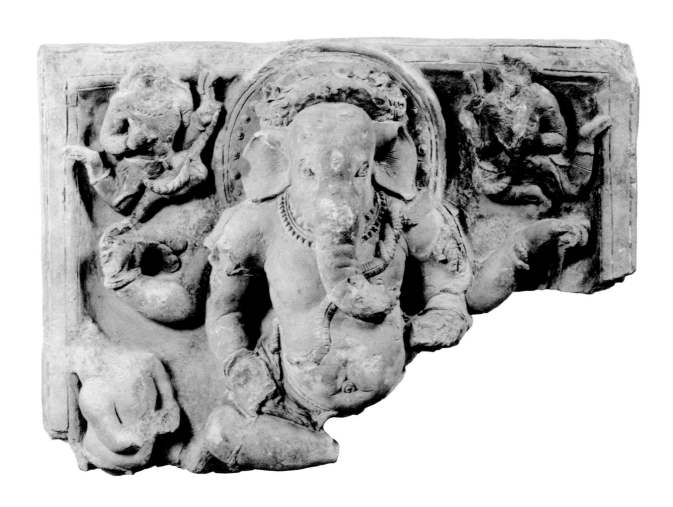

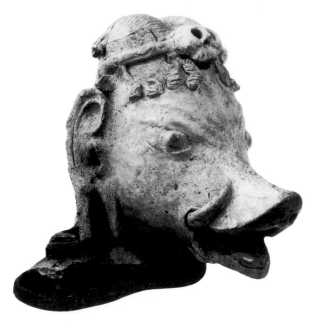

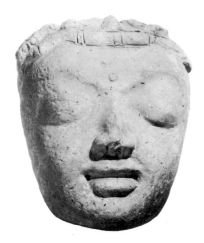

| 111 | **Head of Varahi** | 112 | **Female Head** |

111 **Head of Varahi**
Panna, Midnapore District
 (West Bengal)
Late Gupta period
Hand-modeled terracotta, 29.0 cm.
*State Archaeological Museum
 (West Bengal), Calcutta*

112 **Female Head**
Panna, Midnapore District
 (West Bengal)
Late Gupta period
Hand-modeled terracotta, 13.0 cm.
*State Archaeological Museum
 (West Bengal), Calcutta*

Panna is the site of a recent discovery of several almost life-size terracotta heads and a well preserved relief tile representing a seated Buddha in the *dharmachakramudra* gesture. These finds are ascribed on stylistic grounds to the fifth to sixth centuries.[1] The Panna heads, as shown here, are carved in the round.[2] Sensitively modeled, with intricate details of physiognomy, each is covered with a tannish-ocher slip that evens out the rough spongelike surface.

The boar-shaped head seen here (cat. no. 111) represents Varahi, the consort of Vishnu's boar incarnation and one of the seven mother-goddesses. With its mouth agape, wide-open staring eyes, upturned tusks, long ears, and furrowed brows, it is one of the boldest forms in terracotta from eastern India. A jeweled tiara consisting of pendant elements and a braided rope headband converts the starkly realistic boar's head into a religious icon.

Gupta-period terracottas from Bengal are uncommon. Frederick Asher has noted the significance of post-Gupta terra-

cotta sites in Bengal, suggesting that terracotta replaced stucco as a more durable medium for brick temple ornamentation in the region. But the present terracotta heads demonstrate that terracotta workshops preceded the proliferation of brick temple architecture in Bengal.[3] The sites were situated on a well-known commercial route between the Magadha centers and the eastern seaport of Tamralipta (now Tamluk), and the Buddhist plaque at Panna may provide a clue to their importance as religious centers as well.

Notes:
1. Asher 1980, p. 33. The Buddha plaque (now in the Asutosh Museum, Calcutta) is reproduced in *Indian Archaeology: A Review* (1957–58), pl. LXXXVIIb. The plaque is rectangular in shape, its height is 18.6 cm., and the Buddhist creed is inscribed on both sides of the figure.
2. See Asher 1980, pl. 39, for a third head in the Asutosh Museum.
3. Ibid., p. 34.

Reference:
(Cat. no. 111) Biswas 1981, pp. 30–31, pl. LXII.

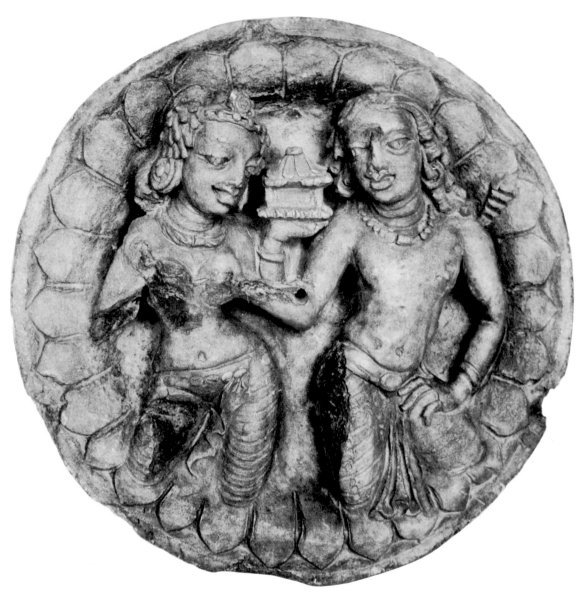

113 Mithuna

Mahasthangarh, Bogra District,
 Bangladesh
Pala period, 8th century A.D.
 or earlier
Terracotta relief tile, 34.5 cm.
Indian Museum, Calcutta

During the post-Gupta period, eastern Bengal stood out for its magnificent brick temples, built through both royal and merchant patronage. Although terracotta plaques and figures dating from Maurya times have been found throughout eastern Bengal, the region is also known for its carved and molded panels from Hindu and Buddhist sites of the Gupta period through the ninth century. Monumental edifices incorporating terracotta tiles in their decorative schemes were more prevalent than miniature art in this period. Mahasthangarh, Paharpur, and Mainamati are outstanding among the brick temple remains in what is now Bangladesh. The terracotta tiles from these sites demonstrate that the Gupta terracotta tradition had been transmitted eastward to areas under Gupta control.

In the roundel from Mahasthangarh shown here (cat. no 113), a male and female couple is surrounded by a border of repeated lotus petals.[1] The subject is generally referred to as a *mithuna* (see cat. no 29) or

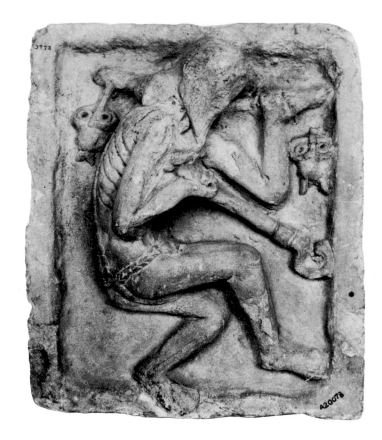

114 Mendicant

Paharpur, Rajshahi District,
 Bangladesh
Pala period, 8th century A.D.
Terracotta relief tile, 34.9 cm.
Indian Museum, Calcutta

dampati. Engaged in conversation, the figures assume gracefully swaying poses, the male reaching out to the female, who holds a casket in her left hand. The three-dimensional form, typical of Mahasthangarh relief tiles, is achieved by high-relief carving augmented by great attention to the posture and elaborate hairstyles.

The emaciated and naked mendicant from Paharpur (cat. no. 114) and the animated buffalo scratching its ear from Mainamati (cat. no. 115) are among the customary subjects depicted in terracotta plaques on the lower friezes of brick *stupas*. They present an observation of life at the time, perhaps a more informal approach to the joys and sorrows of life than the main Buddhist images in stone, stucco, or bronze.

Paharpur and Mainamati were important Buddhist centers in the medieval period, and the terracotta panels from there show stylistic and iconographic features that place them slightly later than the sculpture from such great Buddhist monasteries as the one at Nalanda, a site located further to the north in Bihar.[2] Nalanda's great *stupa* is built of brick with impressive life-size Buddha images carved in stucco. Temple decoration in contemporaneous Bangladesh was by comparison restrained, the figures more simply embellished and isolated within the borders of the brick panels.

Notes:
1. Mahasthangarh was a major commercial center in the Gupta era and was located on the main trade route from Magadha.
2. See Asher 1980, pp. 91–92.

References:
Biswas 1981, pls. LXVII, LXXIIa, and LXXVIII.

176

115 **Buffalo**
Mainamati, Comilla District,
 Bangladesh
Pala period, 9th century A.D.
Terracotta relief tile, 25.1 cm.
Indian Museum, Calcutta

116 Seated Buddha

Antichak, Bhagalpur District
(Bihar)
Pala period, 8th century A.D.
Terracotta relief tile,
33.0 x 26.0 x 7.0 cm.
Archaeological Survey of India, Patna

Antichak is believed to be the location of the ancient monastery of Vikramashila, one of the principal Buddhist sites in eastern India. The extent of the remains suggests that the site was a center of Buddhist worship that was probably established during the reign of Dharmapala (circa 783–818), the Pala monarch and patron of several major religious establishments; the monastery remained active through the twelfth century.[1] The terracotta panels shown here were found at the site, and represent the earliest period of activity. Although elaborately detailed limestone sculptures have also been found at Antichak, they differ significantly from the terracotta tiles, which are generally freer representations of solitary deities or playful secular figures.

A similar monumental brick *stupa* adorned with terracotta panels is located at Paharpur in Bangladesh (see cat. no. 114). This site compares to Antichak not only stylistically but architecturally as well. Both contain tiered cruciform-plan brick monuments, although at Paharpur a number of stone panels are inserted into niches along a lower terrace of the *stupa*.[2] The official excavation reports for the two sites have not yet been released, but publications suggest

that there may have been a local style from the same or a related terracotta workshop.[3]

Among the extant terracotta images from the Vikramashila *stupa* at Antichak are seated Buddhas, *bodhisattvas* (enlightened beings), and various seated deities interspersed with animals and plants that were placed along the lowest register of the *stupa*.[4] The seated Buddha shown here in the earth-touching gesture of Enlightenment (cat. no. 116) is a type often repeated at the site. The subject is frequently found at Buddhist monuments of the period. Although the face of the Antichak seated Buddha is now obliterated, the placement and shape of the halo and the high *ushnisha* (cranial protuberance), along with the gesture, suggest an association with Bodh Gaya, the place of Buddha's Enlightenment, indicating both a stylistic affinity with early Pala-period sculptures at the Bodh Gaya temple and the importance of Enlightenment in contemporaneous Buddhist practice.[5] The monastic garment covers only the figure's left shoulder, and the waist is tapered without the characteristic bulge of the stomach.

A comparable terracotta Buddha panel at Paharpur shows stronger ties to

178

117 **Star-Shaped Plaque**

Antichak, Bhagalpur District
 (Bihar)
Pala period, 8th century A.D.
Terracotta relief, diam. 28.5 cm.
Archaeological Survey of India, Patna

Gupta style than generally seen in contemporaneous stone images from this region.[6] The posture of the Paharpur Buddha is the same as the Buddha in the Antichak panel, but the treatment of the Paharpur Buddha figure is fuller, with a more conventional aureole and *ushnisha*.

The circular panel depicting an eight-lobed star-shaped design at the center (cat no. 117) exemplifies the finely crafted decorative panels also common at Antichak. Such high-relief geometric panels with a border of beads are typical.

Although the stylistic precedents for Antichak and Paharpur probably came from stone and brick monuments in the Magadha region to the west, especially Bodh Gaya and Nalanda (550–750 A.D.), the recent discovery at Panna of a terracotta plaque depicting a seated Buddha in the *dharmachakramudra* gesture and of several finely sculpted terracotta heads stylistically ascribed to the fifth to sixth centuries indicates at the least that there was a terracotta tradition in the area in the period immediately preceding these brick Buddhist monuments.[7] Panna, near Tamralipta (now Tamluk), is situated on the ancient route that connected Magadha with the sea. The questions that remain are why clay became the preferred material at these major post-Gupta sites, whether the artisans who designed them could have been brought from elsewhere to establish a terracotta workshop in the region under royal patronage, and if so, where they came from.[8]

Notes:
1. Huntington 1984, p. 126.
2. Asher 1980, p. 91.
3. For the excavation reports, see *Indian Archaeology: A Review* (1960–61 through 1970–71) and Dikshit 1938.
4. See Asher 1980, pls. 196–199, 209–214, for illustrations of other examples of Vikramashila terracottas in situ.
5. See Huntington 1984, p. 96.
6. Asher 1980, p. 92 and pl. 216.
7. Ibid., pp. 33–34. Post-Gupta terracotta sites such as Panna and Chandraketugarh provide evidence for the existence of terracotta workshops before the influx of brick temple architecture in Bengal. For an illustration of the Panna Buddha plaque, see *Indian Archaeology: A Review* (1957–58), pl. LXXXVIIb.
8. Asher 1980, p. 91. Asher has suggested that the artisans who built the brick monasteries may have been brought to the sites from places in north-central India, such as Ahichchattra or Bhitargaon.

118 Mandala

North India, 8th–9th century A.D.
Gray terracotta, 12.1 x 11.4 cm.
*The Metropolitan Museum of Art,
New York; Rogers Fund, 1933*

This votive plaque represents a compartmentalized *mandala* (cosmic diagram). The central figure of a Buddha is surrounded by eight figures of equal size, each in its own niche, holding a lotus and seated on another lotus. The type is ordinarily associated with the eastern Indian Buddhist iconography at Nalanda (see cat. nos. 113–115). The central Buddha, seated cross-legged on a lotus pedestal with his hands raised in the *dharmachakramudra* as he turns the Wheel of the Law, recalls the famous fifth-century seated image of Buddha preaching his first sermon in the deer park at Sarnath. But with the actual wheel and the deer missing, the hand gesture and the feet crossed in the lotus posture *(padmasana)* may simply indicate that the Buddha is preaching. Stylistically, the occurrence of figures with long curly coiffures recalls the Gupta-period molded terracotta figures from Rajghat (see cat. nos. 82–84).

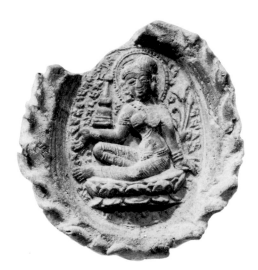

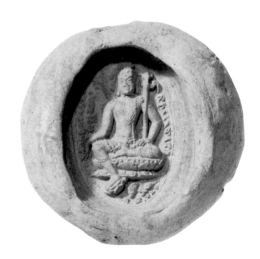

119 Seated Tara

Eastern India
Pala period, 8th–9th century A.D.
Terracotta plaque, 7.0 x 6.5 cm.
*The Brooklyn Museum 84.184.4;
Anonymous gift*

120 Seated Bodhisattva

Eastern India
Pala period, 8th–9th century A.D.
Terracotta plaque, diam. 6.5 cm.
*The Brooklyn Museum 84.184.2;
Anonymous gift*

180

There are numerous stamped plaques of Buddhist images like the three selected here. Produced for reverent pilgrims as souvenirs, these miniature terracottas often depicted either *stupas,* isolated divine figures in high relief, as here, or narrative scenes of *bodhisattvas* (enlightened beings) surrounded by devotees; they may have functioned as reminders of holy images on the great *stupas.* In each of these examples, a deity framed by a precise niche is posed with studied gestures and symbols. The forms of the figures are three-dimensional and are formalized through precisely rendered surface details. The Buddhist creed is inscribed in the background of each plaque in *nagari* script, and applied decorative borders suggest a flame-aureole motif.

These plaques are iconographically consistent with both Buddhist stone sculpture and brick temple decoration of the period.[1] While they portray similar popular Buddhist themes, such as the goddess Tara associated with her counterpart the Bodhisattva Avalokitesvara, they are somewhat less schematized and mechanical than contemporary monumental temple plaques and stone sculptures from Gaya District (Bihar).[2] Some of the more characteristic elements of these plaques are the asymmetrical poses of the seated figures and the variety and complexity of hairstyles. The figures carry requisite attributes, such as the lotus stalk held by both Tara and the *bodhisattva.* Certain idiosyncratic details of style, such as the form of the *stupa* in the Tara plaque or the shape of the lotus fronds, are related to features found in miniature details on the large stone steles of the Pala period in Bihar.

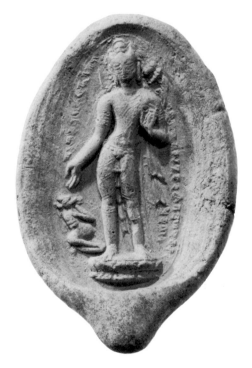

121 **Standing Bodhisattva**
Eastern India
Pala period, 8th–9th century A.D.
Terracotta plaque, 10.0 x 6.5 cm.
The Brooklyn Museum 84.184.3;
 Anonymous gift

Notes:
1. See Huntington 1984, p. 127, for illustrations of Bodh Gaya relief sculpture in the tenth to eleventh centuries.

2. Ibid., p. 126, for a discussion of Pala stone sculpture and related terracotta.

181

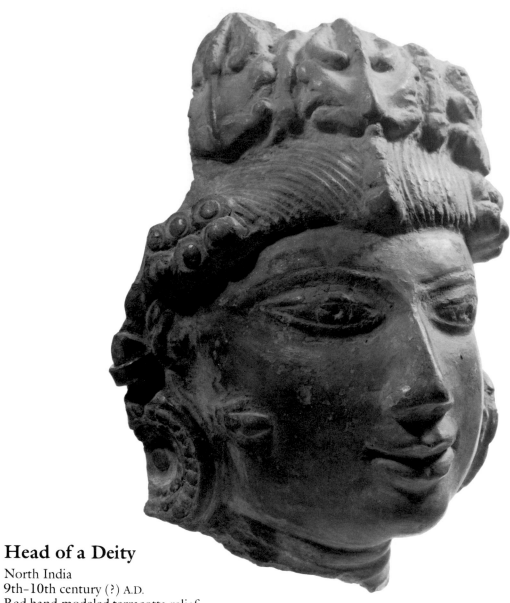

122 Head of a Deity

North India
9th–10th century (?) A.D.
Red hand-modeled terracotta relief,
 12.7 x 9.8 cm.
Collection of Mr. and Mrs.
 John G. Ford

The majesty of the great dynasties of the
north is evoked in this fragment of a head.
Although its exact provenance remains un-
certain, the physiognomy, the supple struc-
ture of the face, the elongated almond-
shaped eyes, the long nose and slightly
everted lips, the molded ornamental details
of the coiffure—surmounted by a *kiriti-
mukha* (lion's face) motif—and the large ear
plaques all suggest a North Indian origin.
The burnished surface no longer shows any
traces of original paint.

182

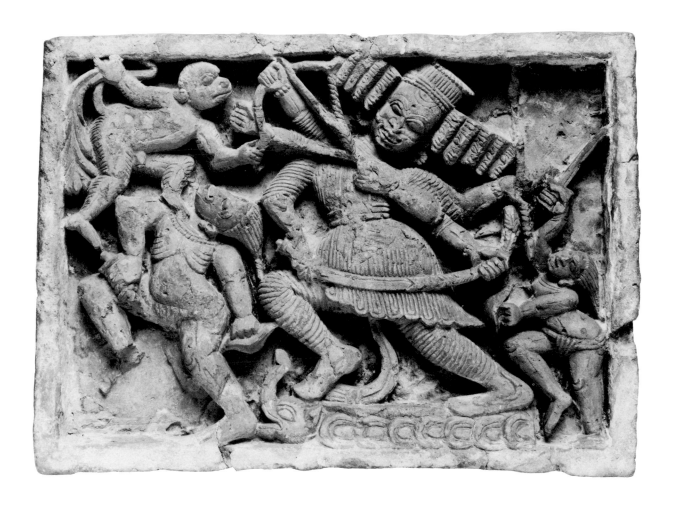

123 **Ravana**

West Bengal
17th century A.D.
Terracotta relief tile,
22.0 x 27.0 cm.
Victoria and Albert Museum, London

This plaque, probably from the basement of a brick temple, depicts a scene from the *Ramayana*. Here Ravana, the ten-headed demon, riding his chariot (indicated by a row of wheels) and attended by two demons, battles with a monkey, possibly Hanuman, the lieutenant of the hero Rama (see cat. no. 95). The figures, posed in energetic postures, have masklike features that recall Indian dancers' exaggerated make-up. The Bengal craftsman's predilection for surface ornamentation is evoked in repeated lines echoing across the surface.

Reference:
London 1979, no. 38.

124 Ship and Sailors

24 Parganas or Hooghly
 (West Bengal)
18th century A.D.
Terracotta relief tile,
 34.8 x 18.0 cm.
Asutosh Museum of Indian Art,
 Calcutta University

These two adjoining brick panels depict a
multi-tiered, seagoing vessel crowded with
cargo and passengers, including four large
figures in Western dress holding a line.
Since the eighteenth century, such reliefs
on brick temples in Bengal have commonly
featured European motifs.[1]

Note:
1. See Michell 1983, p. 158.

125 Three Figures on a Boat

Janardanpur, Midnapore District
 (West Bengal)
Ca. 19th century A.D.
Terracotta relief tile,
 27.5 x 22.0 x 7.2 cm.
Asutosh Museum of Indian Art,
 Calcutta University

Boating scenes are commonly seen on the lower tiers of brick temples throughout Bengal. This relief portrays a typical Bengali nineteenth-century riverboat, its sides covered with bamboo slats.[1] In this period, foreigners held great fascination for local artists; hence the presence of Englishmen wearing hats. The male figure seated at the center smokes a *hookah* held by a female. An oarsman is seated at the bow. Two vase-like vessels appear in the relief's upper corners.

Note:
1. See Michell 1983, p. 155.

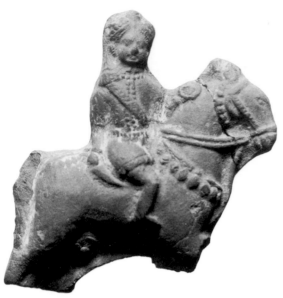

126 Horse and Rider

Calcutta (?) (West Bengal)
1800 A.D. or earlier
Molded terracotta plaque, 7.6 cm.
Museum of Fine Arts, Boston;
 Arthur Mason Knapp Fund

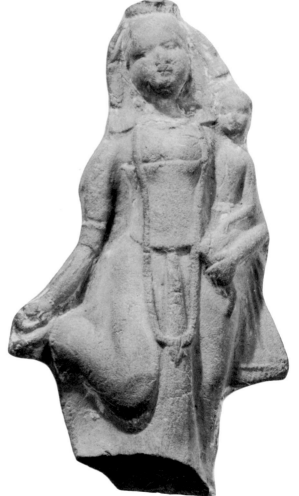

These two plaques remind us that there are certain timeless terracotta types. They repeat and update the technique and style of similar molded subjects of earlier eras. The equestrian figure (cat. no. 126) sports a stylish turban and short curved dagger of a type not seen before the medieval period.[1] In the mother-and-child plaque (cat. no. 127), the mother maintains a timeless pose, coyly pulling a thorn from her foot in a manner usually associated with *yakshis* or *apsarases* (celestial dancers), although she is dressed in a later costume and carries a child in her arm. More recent terracottas of this type found in the region of Calcutta—and more specifically at Chandraketugarh— have often been mistakenly catalogued as Gupta- or even Shunga-period plaques.

References:
(Cat. no. 126) Coomaraswamy 1927, p. 94, fig. 13, as Shunga-period; Boston 1977, no. 78, p. 46, as fourth-fifth century A.D.

127 Hariti and Child

Chandraketugarh (?) (West Bengal)
Ca. 1800 A.D.
Molded terracotta plaque,
 11.5 cm., including stand
Collection of Dr. Bertram Schaffner;
 on loan to The Brooklyn Museum

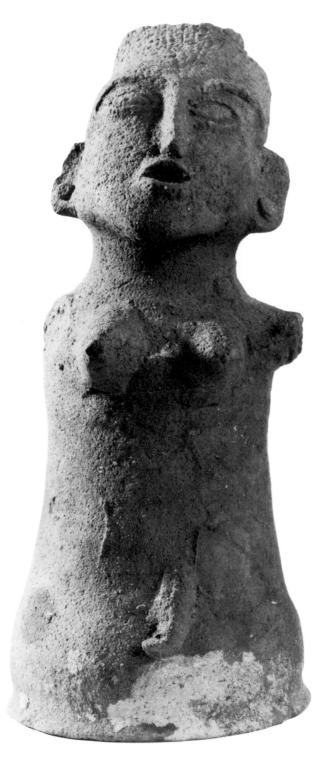

128 **Female Pot Figure**

Malavalli, Uttar Kanara District
 (Karnataka)
Date unknown
Red hand-modeled terracotta,
 35.5 x 16.0 cm.
Private Collection

Collected from an abandoned shrine deep
in a mountainous jungle, this sculpture is of
unknown age and purpose. No potters in the
area now make terracotta images, and no
local villagers know who made those found
here. Other shrines containing pot figures
have been discovered in Uttar Kanara Dis-
trict. Some of the figures are worshiped as
the mother-goddess and are called *Mage-
muduvudu,* or "coming from the earth,"
because they emerge from the ground after
the monsoons.[1]

Although pot figures have been
found in several Kushan sites, and are now
being made and worshiped in Bengal (see
essay by Stephen P. Huyler, above), those
found in Uttar Kanara District are entirely
different in style, especially in the tilt of the
head, the high cheekbones, the broad jaw,
and the long aquiline nose, as in the present
figure. The back of this figure's head is
broken and open, suggesting that at one
time it had a larger headdress. Its arms and
right leg have been lost. The diminutive size
of the calf and foot of its left leg, still att-
ached to the base, is typical of Indian pot
figures.

Note:
1. Bhat 1976.

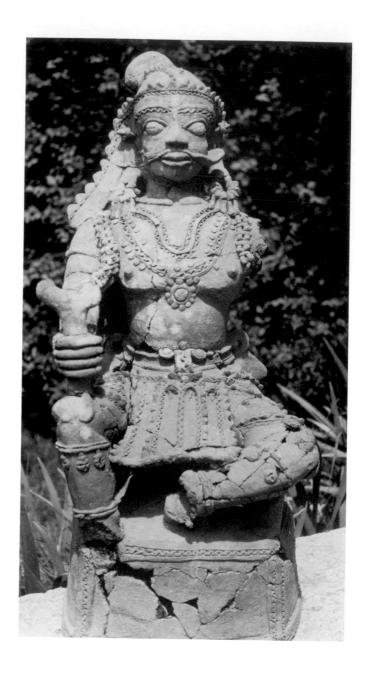

129 Ayyanar

Sittanavasal region (Tamil Nadu)
19th century A.D.
Red hand-modeled terracotta
 with applied ornaments, 83.8 cm.
Private Collection

In the rural areas of eastern Tamil Nadu in
South India, there are shrines to the
guardian deity Ayyanar in almost every vil-
lage. Generally he is accompanied by clay
horses that are offered in an annual ritual.
Here he is shown holding a scepter and
seated in the pose of royal ease *(lalitasana)*.
In spite of the object's largely repaired con-
dition, the masklike face with bulging eyes
and mustache and the raised detailing of the
skirt, belt, and jeweled ornament heighten
the sense of energy, especially when com-
pared to the static pose of a seated princely
figure (see cat. no. 107) of Gupta-period
date. The base of the sculpture is decorated
with repeated chevrons on the borders.

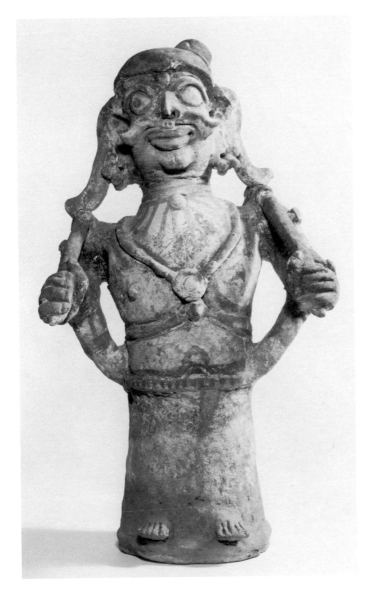

130 Veeran

Tamil Nadu
Early 20th century A.D.
Red hand-modeled terracotta
 with polychrome,
 41.9 x 15.2 x 27.9 cm.
Collection of Harry Holtzman

The hollow terracotta vessels required for festivals, funerals, and other ritual occasions often take the form of protective deities and their vehicles, such as this figure of Ayyanar's attendant, Veeran, a South Indian village deity (cat. no. 130), and the clay dog illustrated on the following page (cat. no. 131), which may be intended as a symbolic vehicle of Bhairava, Shiva's fierce aspect. The detail of these two figures is conventionally baroque, with the applied and painted ornament and facial features distinctive of folk terracottas from Tamil Nadu. Such clay sculptures vary in height from about 5 inches to as much as 16 feet. Each Tamil village has its own deities, and the sculptures given to these dieties themselves constitute the deities' temples.

Ayyanar's attendant is here represented in a typical hollow figure modeled out of a pottery vessel form, with the conventional exaggerated features of bulging eyes and a broad mustache that signify fierce power. He holds two scepters to ward off sickness and other evil. The dog, also formed in a potter's shape, is one of the more individual applications of the potter's art: it sits back on its haunches in seeming indolence, yet its mouth agape, tongue wagging, and ears pricked tautly upward make for an awesome presence.

Reference:
(Cat. no. 131) Kramrisch 1968, no. 109.

131 **Dog**
Pudukkottai (Tamil Nadu)
Early 20th century A.D.
Red hand-modeled terracotta
 with polychrome,
 29.8 x 30.5 cm.
Collection of Harry Holtzman

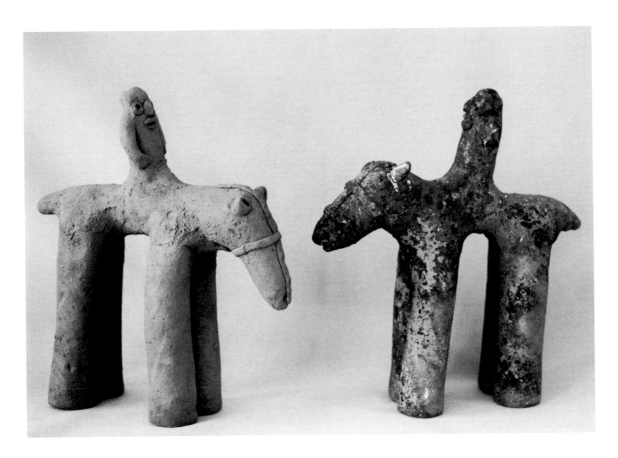

132 Pair of Votive Horses with Riders

Kharwar (Karnataka)
20th century A.D.
Red hand-modeled terracotta,
 19.0 x 16.0 x 5.0 cm. each
Private Collection

Each year in late April most of Kharwar's Hindus converge on the Gramadevasthana shrine in Bandissiti to sacrifice hundreds of roosters and several sheep as a part of the Bandi Habba Festival. At this time, dozens of terracotta horses are placed in the shrine as votive gifts to the god of crop fertility. According to Stephen P. Huyler, a local potter named Vitoba K. Guniga creates these archaic forms from four rolled dowels. He bends two of the dowels into arches to make the four legs and joins them with a third as the horse's trunk and neck. The end of this third dowel he cuts at an angle and reverses to become the horse's head. The last dowel is placed upright in the center of the third, creating the rider's torso. Strips of clay are added for arms, bridle, and tail, and pellets are applied for eyes, ears, nose, and lips. For the finishing touches the potter uses a stick to delineate pupils and an open mouth. Of the two figures shown here, one is unweathered, fresh from the kiln, while the other, its rider's arms and one of the horse's ears broken, was rescued from the discard heap of numerous terracottas at the shrine.

133 Seated Four-Armed Ganesha

West Bengal
20th century A.D.
Terracotta, 27.0 cm.
Collection of S. Neotia

A striking example of modern terracotta sculpture is this votive figure of the elephant-headed god Ganesha shown with four arms and seated in a meditative position. Believed to be the son of Shiva, Ganesha is revered by most Hindus, both Shaivites and Vaishnavites (see cat. no. 110). His rotund image is placed above the front door of many homes as protection against evil spirits. Stephen P. Huyler reports that he is particularly worshiped throughout India during the Ganesha Chaturthi festival in August or September, when terracotta Ganesha images are made and sold to be placed in each Hindu home. His image is also carried in procession, given gifts of food, and prayed to for several days. The Bengali sculpture shown here was probably made for this festival.

Group of Molds:

Impression of cat. no. 134

134 Mold for a Demon's Head

Mathura (Uttar Pradesh)
Maurya period
Terracotta, 5.7 cm.
The Brooklyn Museum 73.99.56;
Gift of Dr. Bertram Schaffner

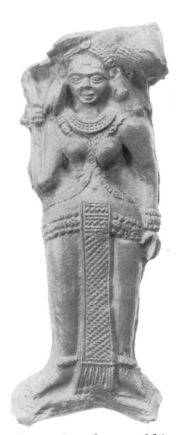

Impression of cat. no. 136

135 Mold for an Ornamented Female Face

Mathura (Uttar Pradesh)
Shunga period, ca. 1st century B.C.
Black terracotta, 6.3 cm.
The Brooklyn Museum 73.99.15;
Gift of Dr. Bertram Schaffner

136 Mold for a Bejeweled and Ornamented Standing Female

Kaushambi (Uttar Pradesh)
Shunga period, ca. 1st century B.C.
Red terracotta, 14.2 cm.
Collection of Samuel Eilenberg
(Not illustrated)

193

137 **Mold for a Crouching Demon Dwarf**

North-central India
Shunga period,
 ca. 2nd–1st century B.C.
Terracotta, 11.0 x 6.0 cm.
Collection of Samuel Eilenberg
(Not illustrated)

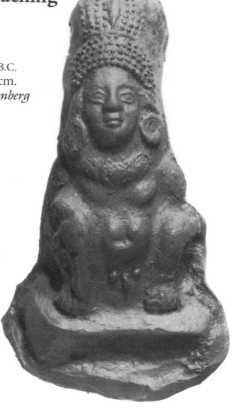

Impression of cat. no. 137

138 **Mold for a Lion Figure**

North India
Kushan period
Red terracotta, 7.0 cm.
Collection of Samuel Eilenberg

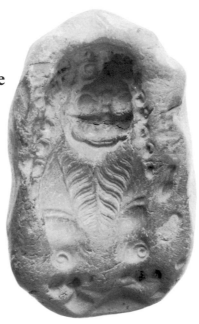
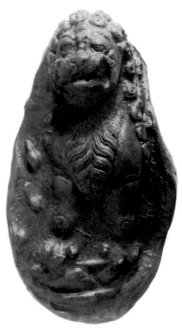

Impression of cat. no. 138

194

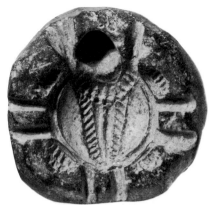

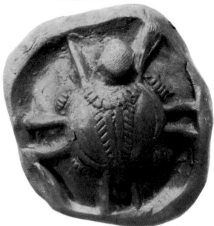

Impression of cat. no. 139

139 Mold for a Tortoise Amulet

Northwest India
3rd–5th century A.D.
Terracotta
Collection of Samuel Eilenberg

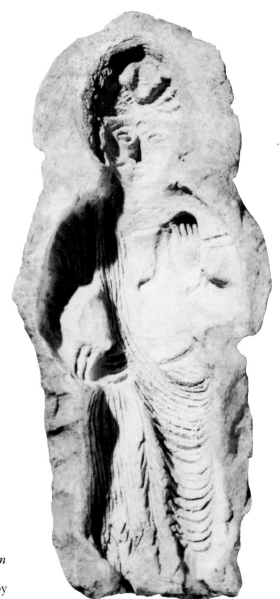

140 Mold for a Standing Bodhisattva

Kala Dheri
3rd–5th century A.D.
Terracotta, 25.7 x 8.7 cm.
Victoria and Albert Museum, London

This object has been authenticated by thermoluminescence analysis.

141 Set of Three Molds Possibly for Floral Ornament on Bronze Aureoles

Taxila
3rd–5th century A.D.
Red terracotta,
 6.0, 8.0, and 8.5 cm. respectively
Collection of Samuel Eilenberg

142 Mold for a Bust of Shiva

Northwest India
Gupta or post-Gupta period
Terracotta, 14.0 x 10.0 cm.
Collection of Samuel Eilenberg
(Not illustrated)

Impression of cat. no. 142

 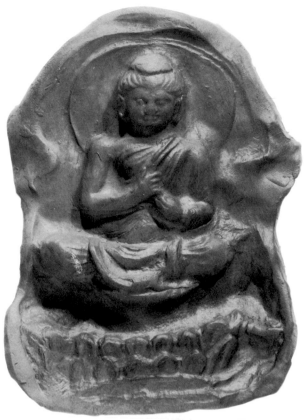

Impression of cat. no. 143

143 **Mold for a Seated Buddha**

Gandhara region
6th–7th century A.D.
Terracotta, 12.2 cm.
Collection of Samuel Eilenberg

Selected Bibliography

Agrawala, V.S. "Rajghat Terracottas." *Journal of the Indian Society of Oriental Art,* 9 (1941).

————. "Terracotta Figurines of Ahichchattra." *Ancient India: Bulletin of The Archaeological Survey of India,* 4 (1947–48), pp. 104–179.

Altekar, A.S. *The Coinage of the Gupta Empire* (Banaras, 1957).

Asher, F.M. *The Art of Eastern India, 300-800* (Minneapolis, 1980).

The Asia Society, New York. *Handbook of the Mr. and Mrs. John D. Rockefeller 3rd Collection* (New York, 1981).

ASIAR. *Archaeological Survey of India Annual Report.*

Auboyer, J. "Septs terres cuites de style Sunga/Kanya au Musée Guimet." In *Indologen-Tagung, 1971,* ed. H. Härtel and V. Moeller (Wiesbaden, 1973), pp. 88–98.

————. "About an Indian Terracotta of the Guimet Museum, Paris." In *Chhavi— 2: Rai Krishnadasa Felicitation Volume* (Banaras, 1981), pp. 158–160.

Banerjee, P. "A Terracotta Panel from Bhitargaon." *Roopa Lekha,* 57 (1985), pp. 86–88.

Basham, A.L. "The Mandasor Inscription of the Silk-Weavers." In *Essays on Gupta Culture,* ed. Bardwell L. Smith (New Delhi, 1983), pp. 93–105.

Behura, N.K. *Peasant Potters of Orissa: A Sociological Study* (New Delhi, 1978).

Bhandarkar, D.R. *The Archaeological Remains and Excavations at Nagari* (Memoirs of the Archaeological Survey of India, 4) (Calcutta, 1920).

Bhandarkar, D.R., B. Chhabra, and G.S. Gai, eds. *Inscriptions of the Early Gupta Kings* (New Delhi, 1981).

Bhat, H.R.R. "Some Terracotta Images from North Kanura." *Archaeological Studies: Volume I* (Mysore, 1976), pp. 29–34.

Biswas, S.S. *Terracotta Art of Bengal* (New Delhi, 1981).

Boston, Museum of Fine Arts. *The Arts of India and Nepal: The Nasli and Alice Heeramaneck Collection.* Exhibition catalogue (Boston, 1970).

————. *From River Banks and Sacred Places: Ancient Indian Terracottas.* Exhibition catalogue (Boston, 1977).

Burton, R., trans. *The Kama Sutra of Vatsyayana* (ed. New York, 1962).

Bussabarger, R.F. and B.D. Robins. *The Everyday Art of India* (New York, 1968).

Bussagli, M. and C. Sivaramamurti. *5000 Years of the Art of India* (New York, 1978).

Chandra, M. "Terracottas in Bharat Kala Bhavan." In *Chhavi: Bharat Kala Bhavan Golden Jubilee Volume* (Banaras, 1971), pp. 1–15.

————. *Trade and Trade Routes in Ancient India* (New Delhi, 1977).

Chandra, P. "The Cult of Sri Lakshmi and Four Carved Discs in Bharat Kala Bhavan." In *Chhavi: Bharat Kala Bhavan Golden Jubilee Volume* (Banaras, 1971), pp. 139-148.

Coomaraswamy, A.K. "Early Indian Terracottas." *Bulletin of the Museum of Fine Arts, Boston,* 25 (1927), pp. 90-96.

_____. *History of Indian and Indonesian Art* (Boston, 1927) (1927a).

_____. "Archaic Indian Terracottas." *Jahrbuch für Prähistorische und Ethnographische Kunst* (1928), pp. 64-76.

_____. *La Sculpture de Bharhut* (Paris, 1956).

Cousens, H. "Ter-Tagara." ASIAR 1902-03, pp. 195-204.

_____. "Buddhist Stupa at Mirphur-Khas, Sind." ASIAR 1909-10, pp. 80-92.

Czuma, S. *Indian Art from the George P. Bickford Collection.* Exhibition catalogue (Cleveland Museum of Art, 1975).

_____. *Kushan Sculpture: Images from Early India.* Exhibition catalogue (Cleveland Museum of Art, 1985).

Dales, G.F. "Of Dice and Men." In *Ancient Cities of the Indus,* ed. G. Possehl (New Delhi, 1979), pp. 138-144.

Dani, A.H. "Shaikhan Dheri Excavation, 1963 and 1964 Seasons." *Ancient Pakistan,* 2 (1965-66), pp. 17-214.

Das, S.K. "A Study of Folk Cattle Rites." *Man in India,* 33 (1953), pp. 232-241.

Dasgupta, C.C. "Bibliography of Ancient Indian Terracotta Figurines." *Journal of the Royal Asiatic Society of Bengal, Letters,* 4 (1938).

_____. "Some Unpublished Ancient Indian Terracottas Preserved in the British Museum" *Artibus Asiae,* 13 (1950), pp. 254-269.

_____. "Unpublished Ancient Indian Terracottas Preserved in the British Museum." *Artibus Asiae,* 14 (1951), pp. 283-285.

_____. *Origin and Evolution of Indian Clay Sculpture* (Calcutta, 1961).

Dasgupta, P.C. "The Early Terracottas from Chandraketugarh." *Lalit Kala,* 6 (1959), pp. 45-52.

_____. *The Excavations at Pandu Rajar Dhibi* (Calcutta, 1964).

Dehejia, V. *Early Stone Temples of Orissa* (New Delhi, 1979).

Desai, D. *Erotic Sculpture of India: A Socio-Cultural Study* (New Delhi, 1975; 2nd ed. 1985).

_____. "Social Background of Ancient Indian Terracottas." In *History and Society: Essays in Honour of Professor Niharranjan Ray,* ed. D. Chattopadhyaya (Calcutta, 1978), pp. 143-168.

_____. "Mother Goddess and Her Partner." *Aruna Bharati* (Baroda, 1983).

_____. "Terracottas and Urban Culture of Ancient India." *National Museum Bulletin,* nos. 4-6 (1983), pp. 59-65 (1983a).

Dhavalikar, M.K. *Masterpieces of Indian Terracottas* (Bombay, 1977).

Dikshit, K.N. *Excavations at Paharpur, Bengal* (Memoirs of the Archaeological Survey of India, 55) (New Delhi, 1938).

Dikshit, M. *Sirpur and Rajim* (Bombay, 1960).

Fabri. C.L. "Akhnur Terracottas." *Marg,* 8, no. 2 (1955).

Fisher, R.E. "The Enigma of Harwan." *Art International,* 25 (November-December 1982), pp. 33–45.

Fleet, J.F. *Inscriptions of the Early Gupta Kings and Their Successors* (Banaras, 1970).

Gajjar, I.N. *Ancient Indian Art and the West* (Bombay, 1971).

Gangoly, O.C. and A. Goswami. *Indian Terracotta Art* (New York, 1959).

Graindor, P. *Terres cuites de l'Egypte gréco-romaine* (Antwerp, 1915).

Great Centres of Art: Calcutta (New York, 1973).

Gupta, P.L. *Gangetic Valley Terracotta Art* (Varanasi, 1972).

Gupta, S.P. *The Roots of Indian Art* (New Delhi, 1980).

Harle, J.C. *Temple Gateways in South India* (Oxford, 1963).

————. "On a Disputed Element in the Iconography of Early Mahisasuramardini Images." *Ars Orientalis,* 8 (1970), pp. 147–153.

————. *Gupta Sculpture* (Oxford, 1974).

Härtel, H. "A Kushana Naga Temple at Sonkh." *Bulletin, Museums and Archaeology in U.P.,* nos. 11–12 (1973), pp. 1-6.

————. "Some Results of the Excavations at Sonkh: A Preliminary Report." In *The Excavations at Sonkh.* Exhibition catalogue (National Museum, New Delhi, 1977).

Higgins, R.A. *Greek Terracotta Figures* (London, 1963).

Hiralal, R.B. "The Sirpur Stone Inscription of the Time of Mahasivagupta." *Epigraphia Indica,* 11 (1911–12), pp. 184–201.

Hofmann, I. "Eine neue Elephantengott-Darstellung aus dem Sudan." *JEA,* 58 (1972), pp. 245ff.

————. *Wege und Möglichkeiten eines indischen Einflüsses auf die meroitische Kultur* (Bonn, 1975).

Huntington, S.L. *The Pala-Sena Schools of Sculpture* (Leiden, 1984).

————. *The Art of Ancient India* (New York, 1985).

Hutton, J.H. *Caste in India* (Cambridge, England, 1946).

Ingen, W. Van. *Figurines from Selucia* (Ann Arbor, 1939).

Irwin, J. "The Heliodorus Pillar: A Fresh Appraisal." *Art and Archaeology Research Papers,* 6 (December 1974), pp. 1–11.

Jain, J.C. *Ancient India as Depicted in Jain Canons* (Bombay, 1947).

Jarrige, J.-F. and R.H. Meadow. "The Antecedents of Civilization in the Indus Valley." *Scientific American,* 243, no. 2 (1980), pp. 122–133.

Jayakar, P. *The Earthen Drum* (New Delhi, n.d.).

Johnston, E.H. *Annual Bibliography for Indian Archaeology* (Leiden and Oxford, 1939).

Jones, J.J. *The Mahavastu.* 3 vols. (London, 1956).

Joshi, M.C. and C. Margabandhu. "Some Terracottas from Excavations at Mathura —A Study." *Journal of the Indian Society of Oriental Art,* 8 (1976-77), pp. 16–32.

Kala, S.C. *Terracotta Figurines from Kausambi* (Allahabad, 1950).

_____. *Terracottas in the Allahabad Museum* (New Delhi, 1980).

Kaufmann, M. *Graeco-Aegyptische Koroplastik* (Leipzig, 1915).

Khare, M.D. "Discovering of a Vishnu Temple near the Heliodorus Pillar Besnagar Dist. Vidisha (M.P.)." *Lalit Kala,* 13 (1967), pp. 21-27.

Kramrisch, S. "Indian Terracottas." *Journal of the Indian Society of Oriental Art,* 7 (1939); reprinted in *Exploring India's Sacred Art: Selected Writings of Stella Kramrisch,* ed. B.S. Miller (Philadelphia, 1983), pp. 69-84.

_____. *The Hindu Temple.* 2 vols. (Calcutta, 1946).

_____. "An Image of Aditi Uttanapad." *Artibus Asiae,* 19 (1956), pp. 259-270.

_____. *Unknown India: Ritual Art in Tribe and Village.* Exhibition catalogue (Philadelphia Museum of Art, 1968).

_____. *Manifestations of Shiva.* Exhibition catalogue (Philadelphia Museum of Art, 1981).

_____. "Siva Bholanatha." *Bulletin of the Philadelphia Museum of Art,* 80 (Summer/Fall 1984), pp. 4-7.

_____. "The Ritual Arts of India." In *Aditi: The Living Arts of India* (Washington, D.C., 1985).

Lal, B.B. "Excavation at Hastinapura and Other Explorations in the Upper Ganga and Sutlej Basins, 1950-52." *Ancient India: Bulletin of the Archaeological Survey of India,* 10-11 (1954-55), pp. 5-151.

Lerner, M. In *Notable Acquisitions 1980-1981* (The Metropolitan Museum of Art, New York, 1981).

London, Victoria and Albert Museum. *Arts of Bengal.* Exhibition catalogue (London, 1979).

_____. Arts Council of Great Britain. *In the Image of Man.* Exhibition catalogue (London, 1982).

MacDowall, D.W. and M. Taddei. "The Pre-Muslim Period." In *The Archaeology of Afghanistan,* ed. F.R. Allchin and Norman Hammond (London, 1978), pp. 233-299.

Mackay, J.H. *Further Excavations at Mohenjo-Daro* (New Delhi, 1937).

_____. *Chanhudaro Excavations 1935-36* (Baltimore, 1943).

Mahavastu-Avadanam, ed. R. Basak. 3 vols. (Calcutta, 1963-68).

Mankodi, K. "Siva Gangadhara on a Terracotta from Rang Mahal." In *Madhu: Recent Researches in Indian Archaeology and Art History* (New Delhi, 1982), pp. 243-246.

Margabandhu, C. "Early Transport Vehicles from Ganga Valley." In *Rangavalli: Recent Researches in Indology* (New Delhi, 1983), pp. 163-169.

Marshall, J. *Mohenjo-Daro and the Indus Valley Civilization.* 3 vols. (London, 1931).

_____. *Taxila.* 3 vols. (Cambridge, England, 1951).

McCutchion, D. "Styles of Bengal Temple Terracottas: A Preliminary Analysis." In *South Asian Archaeology,* ed. N. Hammond (London, 1971), pp. 265-278.

_____. "Hindu-Muslim Artistic Continuities." In *The Islamic Heritage of Bengal,* ed. G. Michell (Paris, 1984), pp. 213-230.

Mehta, R.N. and S.N. Chowdhary. *Excavation at Devni-Mori* (Baroda, 1966).

Michell, G., ed. *Brick Temples of Bengal from the Archives of David McCutchion* (Princeton, 1983).

Miller, B.S., ed. *Theater of Memory: The Plays of Kalidasa* (New York, 1984).

Mishra, R.N. *Ancient Artists and Art-Activity* (Simla, 1975).

Mukhopadhyaya, S.K. "Terracottas from Bhita." *Artibus Asiae,* 34 (1972), pp. 71-94.

Neven, A. *New Studies into Indian and Himalayan Sculpture* (Eersel, The Netherlands, 1980).

Pal, P. "Dhanada-Kubera of the *Vishnudharmottara Purana* and Some Images from North-West India." *Lalit Kala,* 18 (1977), pp. 13-25.

———. *The Divine Presence.* Exhibition catalogue (Los Angeles County Museum of Art, 1978).

———. *The Ideal Image: The Gupta Sculptural Tradition and Its Influence.* Exhibition catalogue (The Asia Society, New York, 1978) (1978a).

———. *The Sensuous Immortals.* Exhibition catalogue (Los Angeles County Museum of Art, 1978) (1978b).

———. "An Addorsed Saiva Image from Kasmir and Its Cultural Significance." *Art International,* 24 (1981).

Paris, Musée du Petit Palais. *Inde: cinq milles ans d'art.* Exhibition catalogue (Paris, 1978).

Paul, P.G. "Some Terracotta Plaques from the Swat-Indus Region: A Little-Known Phase of the Post-Gandhara Art of Pakistan." In *South Asian Archaeology,* ed. H. Härtel (Berlin, 1979).

Poster, A. *Figures in Clay: Terracottas from Ancient India.* Exhibition catalogue (The Brooklyn Museum, New York, 1973).

———. "From Indian Earth: Terracottas from Ancient India." In *Festival of India in the United States 1985-1986* (New York, 1985), pp. 23-26.

Pratap, B. "A Technological Study of Terracotta Figurines in India Before the Emergence of the Mould." *Journal of the Oriental Institute, University of Baroda,* 22 (1973), pp. 378-393.

Raghunathan, N., trans. *Bhagavata Purana.* 2 vols. (Madras, 1976).

Ray, N. *Maurya and Sunga Art* (Calcutta, 1945).

———. "Painting and Other Arts." In *The Classical Age* (The History and Culture of the Indian People, 3), ed. R.C. Majumdar (Bombay, 1954), pp. 542-559.

Sahay, S. "Technique of Terracotta Art." In *Dr. Satkari Mookerji Felicitation Volume. Chowkhamba Sanskrit Series,* 69 (1969), pp. 404-409.

Sankalia, H.D. "The Nude Goddess or 'Shameless Woman' in Western Asia, India, and South-Eastern Asia." *Artibus Asiae,* 23 (1960), pp. 111-123.

———. *Pre-historic Art in India* (Durham, North Carolina, 1978).

Sankalia, H.D. and M.K. Dhavalikar. "Terracotta Art of India." *Marg,* 23 (1969), pp. 33-54.

Saraswati, B. *Pottery-making Cultures and Indian Civilization* (New Delhi, 1978).

Sarkar, H. and B.N. Misra. *Nagarjunakonda* (New Delhi, 1966).

Sarma, I.K. and B.P. Singh. "Terracotta Art of Proto-historic India." *Journal of Indian History,* 45 (1967), pp. 773-798.

Sastri, K.A.S., ed. *Mayamatam* (Srirangam, 1966).

Sastri, T.G., ed. *The Silparatna by Sri Kumara* (Trivandrum, 1922).

Sastry, V.V.K. "Terracottas from Peddabankur and Dhulikatta." *Journal of Archaeology in Andhra Pradesh,* 1 (1979), pp. 79–87.

Schweinitz, K. de. *The Rise and Fall of British India* (London and New York, 1983).

Shah, H. *Votive Terracottas of Gujarat* (Ahmedabad, 1985).

Sharma, G.R. "The Excavations at Kausambi (1957–59)." *Institute of Archaeology, Allahabad University Publication,* no. 1 (Allahabad, 1960).

———. *Excavations at Kausambi 1949-50* (Memoirs of the Archaeological Survey of India, 74) (Calcutta, 1969).

———. *History To Prehistory* (Archaeology of the Vindhyas and the Ganga Valley, 11) (Allahabad, 1980).

Sharma, R.C. "The Terracotta Art of Mathura." *U.P. State Lalit Kala Academy Independence Silver Jubilee* (Lucknow, 1972).

———. *Mathura Museum of Art* (Mathura, 1976).

Sharma, R.S. *Sudras in Ancient India* (New Delhi, 1958).

———. *Indian Feudalism* (Calcutta, 1965).

———. "Decay of Gangetic Towns in Gupta and Post-Gupta Times." *Proceedings of the Indian History Congress,* 33rd session (Muzaffarpur, 1972).

Shere, S.A. *Terracotta Figurines in Patna Museum, Patna* (Patna, 1961).

Sinha, B.P., ed. *Potteries of Ancient India* (Patna, 1969).

Sinha, B.P. and L.A. Narain. *Pataliputra Excavations, 1955-56* (Patna, 1970).

Sinha, B.P. and S.R. Roy. *Vaisali: Excavations, 1958-62* (Patna, 1969).

Sinha, B.P. and B.S. Verma. *Sonpur Excavations (1956 and 1959-1962)* (Patna, 1977).

Sivaramamurti, C. *L'Art en Inde* (Paris, 1974).

———. *The Art of India* (New York, 1977).

Smith, P. *A History of India.* (New York, 1982).

Srivastava, M.C.P. *Mother Goddess in Indian Art, Archaeology, and Literature* (New Delhi, 1979).

Srivastava, S.K. "Techniques and Art of the Gupta Terracottas." In *Chhavi: Bharat Kala Bhavan Golden Jubilee Volume* (Banaras, 1971), pp. 374–381.

Staal, F. *Agni: The Vedic Ritual of the Fire Altar.* 2 vols. (Berkeley, 1983).

Stadtner, D.M. "The Siddhasvara Temple at Palari and the Art of Kosala during the Seventh and Eighth Centuries." *Ars Orientalis,* 12 (1981), pp. 49–56.

Taddei, M. *Inde* (Geneva, 1970).

———. "Inscribed Clay Tablets and Miniature Stupas from Gazni." *East and West,* 30 (1970), pp. 70–86 (1970a).

Thapar, B.K. "Prakash 1955: A Chalcolithic Site in the Tapi Valley." *Ancient India: Bulletin of the Archaeological Survey of India,* 20–21 (1967), pp. 5–167.

Thurston, E. *Castes and Tribes of Southern India* (Madras, 1909).

Vafopoulou-Richardson, C.E. *Greek Terracottas.* Exhibition catalogue (Ashmolean Museum, Oxford, 1981).

van Buitenen, J.A.B., trans. *The Little Clay Cart* (New York, 1968).

————. *Mahabharata* (Chicago, 1973).

van Wijngaarden, W.D. *De Grieks-Egyptische Terracotta's in het Rijksmuseum van Oudheden* (Leiden, 1958).

Varma, K. *The Indian Technique of Clay Modelling* (Proddu, 1970).

Vogel, J. "Excavations at Saheth-Maheth." ASIAR 1907-08, pp. 81-131.

————. "Temple at Bhitargaon." ASIAR 1908-09, pp. 5-16.

Watters, T. *On Yuan Chwang's Travels in India, 629-645* A.D. (London, 1904).

Webster, T. *Hellenistic Art* (London, 1966).

Wheeler, R.E.M. "Arikamedhu: An Indo-Roman Trading-Station on the East Coast of India." *Ancient India: Bulletin of the Archaeological Survey of India,* 2 (1946), pp. 17-124.

————. *Charsadda* (London, 1962).

Williams, J. *The Art of Gupta India* (Princeton, 1982).

Woodroffe, J., ed. *The Great Liberation (Mahanirvana Tantra)* (Madras, 1971).

Zaheer, M. *The Temple of Bhitargaon* (New Delhi, 1981).

Index

examples, 123; firing, 20; ca. 50–300 A.D., 37–39; function of, 21; Hellenistic influence, 32; history of, 17, 29–41; iconographic components, 22; *Krishna* themes, 40; *Mahabharata* themes, 40; materials and techniques of, 20–21, 44–45, 67; medieval, 41; modern traditions, 28; period following Muslim invasion, 28; in 19th and 20th centuries, 57–66; plaques, 38, 40, 49, 50, 100, 179; primordial style, 58, 62, 63, 64; regional differences, 19; religious themes in, 35, 38–39; scholarship, 17–18, 67; secular themes, 40, 105; signatures in, 63; ca. 600–320 B.C., 30–31; social conditions necessary for, 29; stylistic analysis of, 18–19; symbolic meaning of, 21–22; technical examination of, 67–69; temporal style, 58, 59, 60; ca. 320–200 B.C., 32–34; ca. 300–600 A.D., 39–41; tiles, 129, 130, 156; traditional rural, 62–66; ca. 200 B.C.–50 A.D., 34–36; Western influence, 58, 59, 115, 130
Thermoluminescence dating, 68, 91, 92
Tools, 19
Tortoise amulet, 195
Toy cart, 78, 108, 109, 110
Toy whistle, 78
Toys, 78, 79

Uma-Maheshvara, 159
Uraiyur, 114
Uttar Kanara, 63
Uttar Pradesh, 28, 33, 65, 89, 90, 91, 92, 93, 112, 138, 145, 152, 153, 154, 156, 159, 163, 164

Vaishali, 31, 34, 40
Varaha, 54
Varahi, 174
Varanasi, 143, 147
Veeran, 189
Vegetation cults, 35
Victoria and Albert Museum, 116, 130
Vishnu, 26, 46, 49, 52, 149, 152, 153, 154
Vishnudharmottara Sutra, 121, 161
Votive figures, 21, 58, 60, 63
Votive tanks, 39, 63

Yakshas, 38, 106, 115
Yakshis, 22, 25, 101, 102, 103
Yamuna River, 94
Yellapur, 114
Yelleshwaram, 37, 38

Zhob culture, 29

208